MW00800866

Dark Stories
By Dark Artists

Nie Youjia

 CYPI PRESS

Preface

Dark art has always been a favorite of artists. As an independent category, dark art is enveloped with eeriness and fearlessness, which makes it distinctive. Death, violence, blood, and shadows have been encapsulated in artistic creations and endowed with life. All these creative works mirror the dark lurking in the corner of our hearts, and reminded us to confront it. It invites to wonder at the dark in the heart of the artists engaged in it. For this reason, we invited many artists to share with us one of the darkest stories in his or her heart, on which this book is based. All the artists invited have been so generous in sharing their dark stories, to facilitate a more comprehensive understanding of dark art on the part of the readers.

This book showcases a rich variety of work in dark art contributed by twenty-four of the most outstanding artists, ranging from painters, sculptors, installation artists to photographers. Through these works, we can marvel at the remarkable imaginative and expressive powers of these artists. Their dark stories might be an unpleasant experience in their childhood, or some mysterious happenings that cannot be explained, or a hidden sentiment. Dark artists give expression to the demons in their heart, revealing the unease we all harbor inside our self. These artists are sharing a story from their own life. Readers are invited to follow the footsteps of the artist and indulge themselves in a dark and eerie vision.

Mankind is drawn by nature to the light. However, light only exists in contrast to dark, just as hope is defined on the basis of fear, or as shade is the loyal companion of sunshine. Such a dichotomy is an integral part of reality, which explains the value of darkness

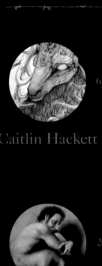

Contents

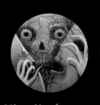

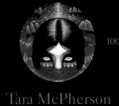

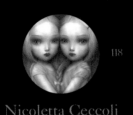
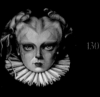
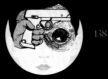
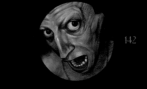
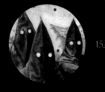
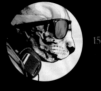
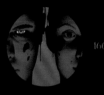
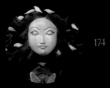
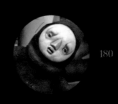

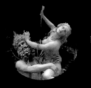
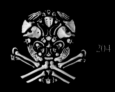

CAITLIN HACKETT *& Her Dark Story*

This scene has stuck with me through the years, a dreamlike memory. I was about four years old, and I was with my preschool group standing beneath a tree on a wet but sunny sidewalk. There had been a storm the night before, and two baby birds, blotchy pink and naked, had fallen from their nest in the storm. My preschool teacher had a towel, and she had picked up their little bodies and was trying, perhaps, to revive them, by gently rubbing them. As she rubbed them the whole towel was turning pink. I don't know or recall if it was their skin coming off, or blood, all I know is that the little pale creatures, with their alien grey eyes sealed beneath thin pink skin, seemed to erode into the towel, and instead of awakening, disintegrated right before our eyes. She flushed them down the toilet afterwards.

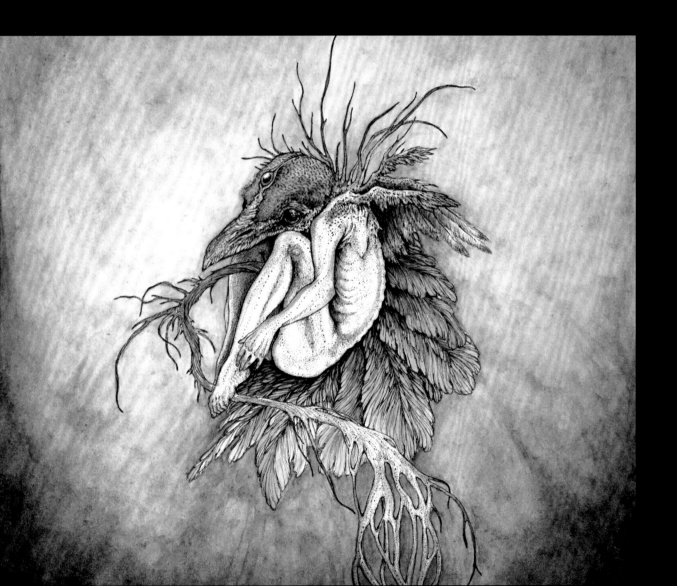

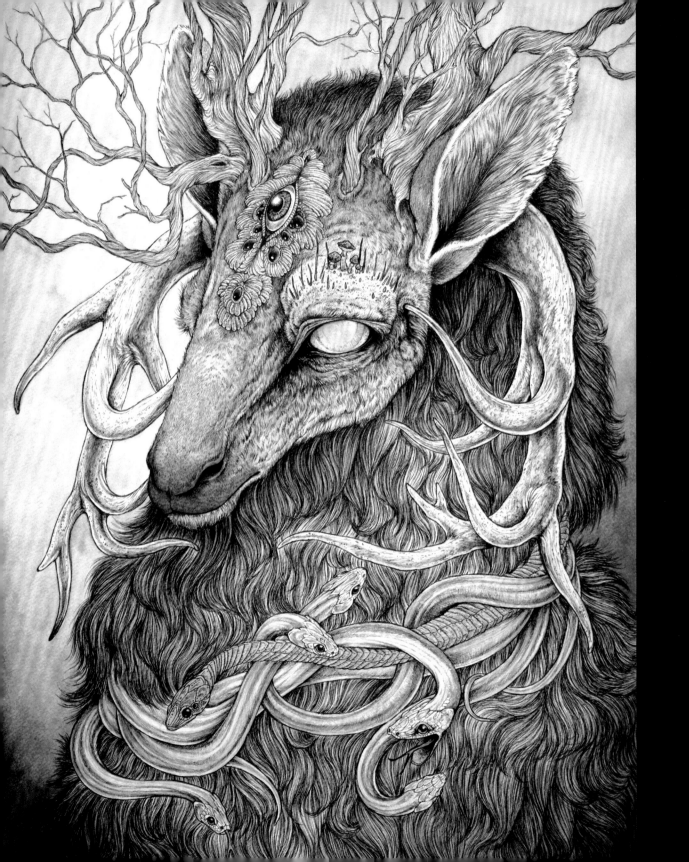

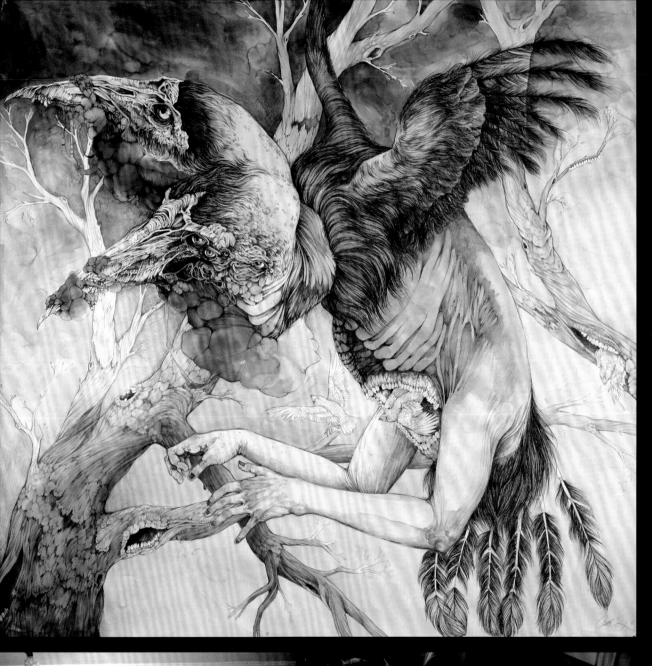

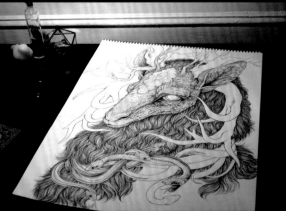

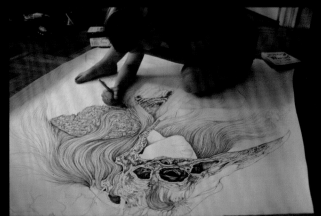

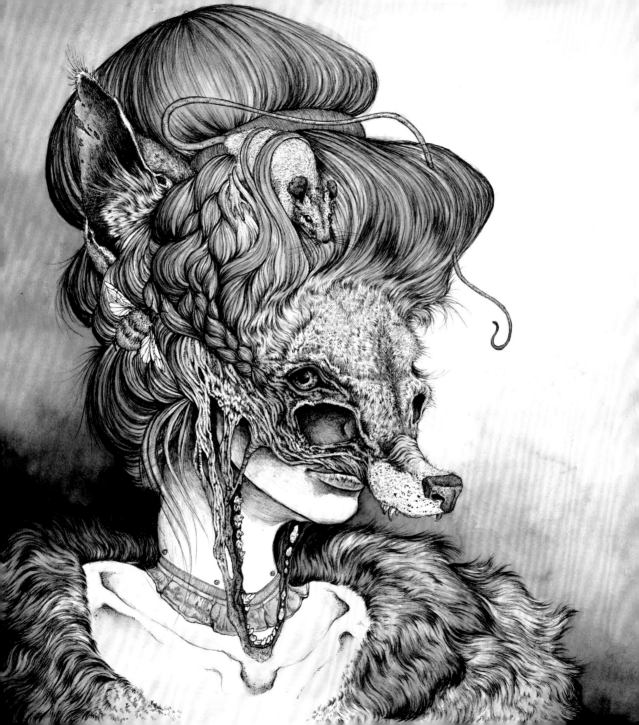

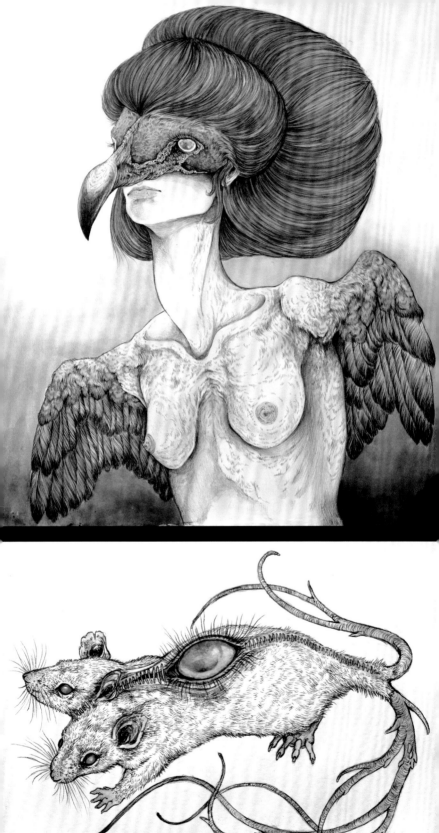

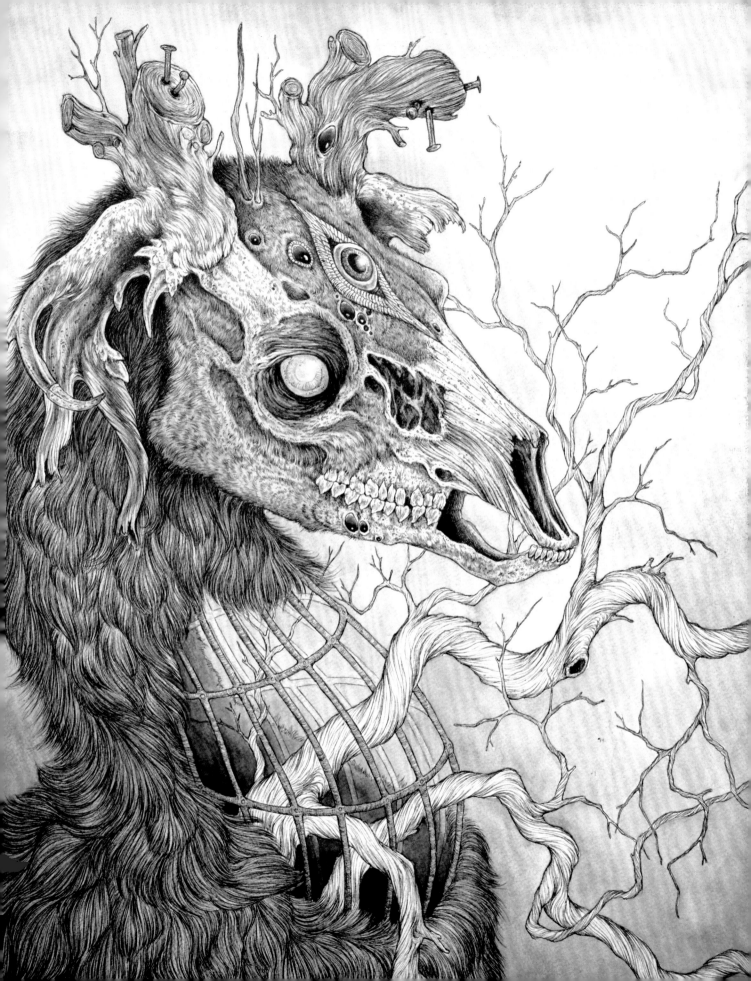

JANA BRIKE & *Her Dark Story*

I would occasionally have conversations with my five-year-old son when he would ask me a question which is stronger, heat or cold, light or darkness. I gave a fast, unwitting answer that there is no cold or darkness in physics at all, so it cannot be stronger.

There is just energy, which is light, and heat – or life – and there is a condition when the energy is absent. As I said it, I thought it sounded like the basic theology I was searching for in my work.

A painting or a story about light would not be complete without telling about darkness too. Both the darkest and the most enlightened stories I can tell are stories about life itself, and I am always telling them through my work.

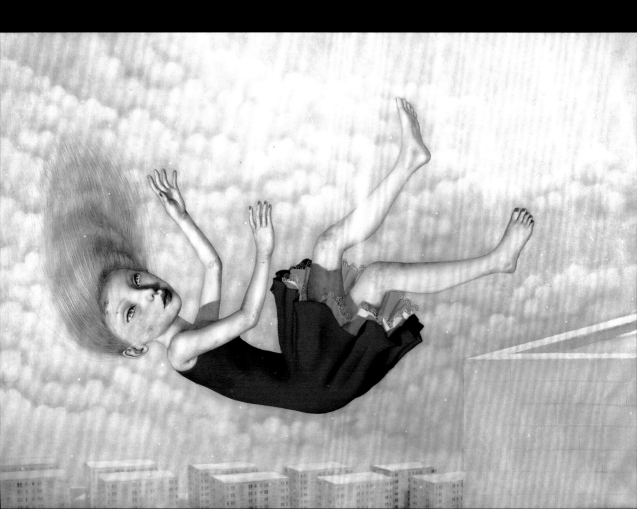

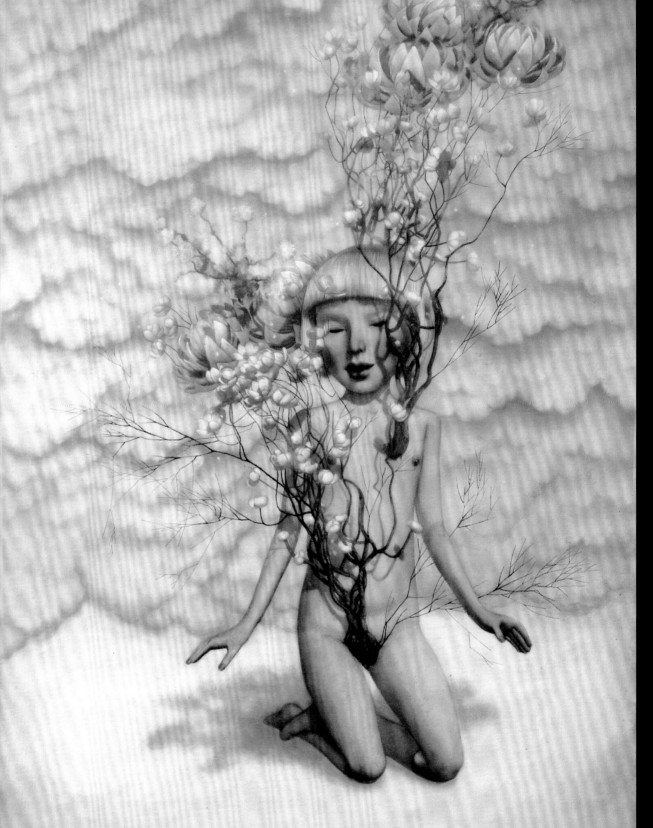

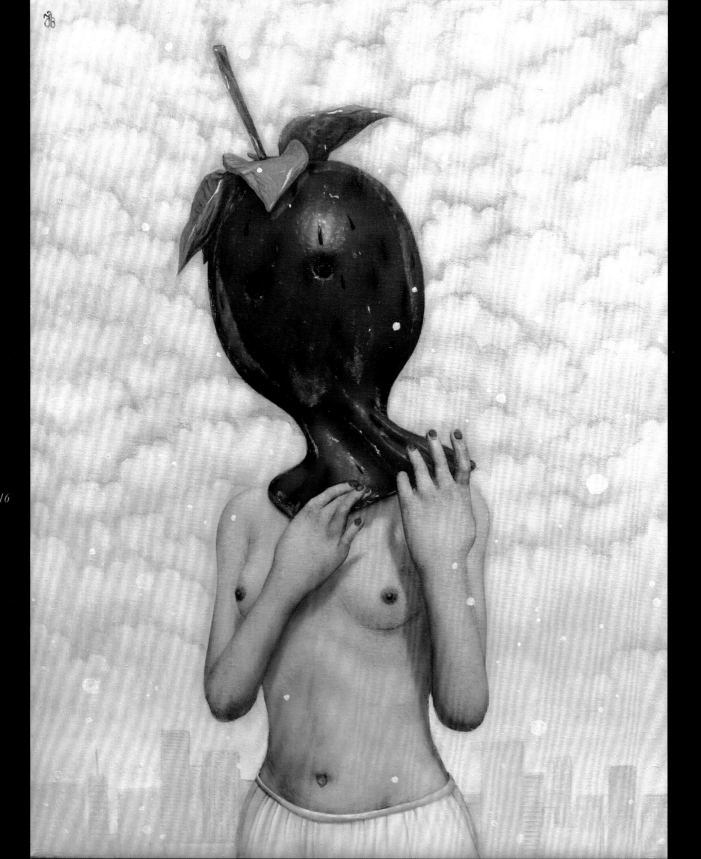

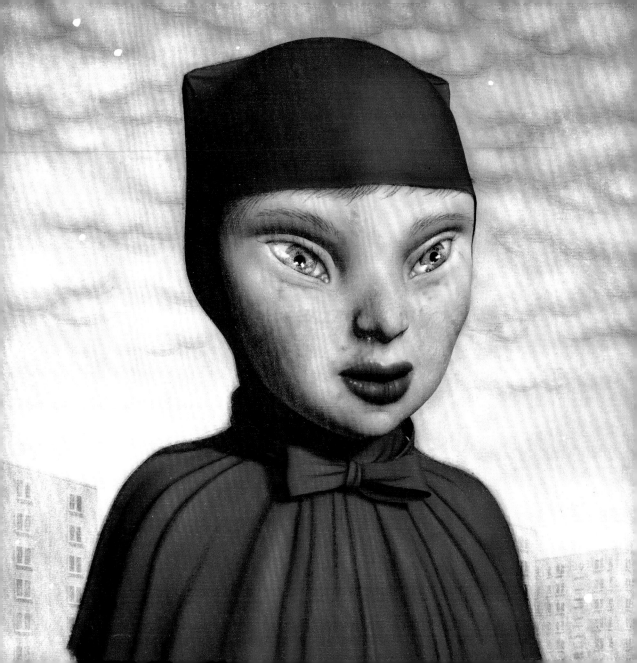

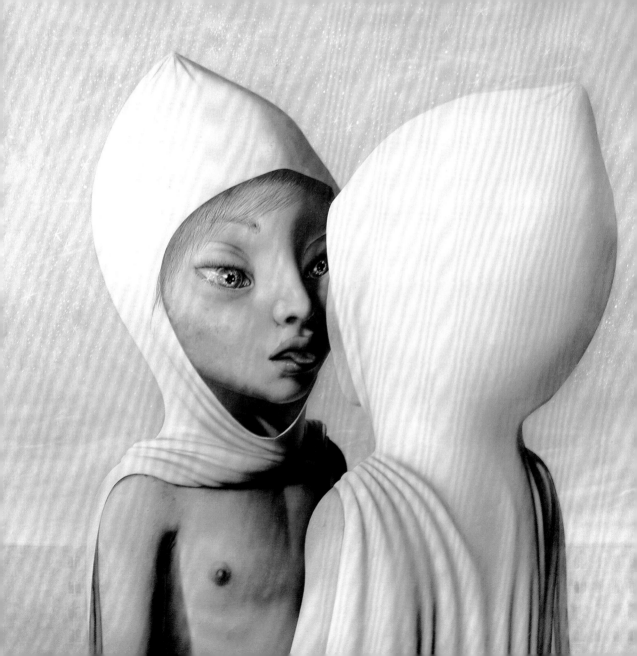

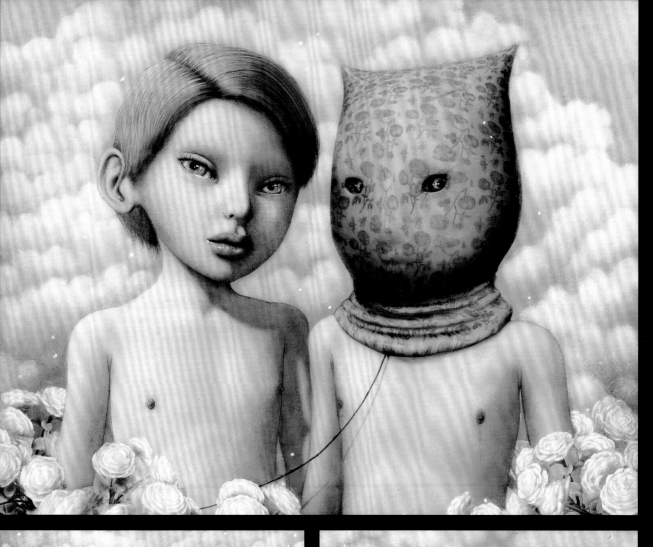

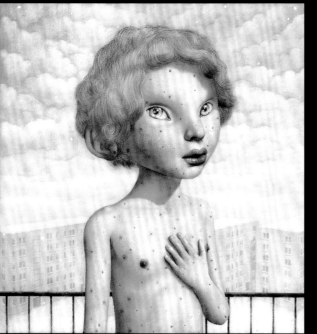

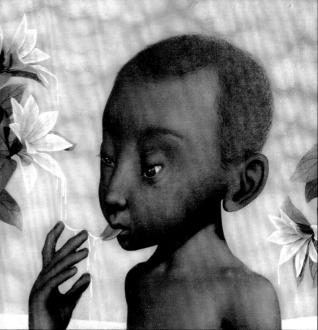

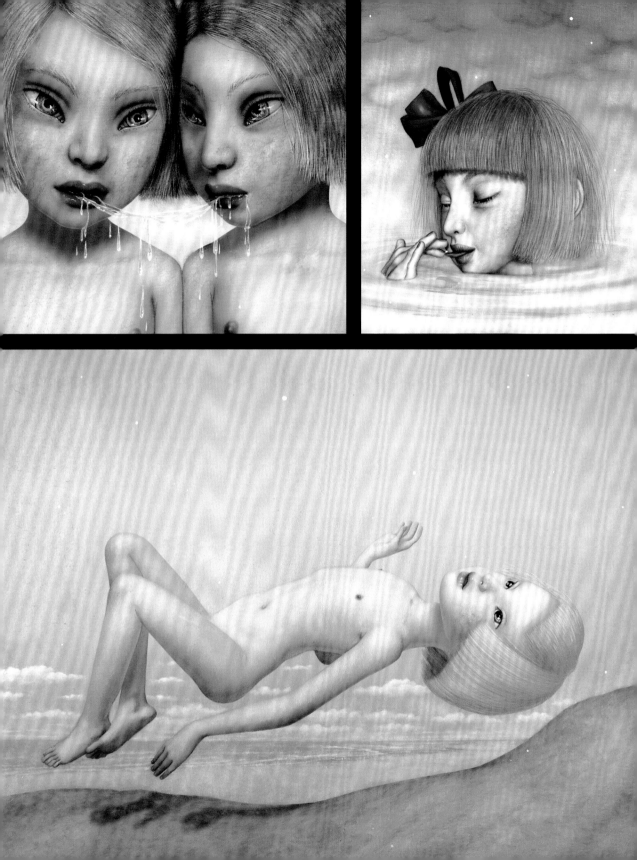

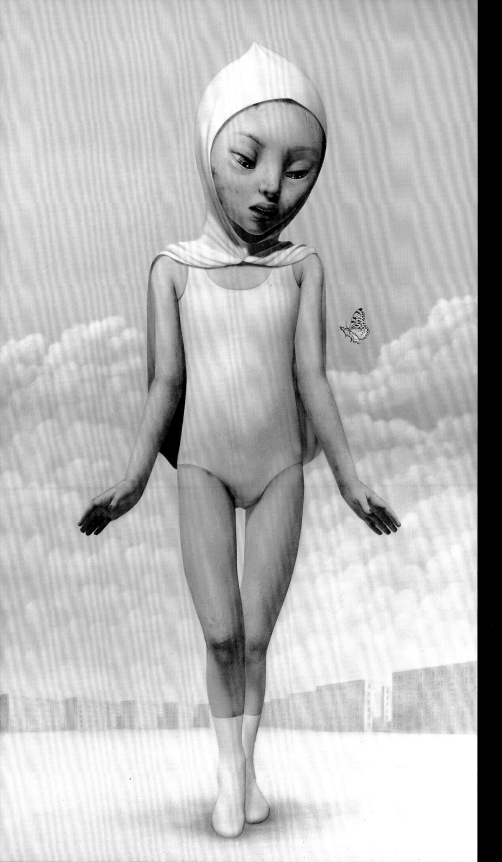

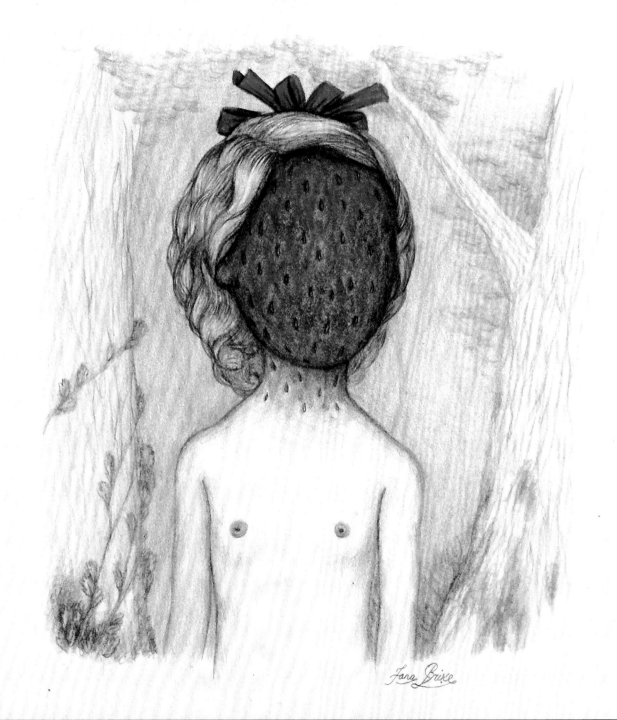

Jana Brike

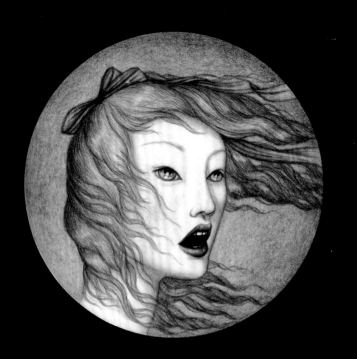
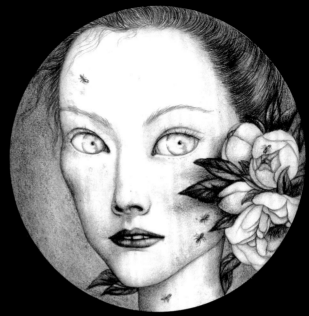

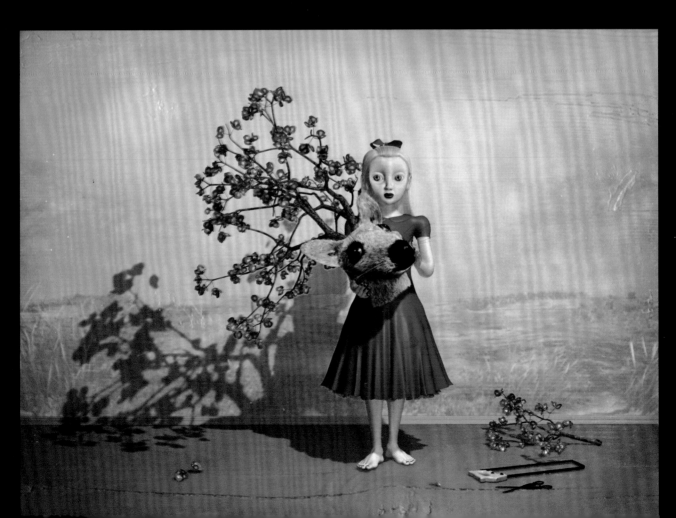

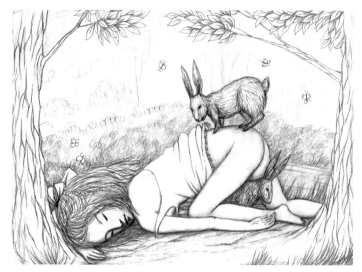

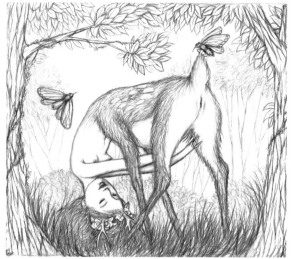

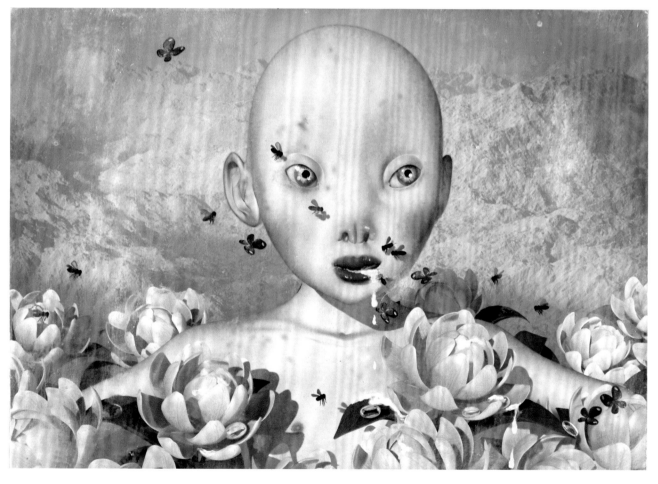

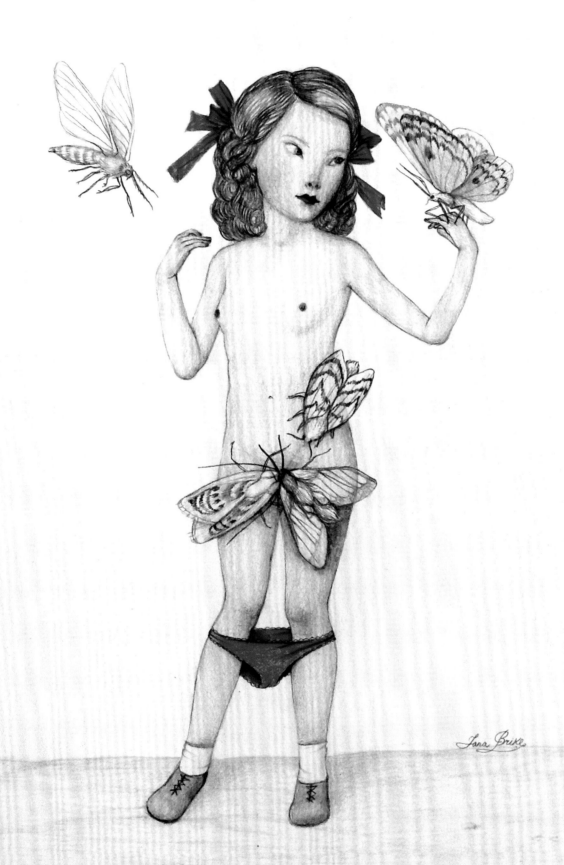

JON BEINART & His Dark Story

At the age of four, an eccentric friend of my family often babysat me. She made black and white woodcuts of anthropomorphic snakes with sagging breasts. They were often pregnant and wore nooses around their necks. She told me on many occasions that I was destined to be an artist when I grew up and that one of her snakes, which held a paintbrush and plate, was in fact a picture of me. When I asked her about the rope around my neck and why I had boobs, she said it was also a self-portrait! I found this very confusing. She was a bit crazy but her encouragement contributed to my development as an artist.

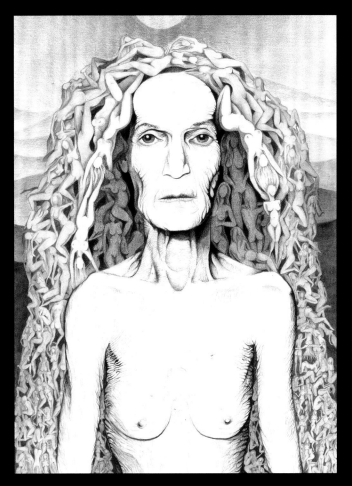

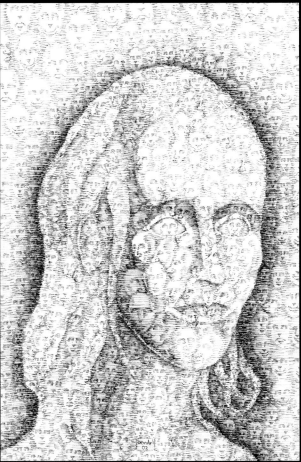

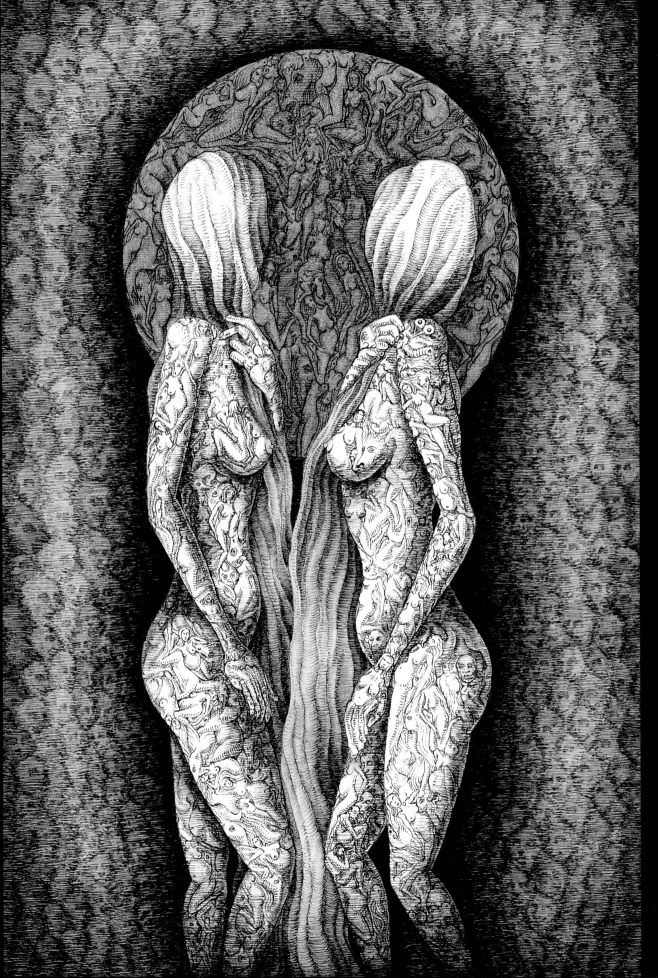

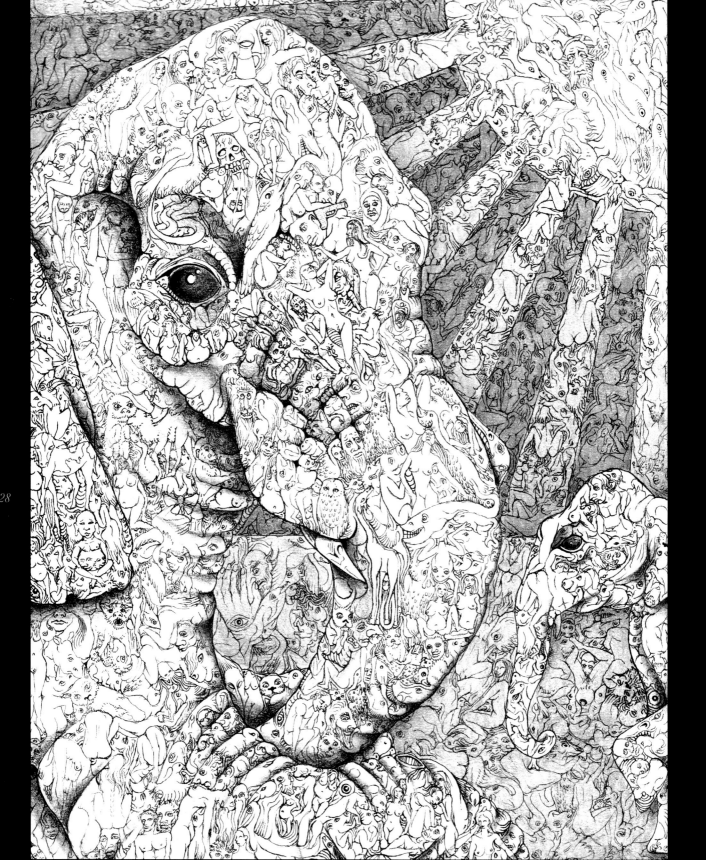

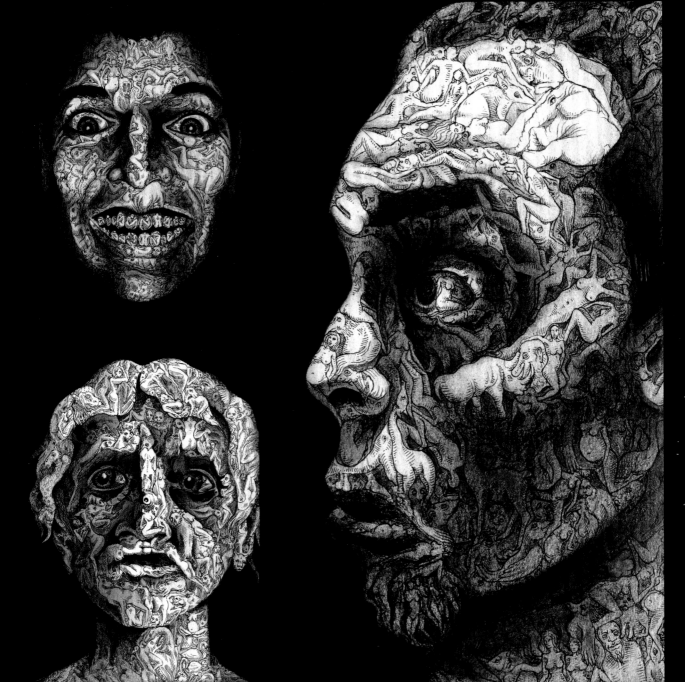

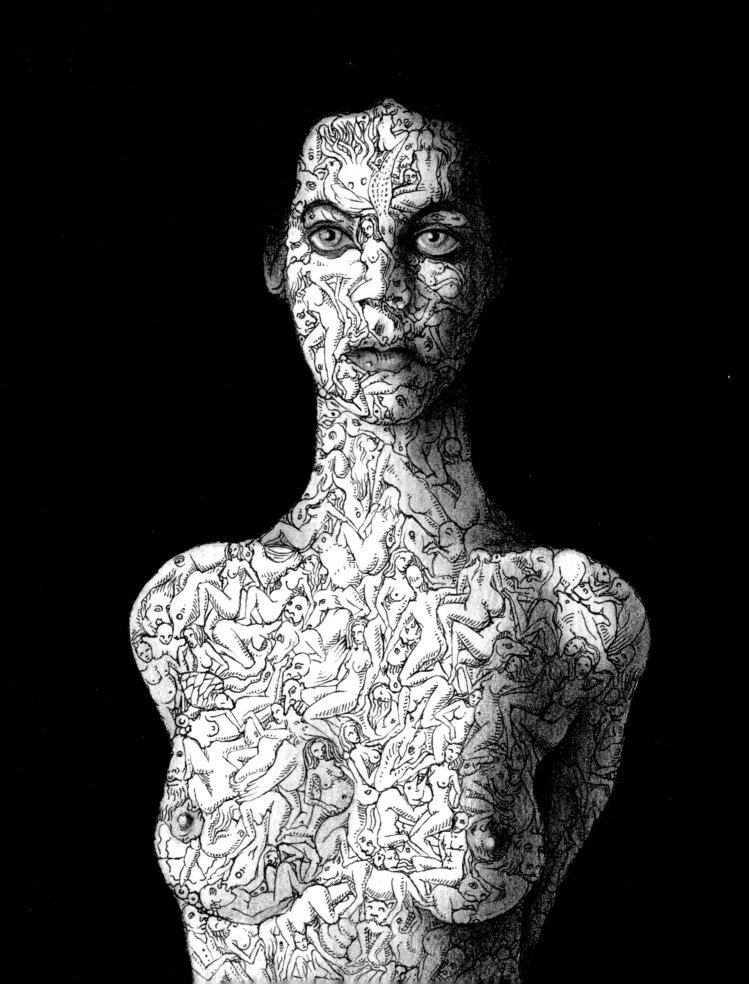

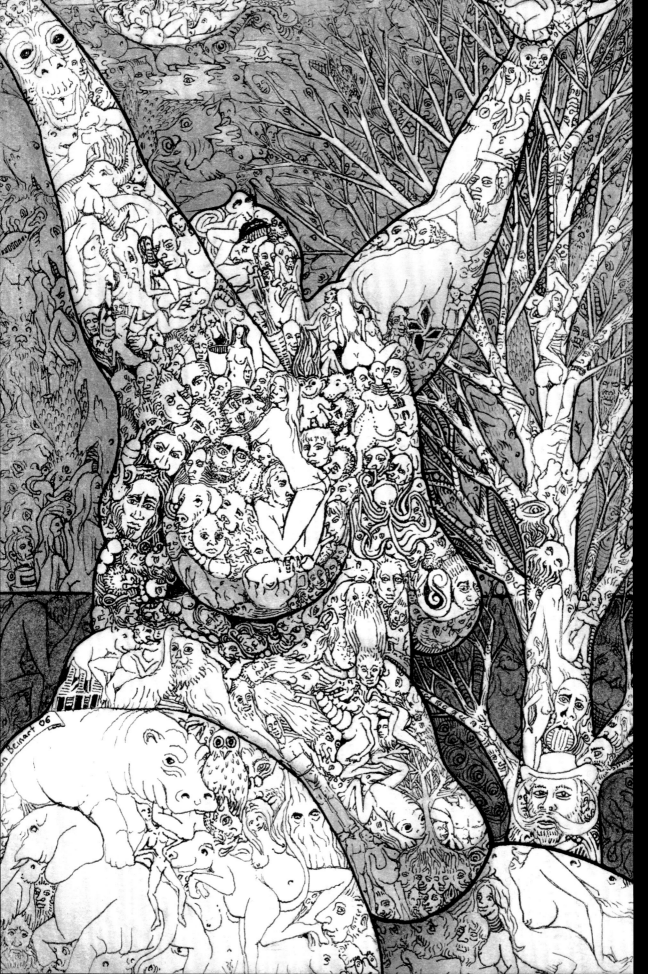

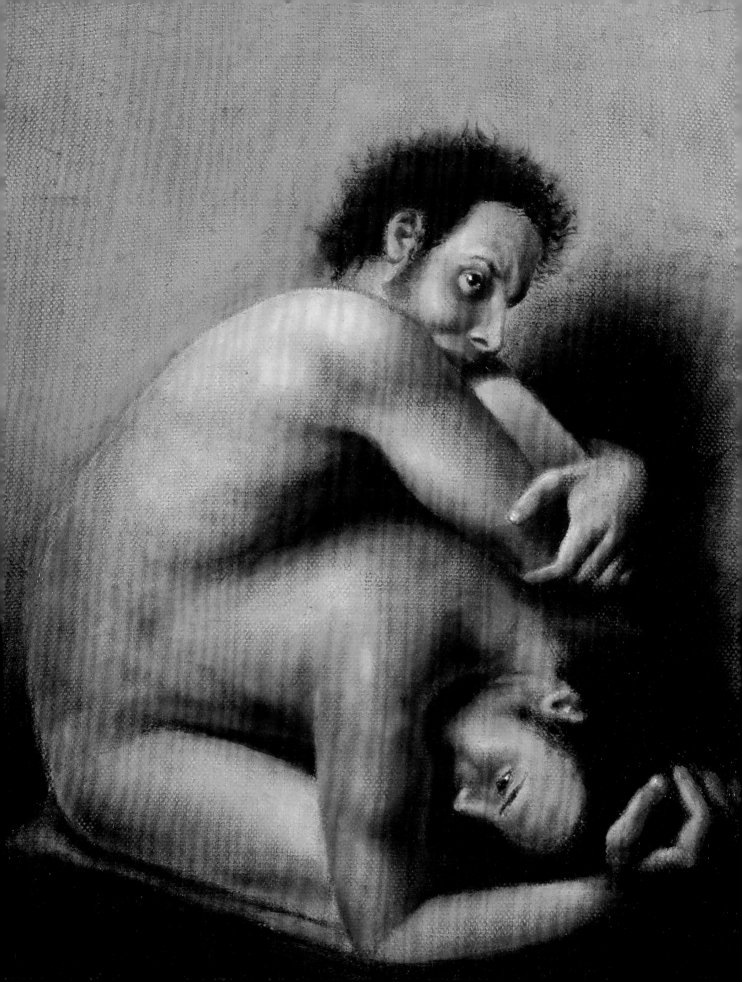

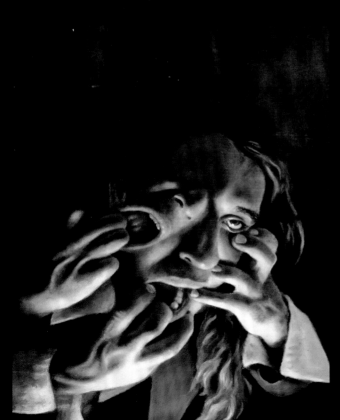
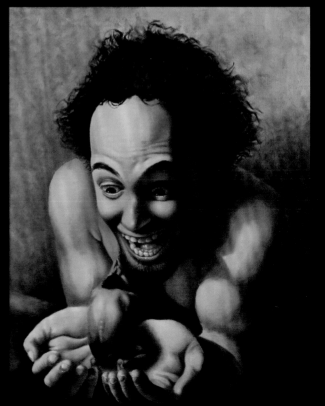

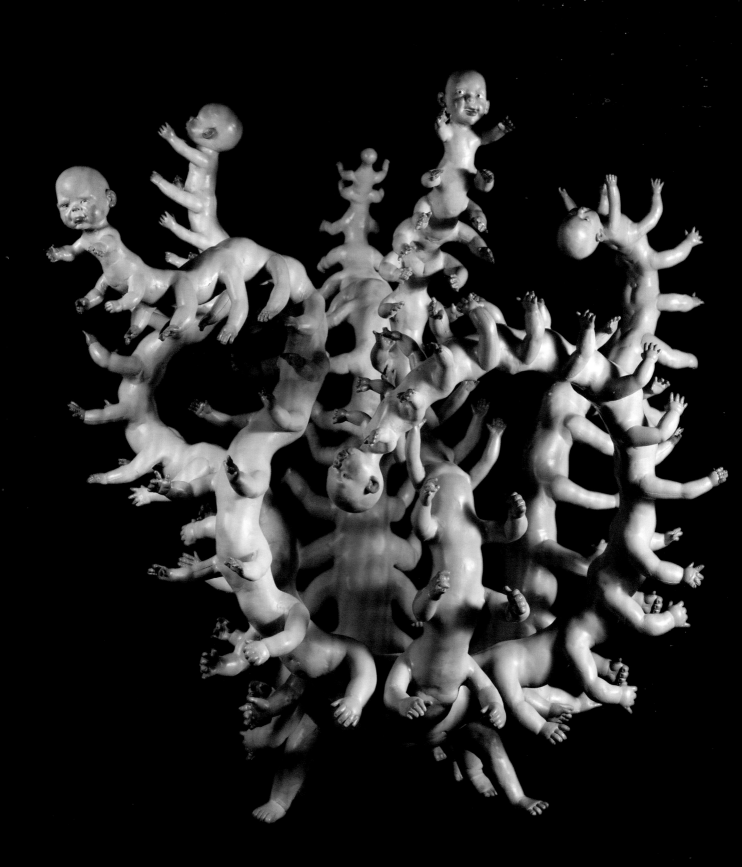

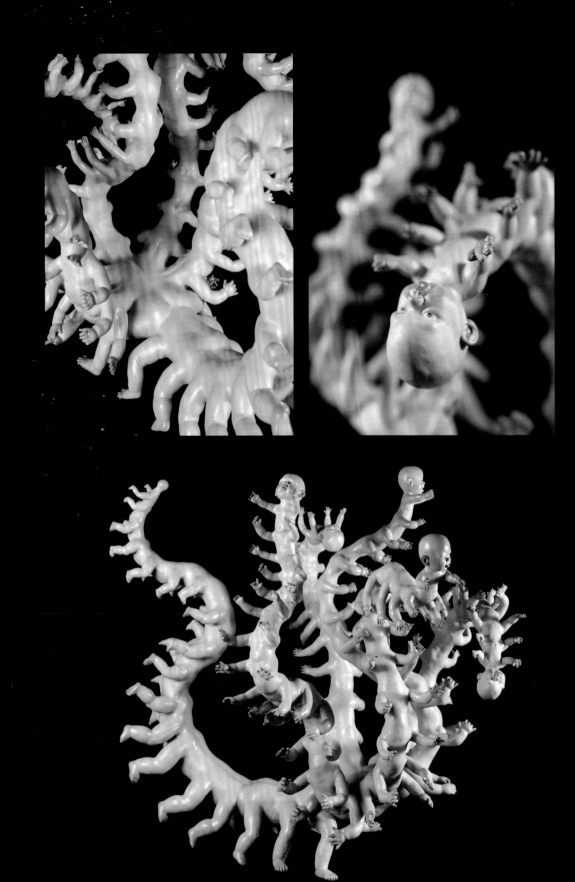

DAVID ARONSON & *His Dark Story*

My dark story is based on a poem based on childhood nightmares.
The artist dreams of attending a formal banquet with his family.
His father makes an inflammatory speech, exclaiming "We reject your values!"
Fleeing the angry mob, the artist's mother becomes a rag doll carried under his father's arm, her stuffed cloth limbs flapping in the wind.
The artist's father drives their car deep into the woods, saying "You'll have to go back to the city."
A forest path leads the artist to his childhood schoolyard.
In the midst of swarming children sits a dais holding a sacred book.
He examines the book and time passes.
The playground is now empty.
Searching for the children, the artist enters the school through the basement.
A skeletal janitor in filthy overalls sleeps in a chair.

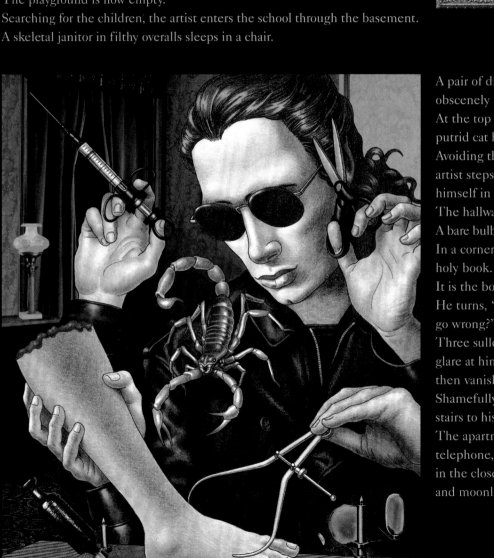

A pair of disembodied hands drifts obscenely through the air.
At the top of a staircase, a dead, putrid cat hangs from a doorknob.
Avoiding the horrific carcass, the artist steps through the door to find himself in a dilapidated building.
The hallway is dark and grimy.
A bare bulb casts a sickly yellow light.
In a corner stands the dais with the holy book.
It is the book of his life.
He turns, "When did it all start to go wrong?"
Three sullen, emaciated women glare at him with swollen, angry eyes then vanish through an open door.
Shamefully, the artist climbs the stairs to his new dwelling.
The apartment is empty; no telephone, no furniture, no clothes in the closet; just bare walls and moonlight.

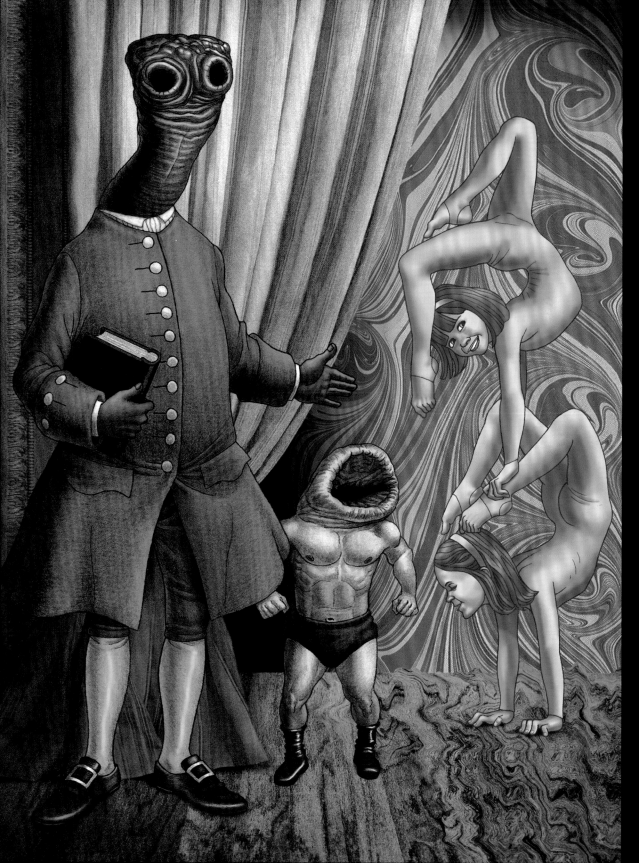

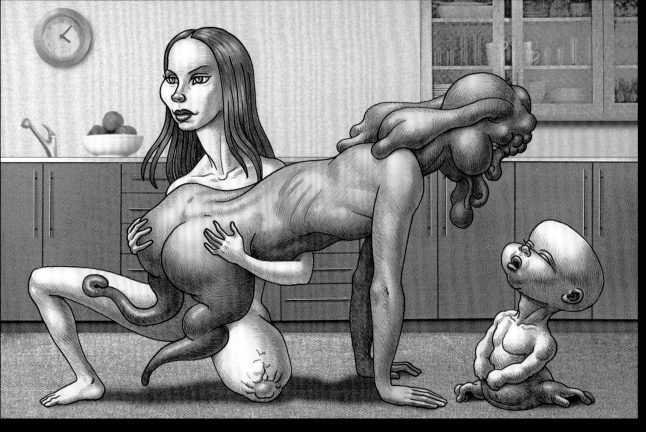

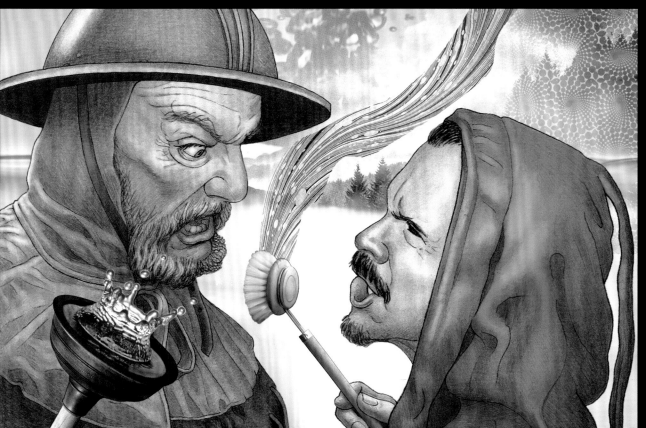

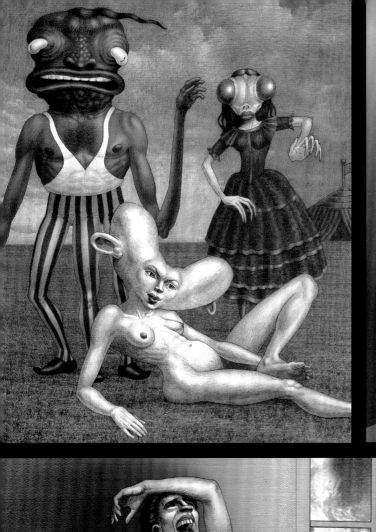
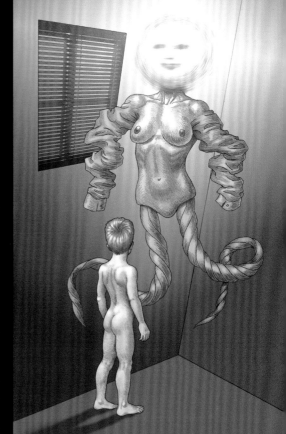
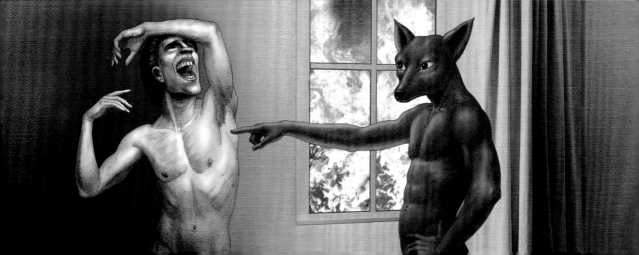

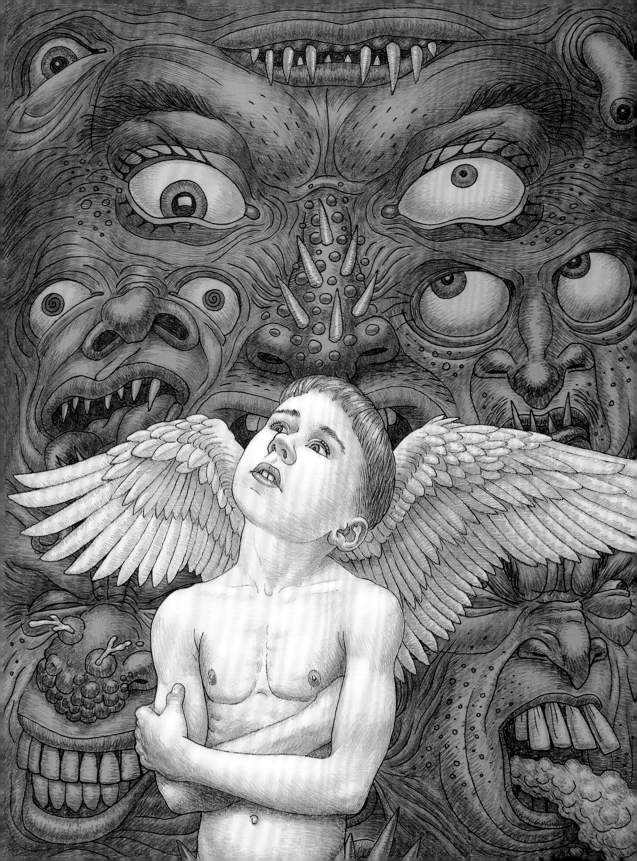

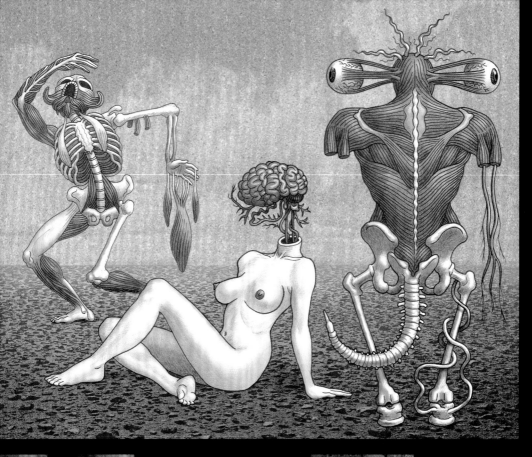

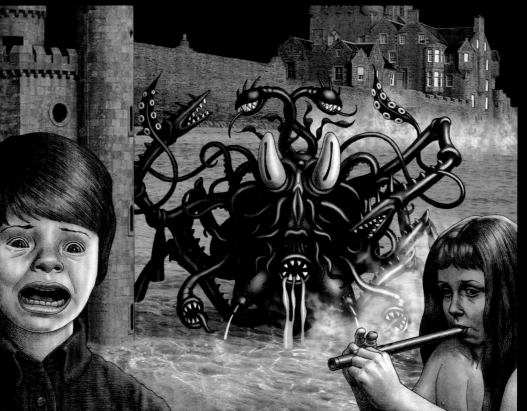

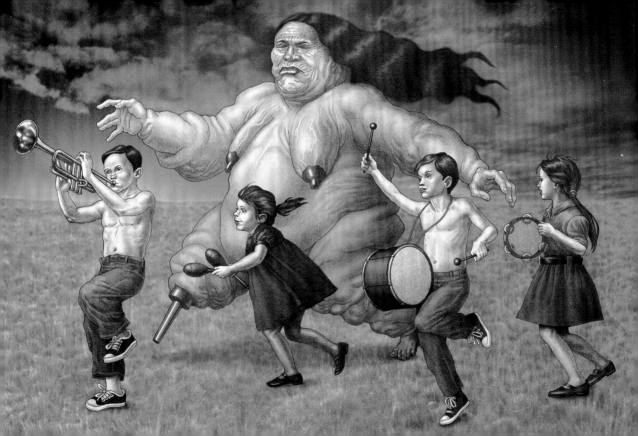

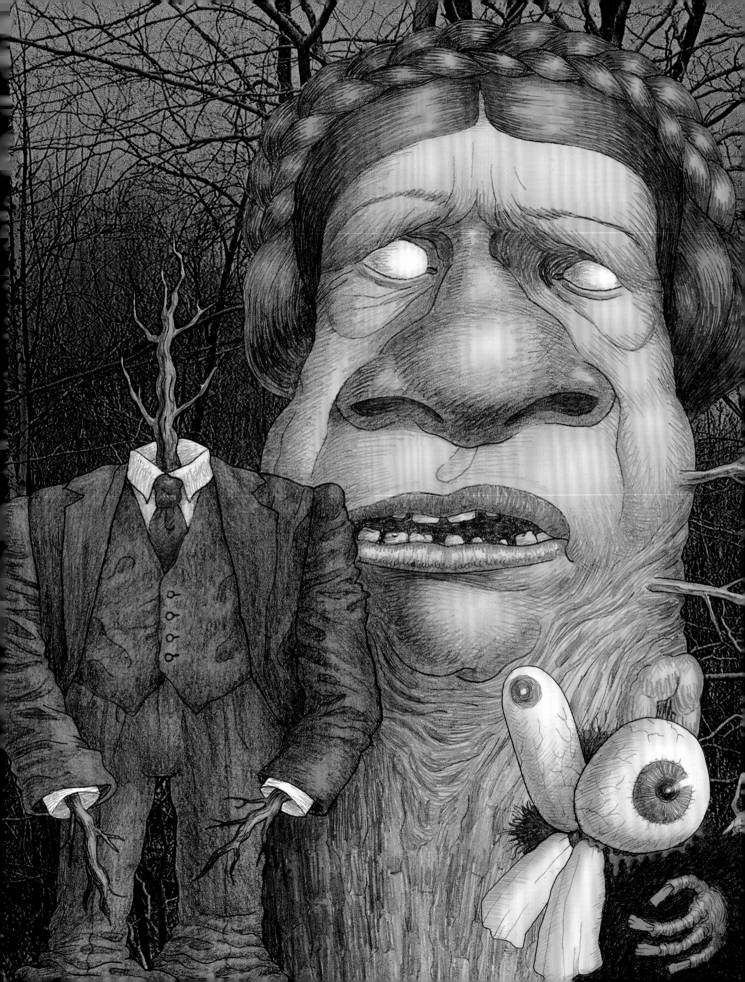

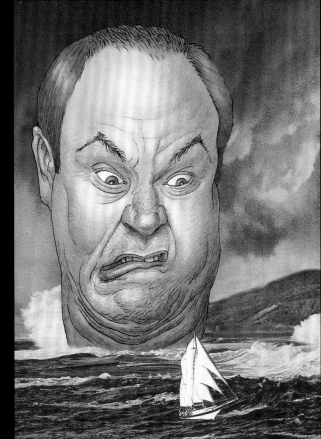
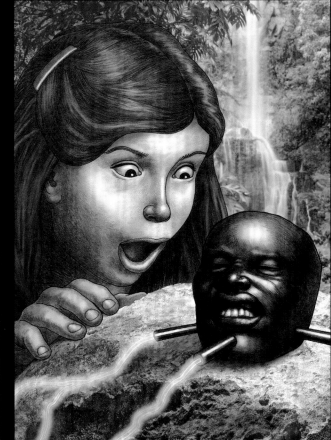
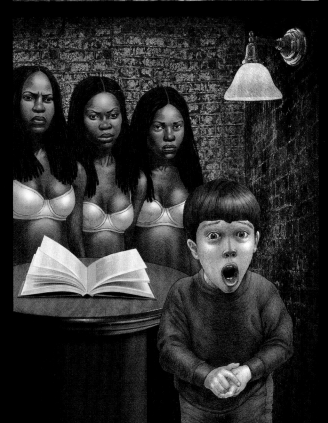
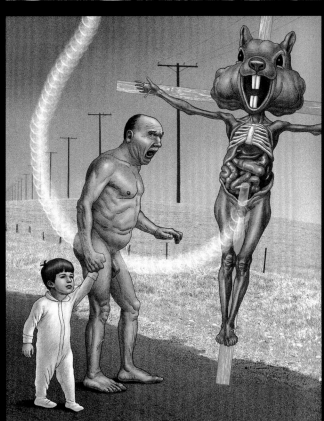

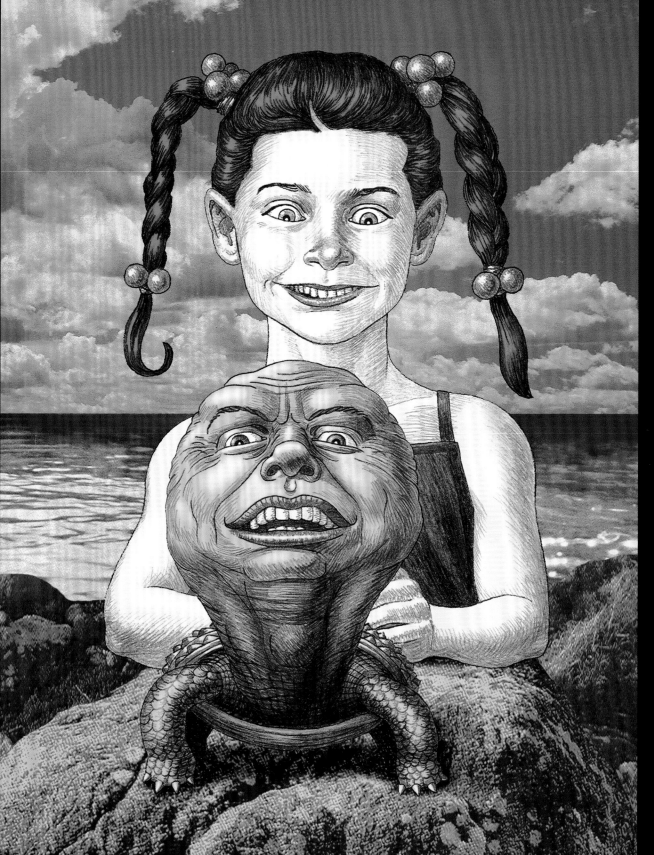

FERNANDO VICENTE *& His Dark Story*

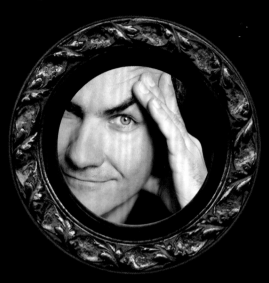

There is no story I particularly remember from my childhood, but since I was a kid I have had a special attraction for all things anatomical and inside human beings. The appearance attracted me strongly. I've always liked skulls, bones and viscera. You could say I was a bit of a special kid, maybe a little morbid.

I remember my mother cooked a rabbit's head to clean and trim it, and I put it in my room. Almost thirty years later, she bought a cow's head. Perhaps my mother is responsible for my special interests.

Since I was a teenager, I have collected old books and anatomical atlases which are sources of inspiration for my current job.

48

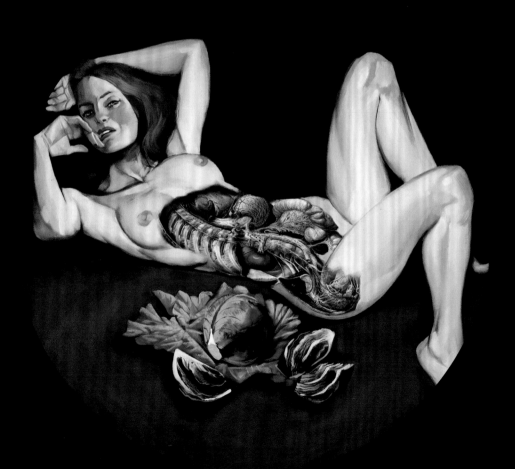

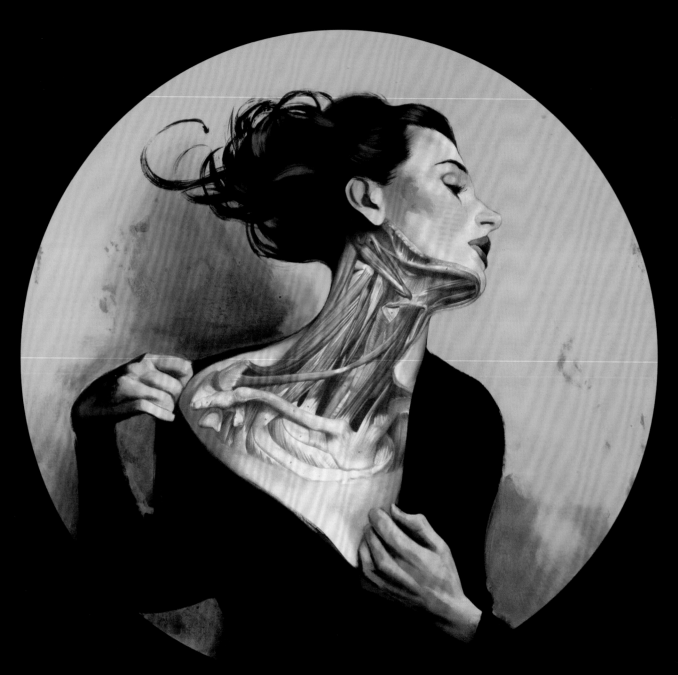

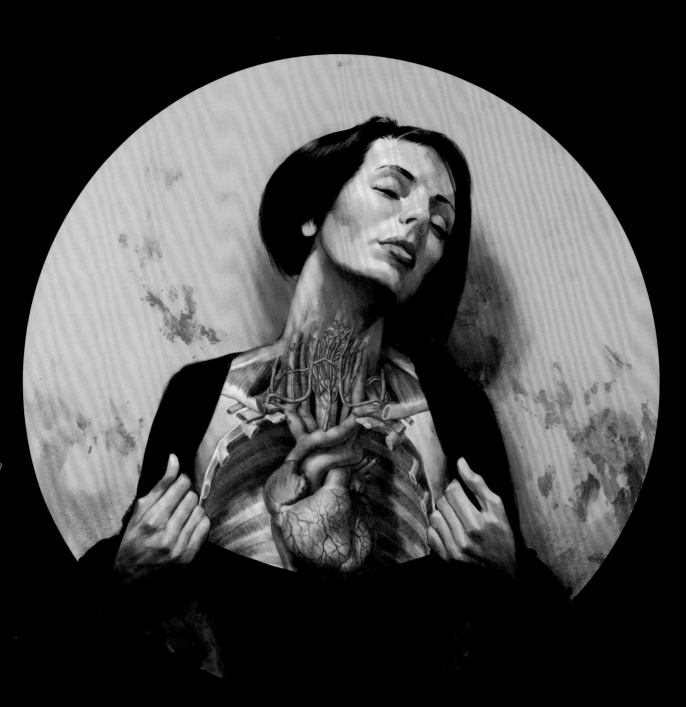

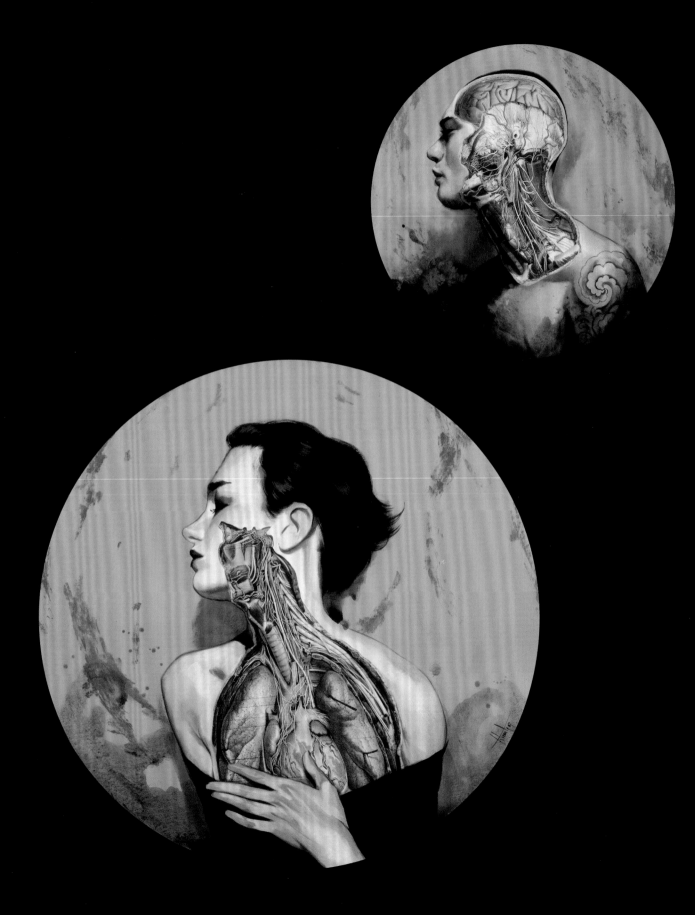

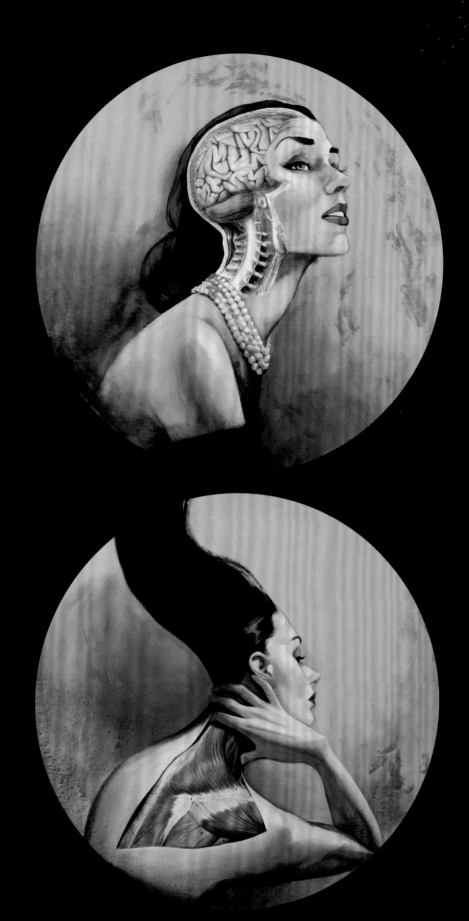

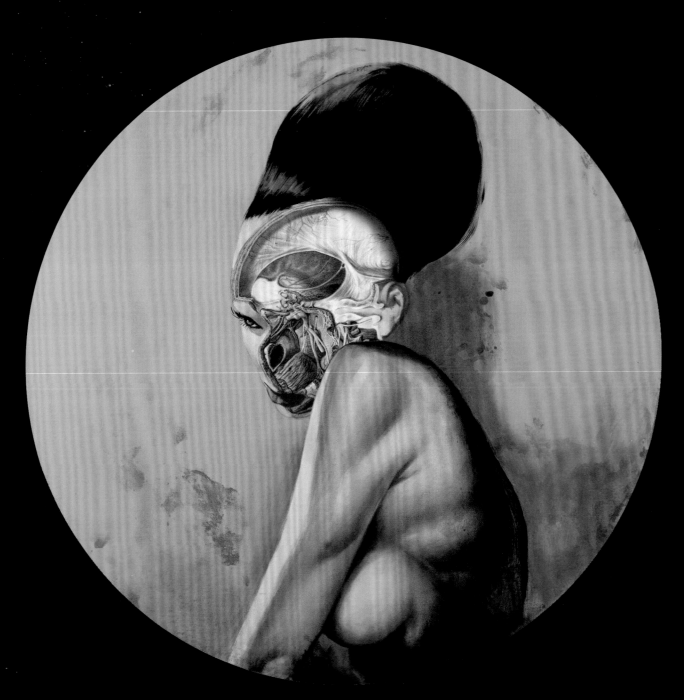

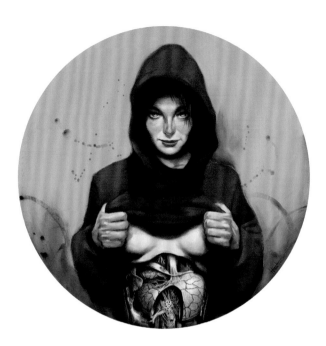
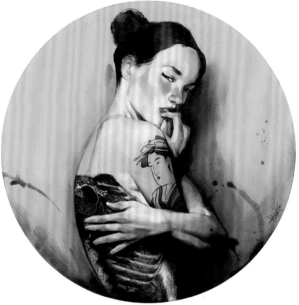
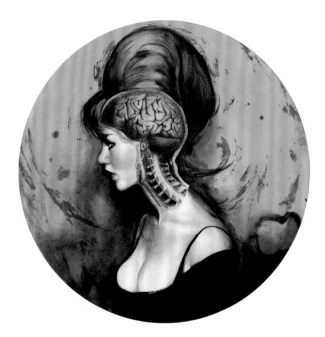
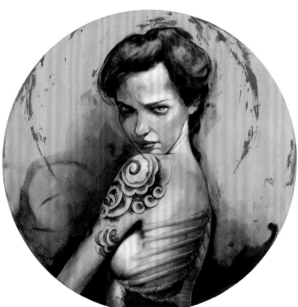

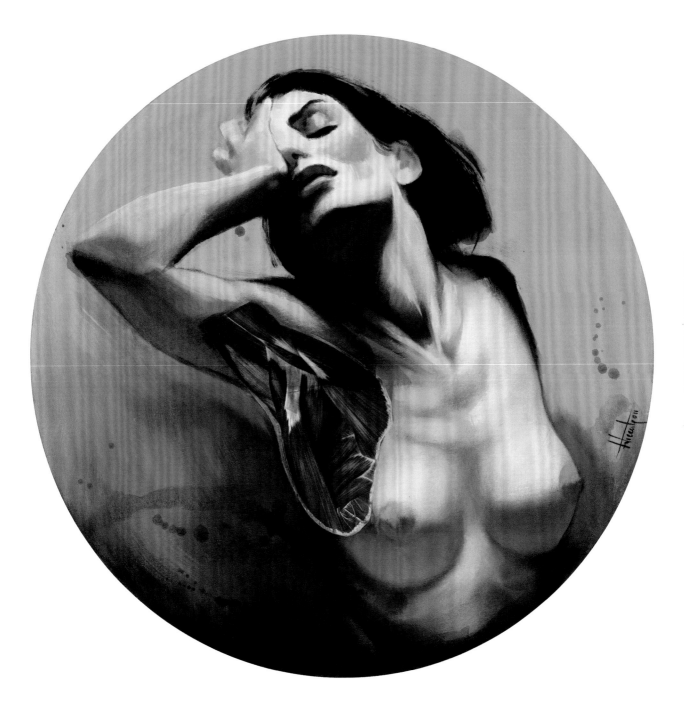

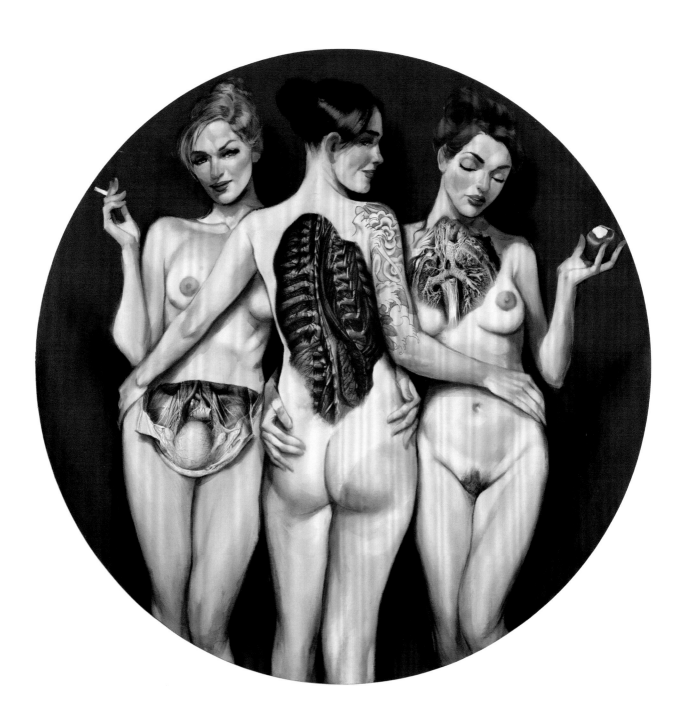

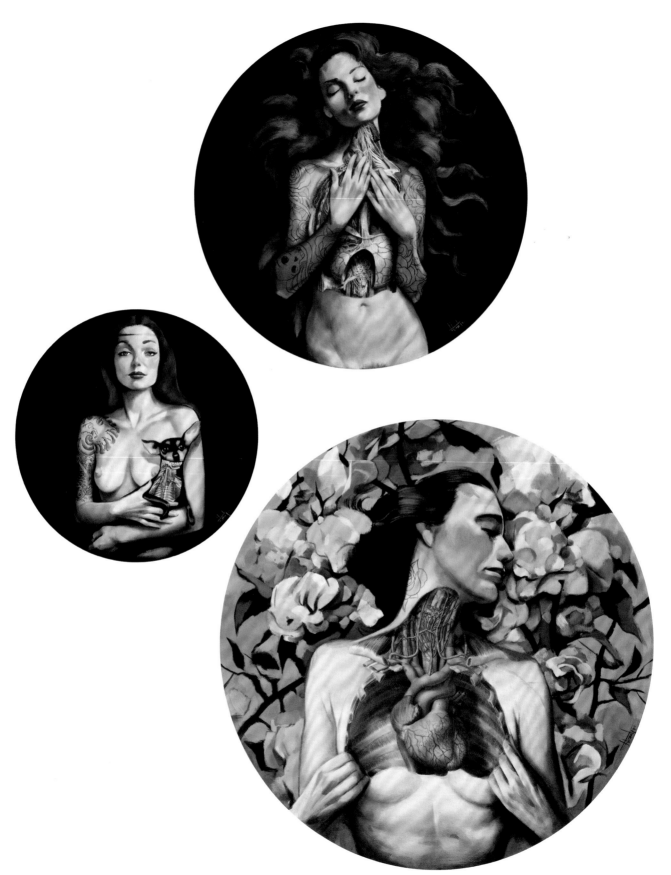

VIRGINIE ROPARS & Her Dark Story

One of my favorite writers is Jean Lorrain, a French decadent writer. In one of his stories called "La Princesse aux Lys Rouges," he describes a young princess, daughter of an old warrior king. She had been sent by her father to live in an abbey, for her own protection. She lived there among monks, waiting for her father to return from battle. The king knew his daughter had a terrible power: to each of her moves, one man's pain and death were bound. In the beautiful gardens of the abbey, the white lilies bloomed everywhere. The young princess, cold and cruel, loved crushing their petals in her white hands. But as soon as a lily dies in her hands, a soldier dies on the battlefield.... One night, under the moonlight, she started to crush the lilies, one by one....

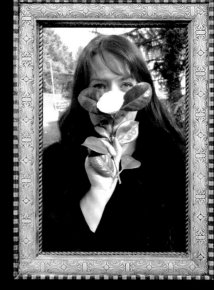

The next morning, the princess was found lying on the ground, holding crushed lilies tightly to her heart. All around her lay lilies that had turned red. The monks said they never bloomed white again.

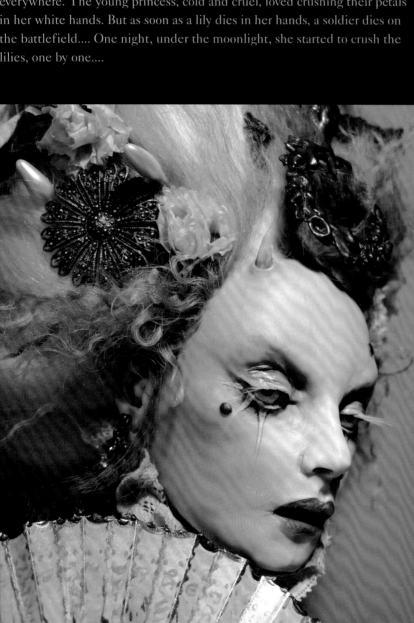

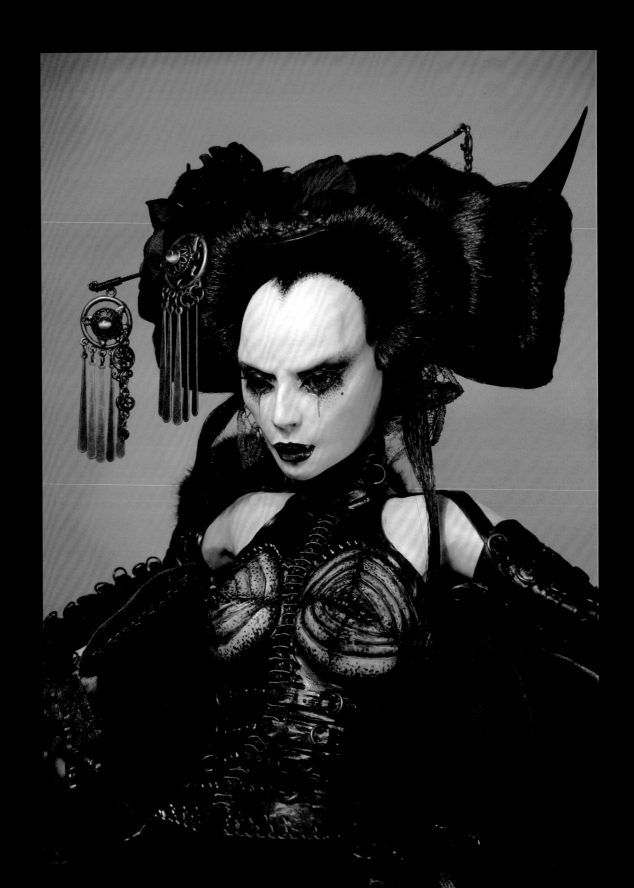

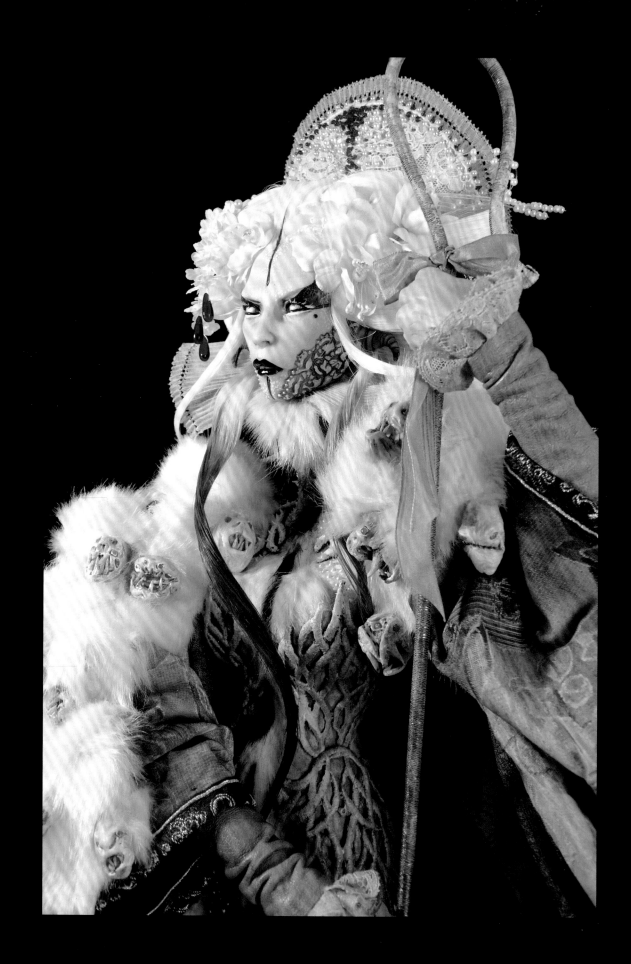

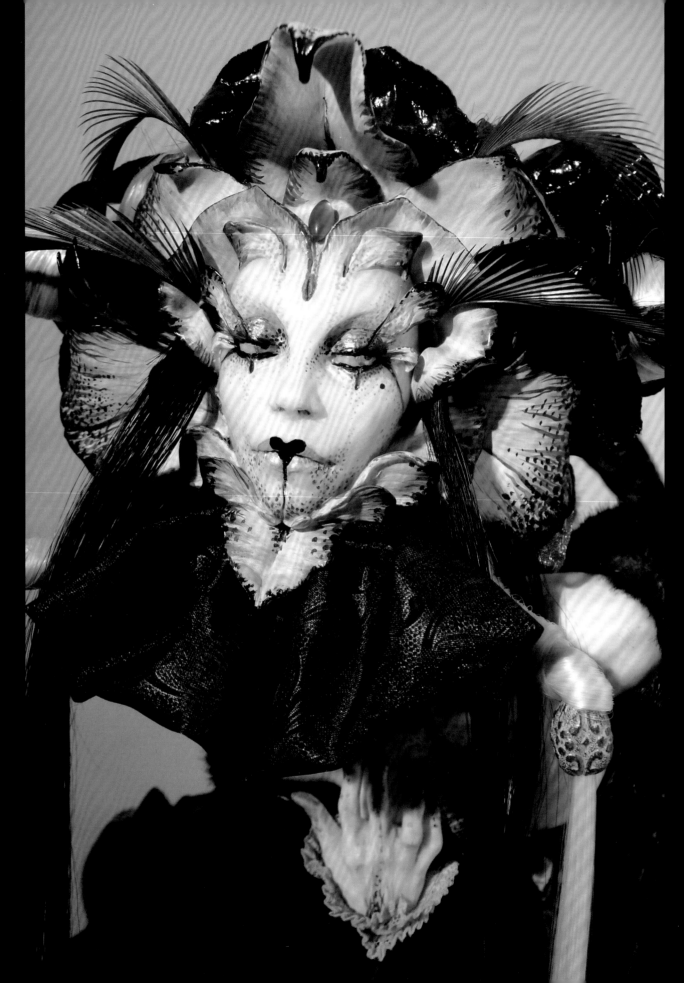

ROZI DEMANT & *Her Dark Story*

I do not like to talk about my artwork. It is very personal to me.

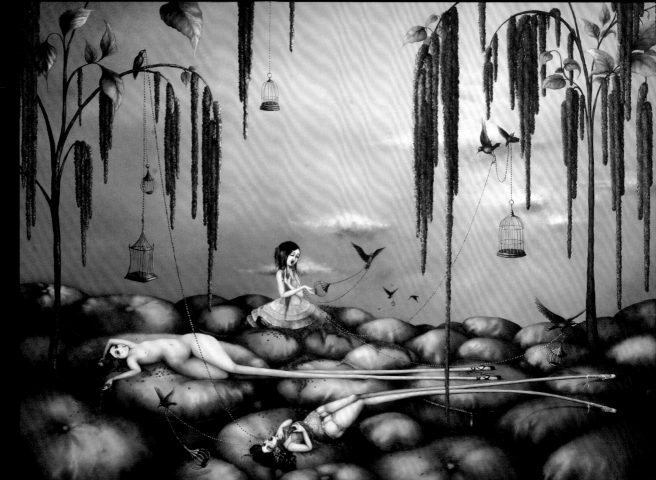

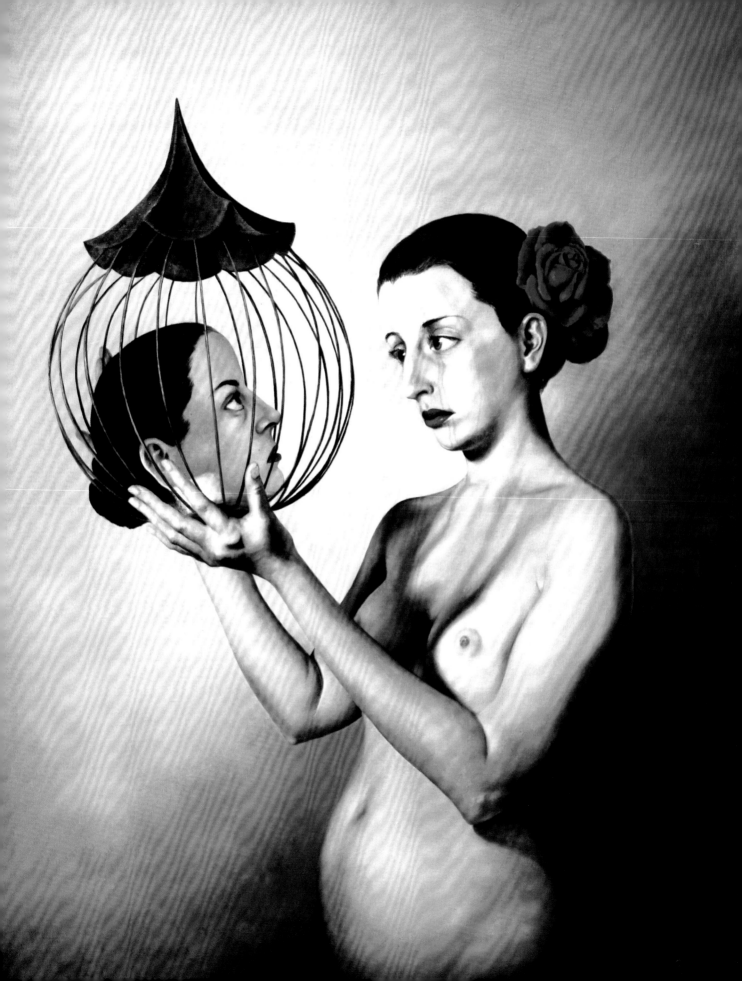

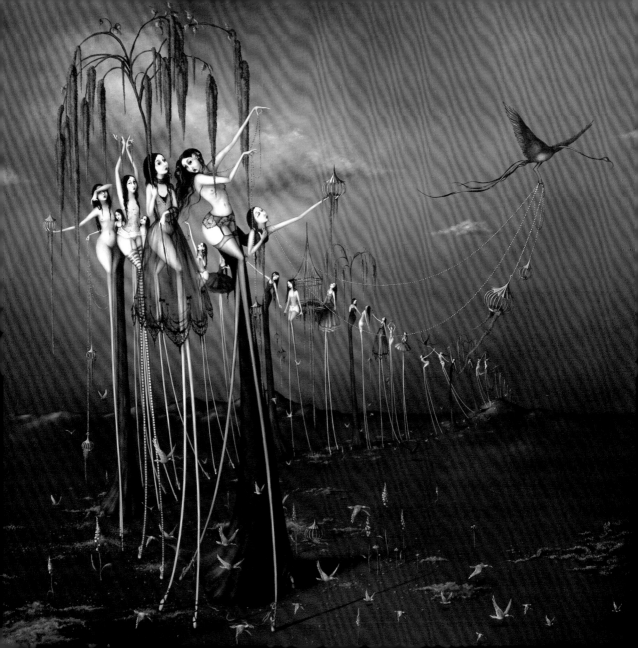

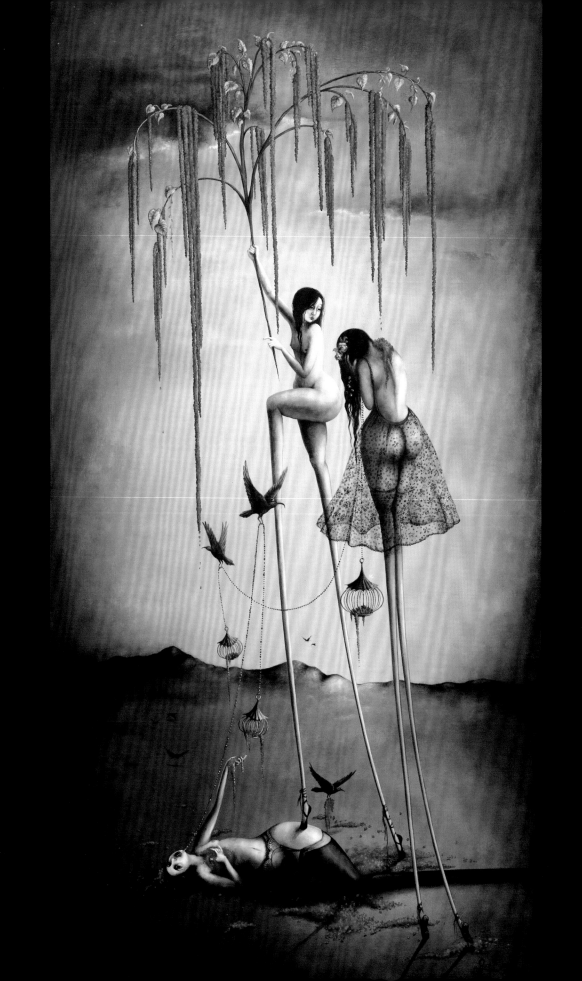

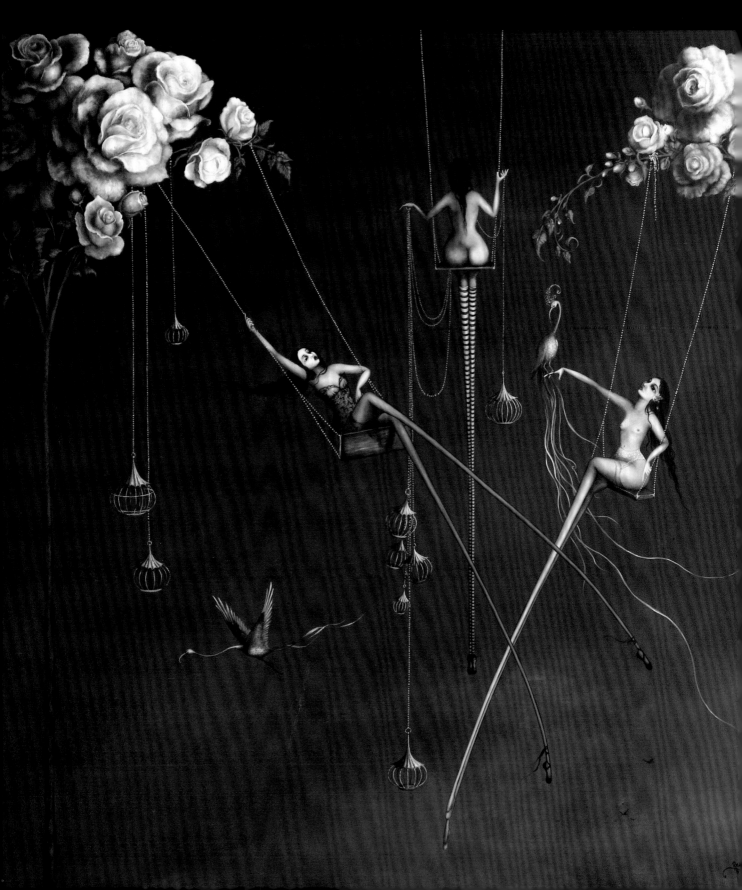

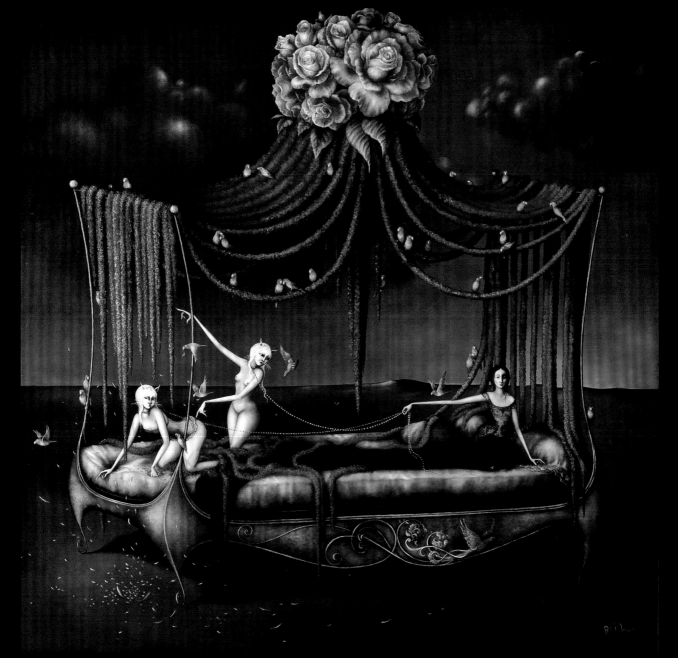

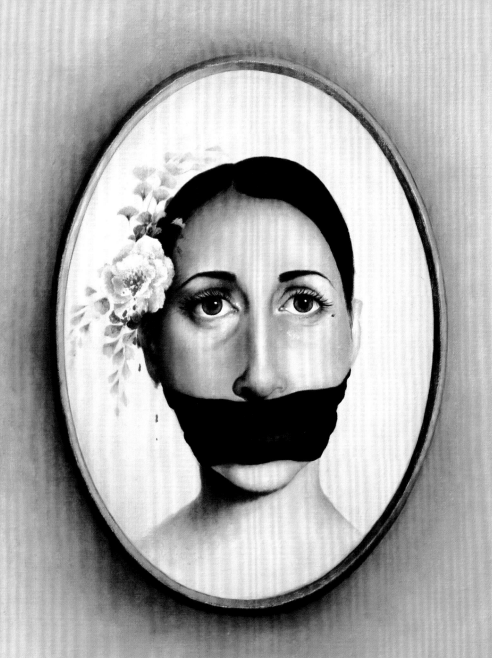

Rozi Demant

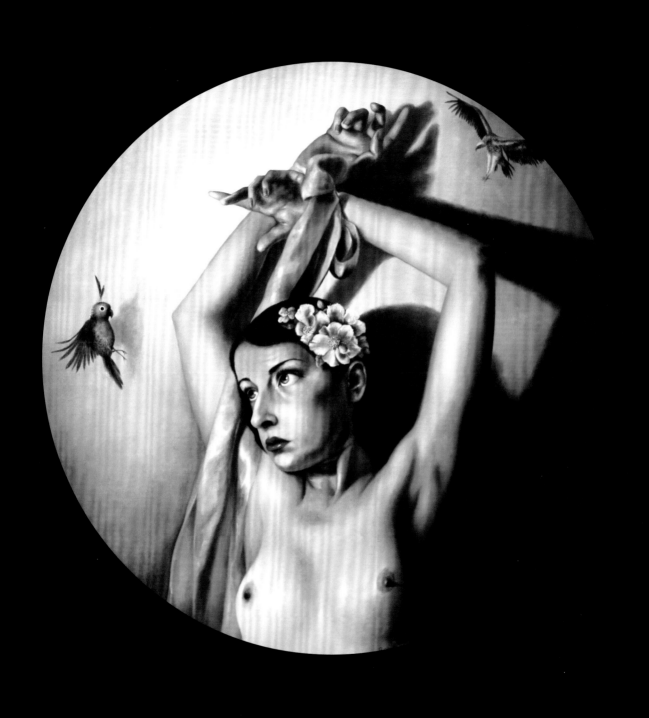

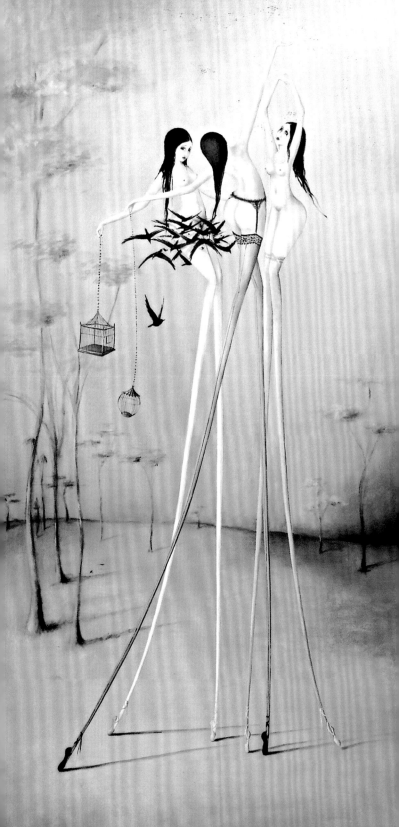

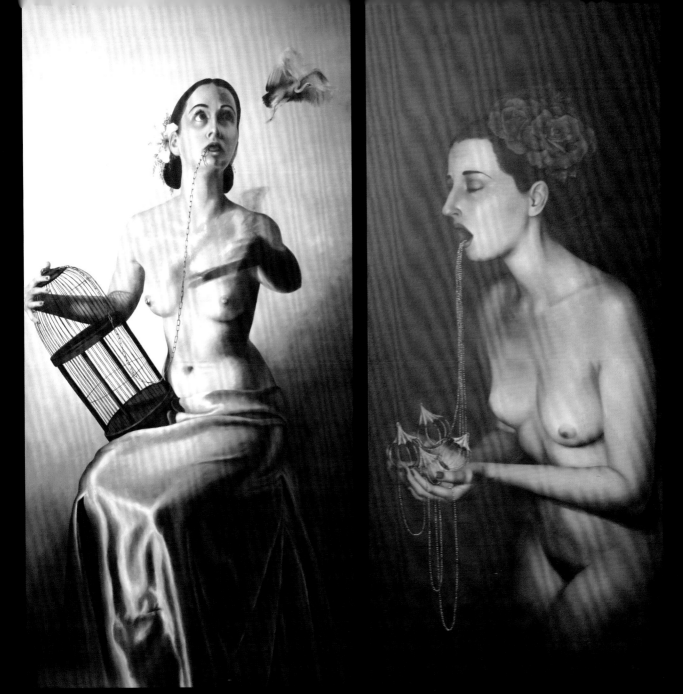

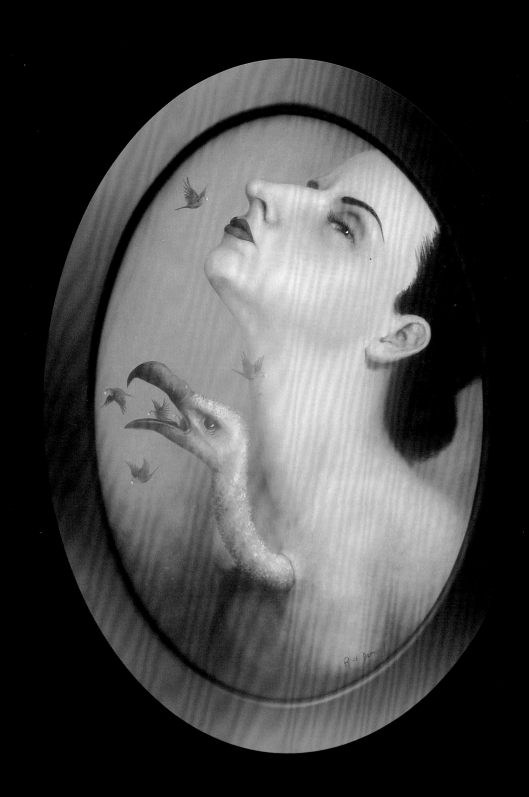

72

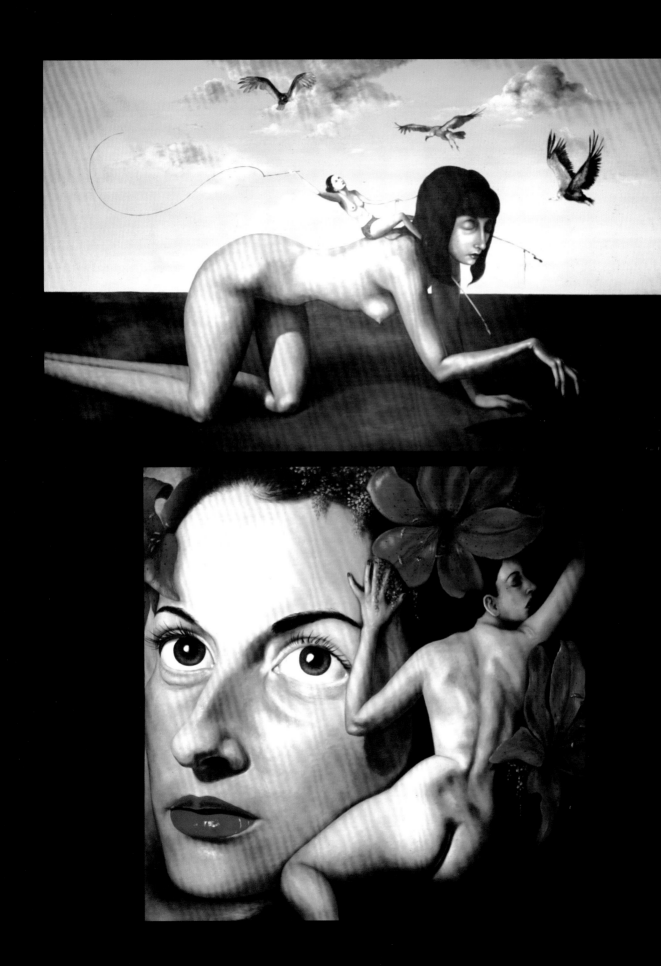

YURY USTSINAU *& His Dark Story*

Idea is never-ending.... The process between the ideas is invisible – they pass at the speed of light, thousands of them per second. You cannot own ideas, nor can you keep them – but they can stay quietly a while at the back of your mind.

Good ideas are like flies. They are sometimes intrusive, annoying and give you no option but to concentrate on them. Some of them fly around you to the point that they get on your nerves and you actually try to capture them. Everyone should try to catch their "fly" and put it in a jar for observation. The black flies are creative thoughts and the cages are their canvas.

Creative thought held captive within the confines of the frame and canvas, and then displayed for everyone to see. Through these new imitations, we discover something we do not see every day.

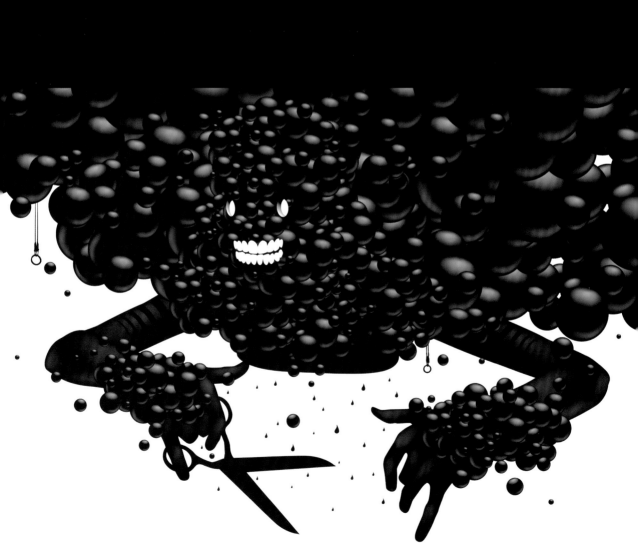

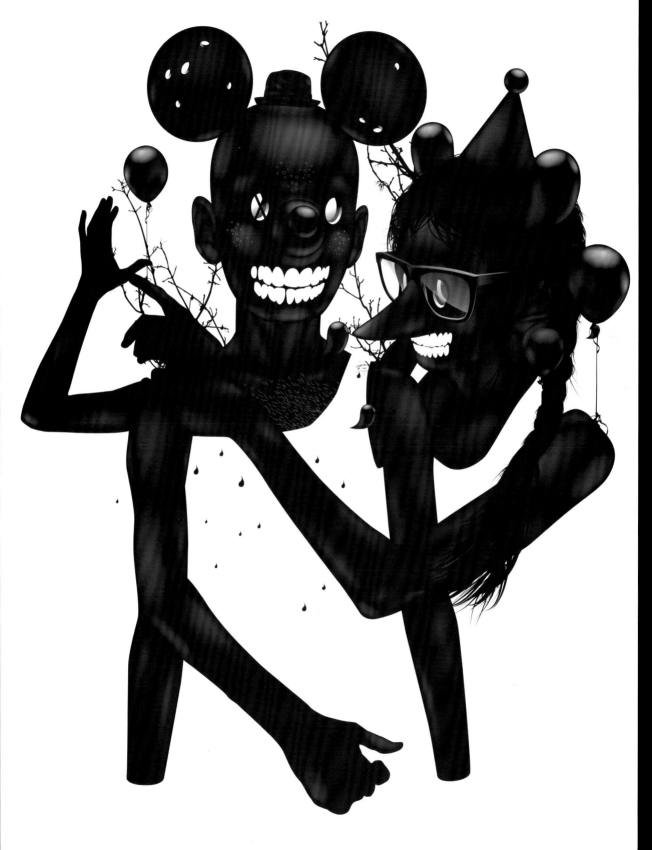

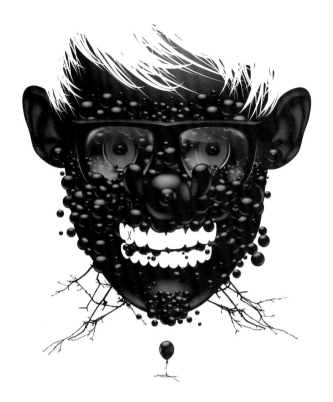
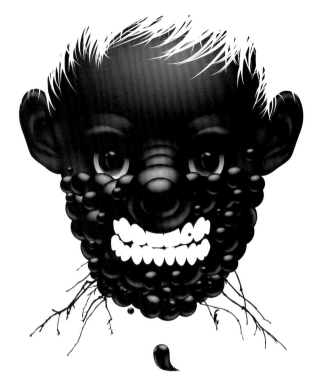

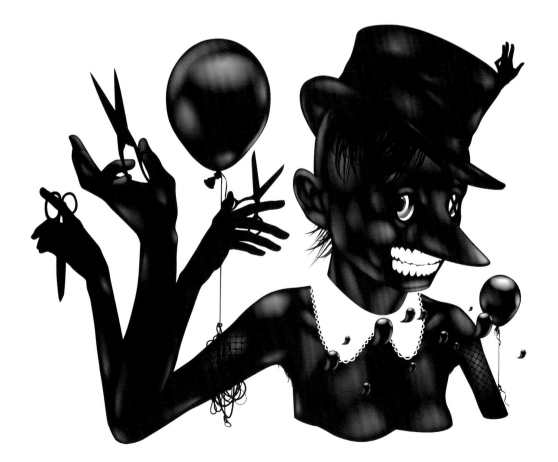

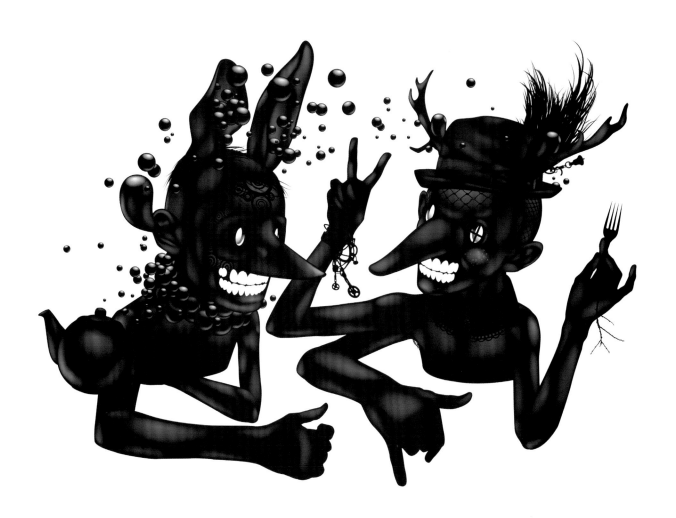

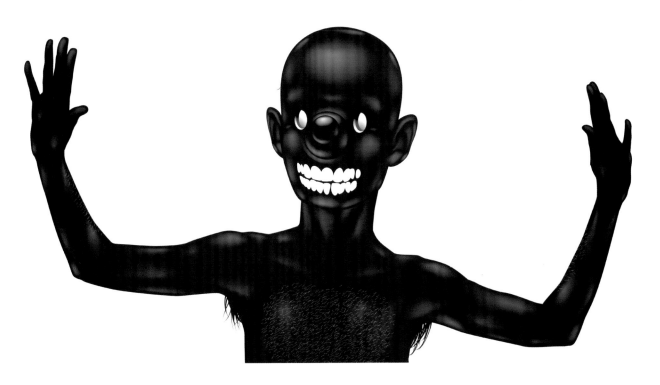

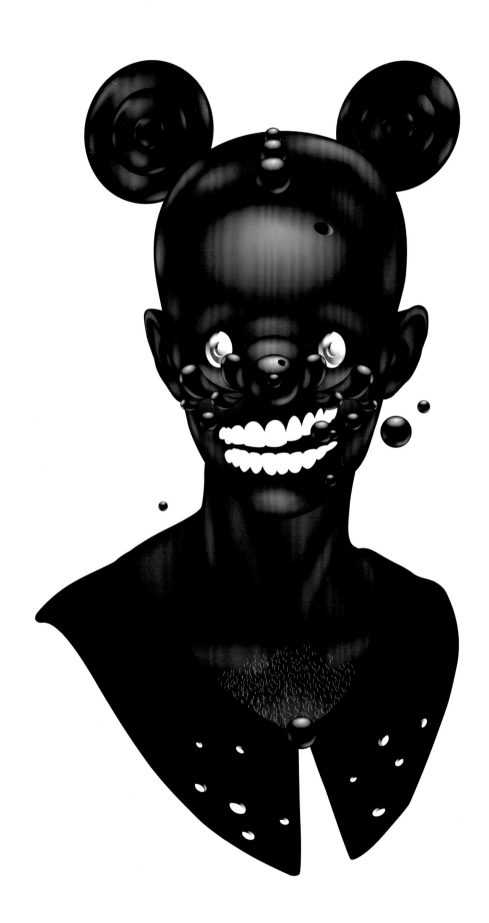

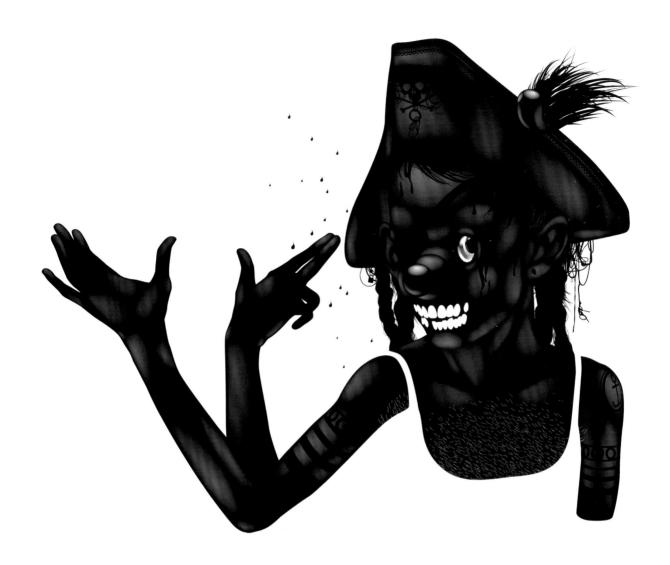

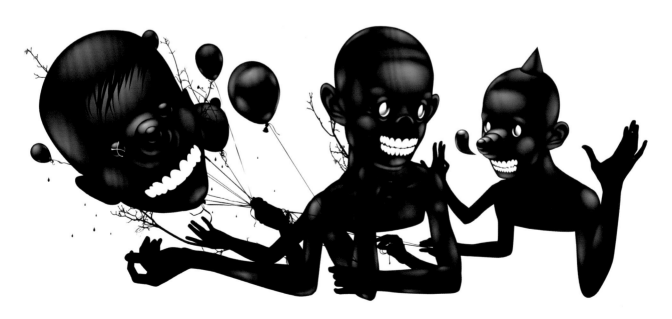

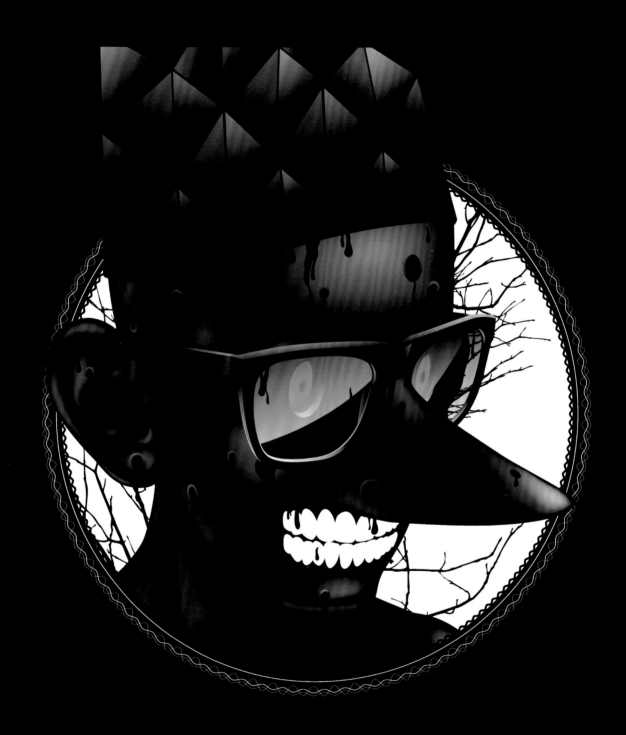

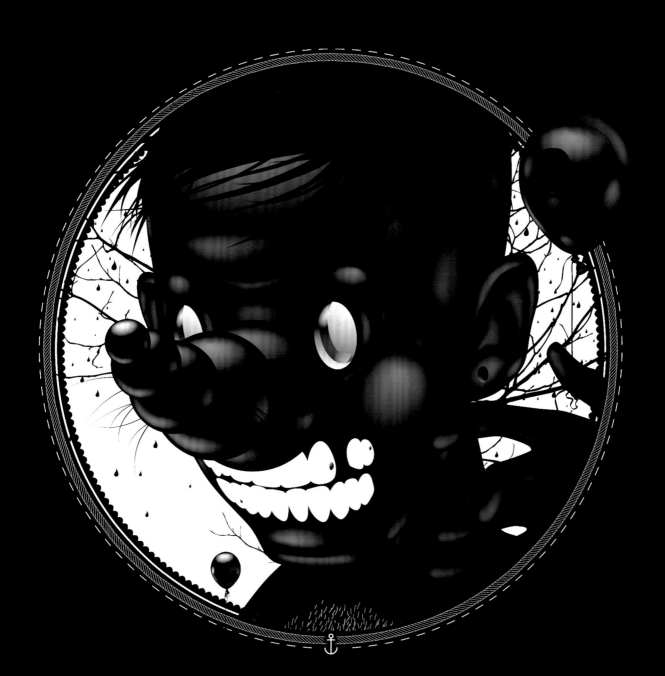

ZHANG SHIHAO *& His Dark Story*

My favorite comic artist is Suehiro Maruo. The comic which has influenced me the most is "MPD PSYCHO." This title is concerned with crimes caused by personality transfer, compensation and various psychological diseases, and thus has also triggered controversy in Japan. In one episode, an architect has captivated many women and cut open their skulls when they are still alive, planting flowers in their brains which are still functioning. Later, he would even transplant the head to the garden. You can imagine how frightened I was when I read this comic at the age of fourteen.

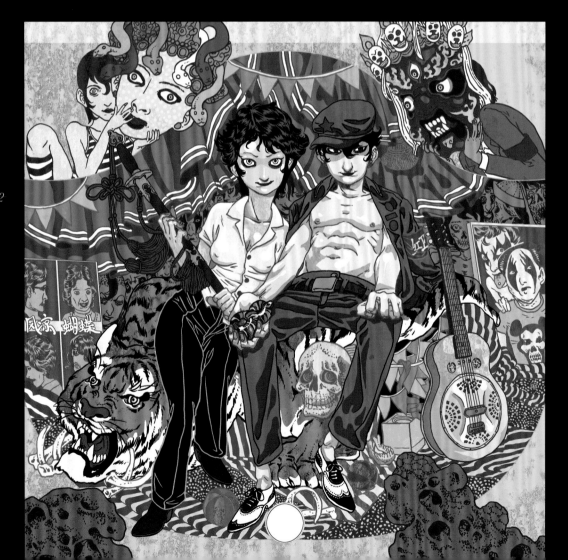

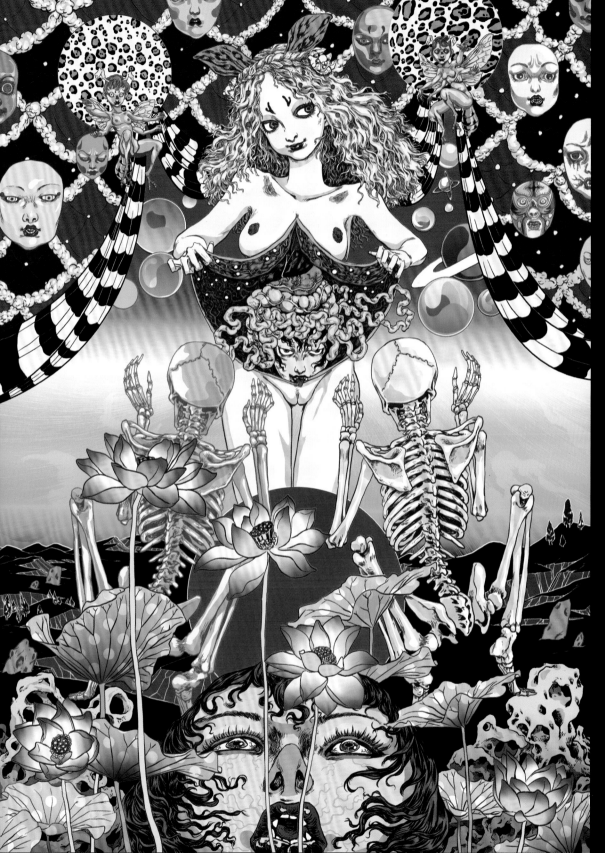

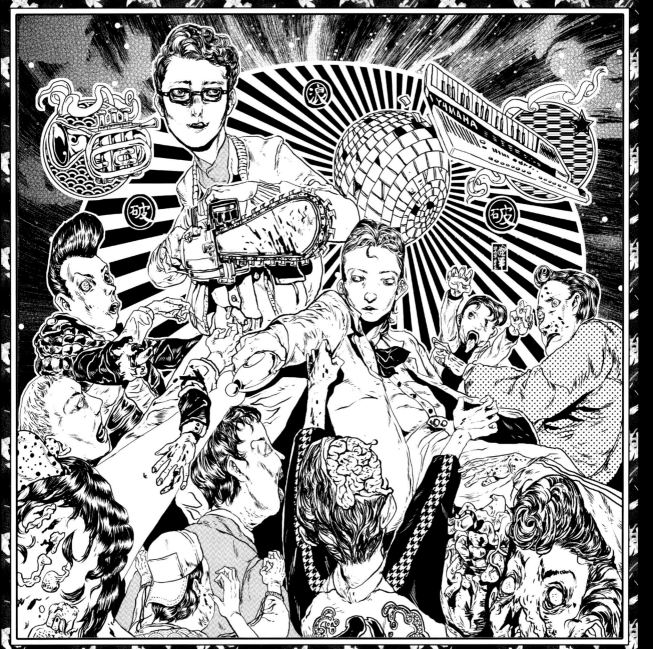

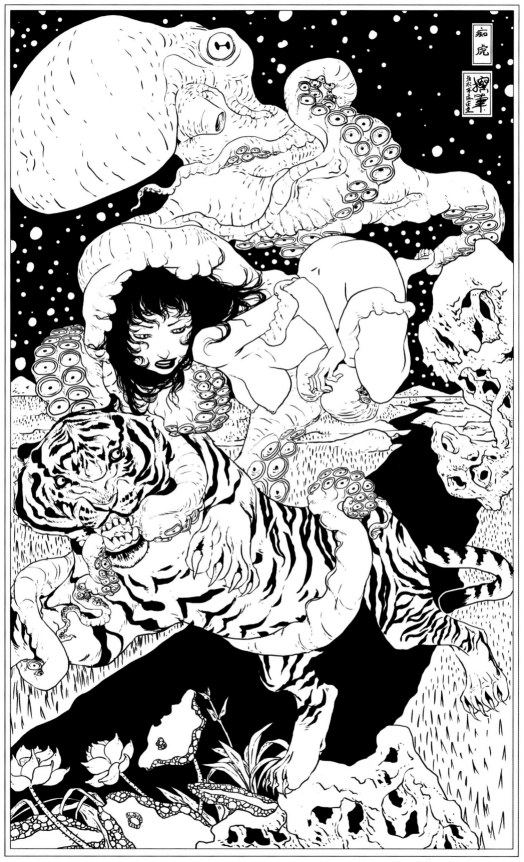

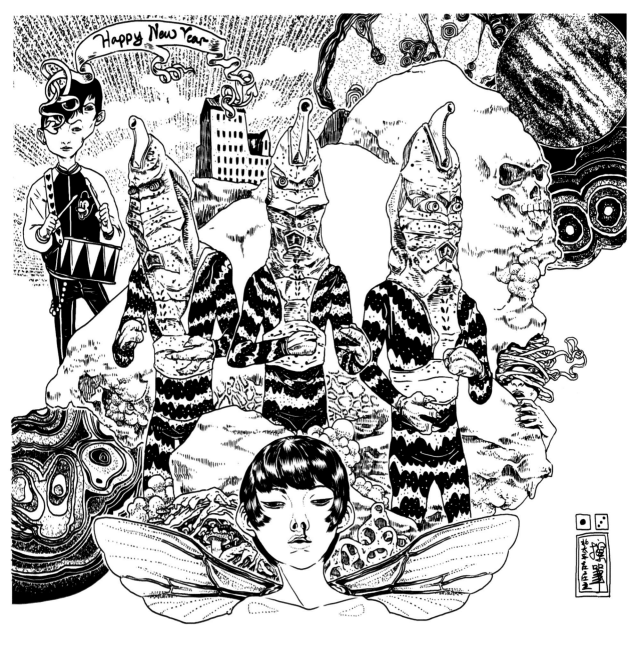

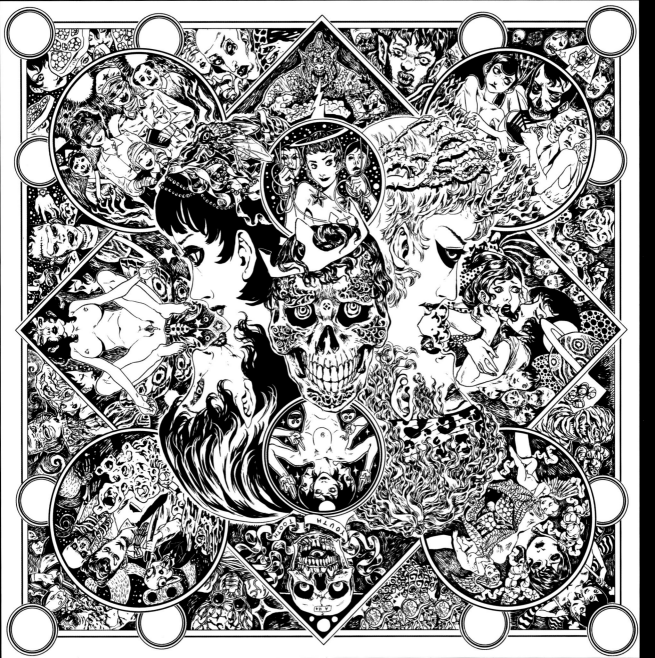

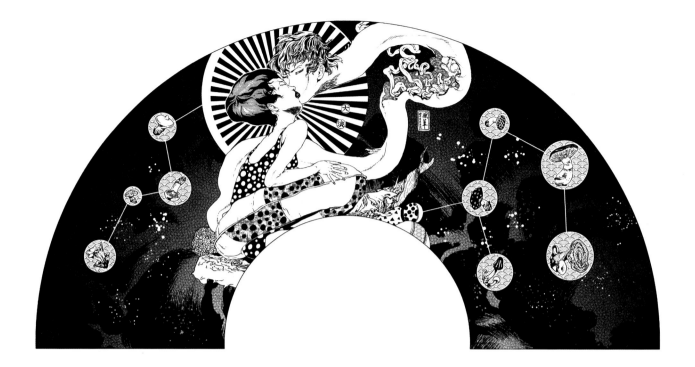

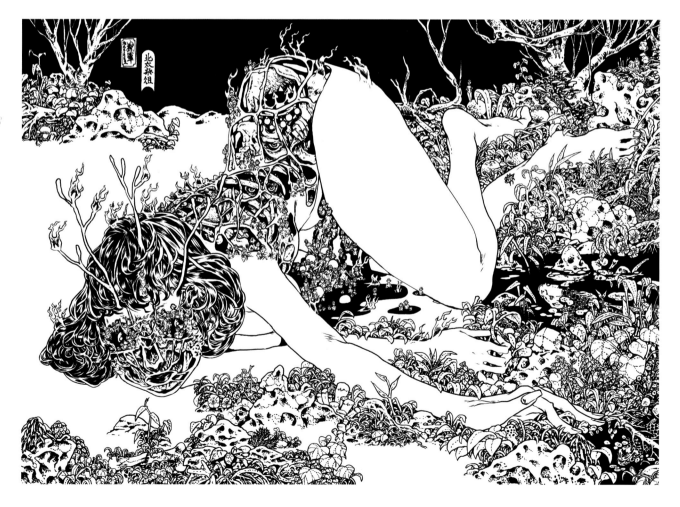

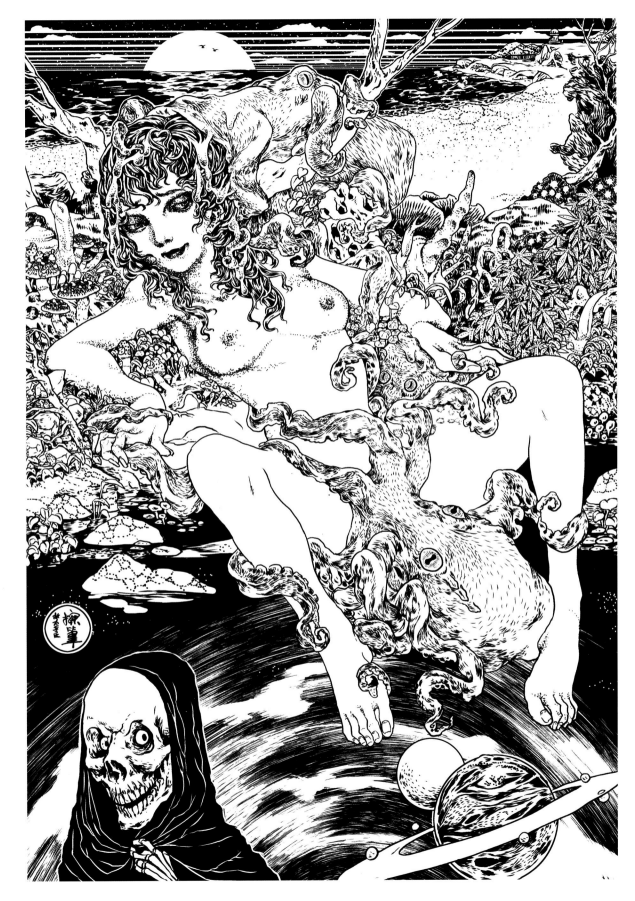

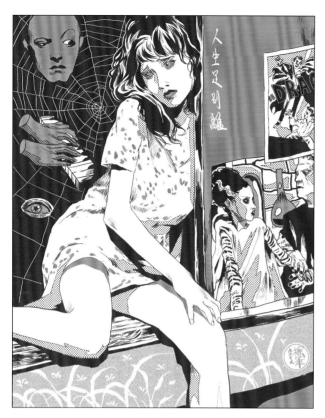

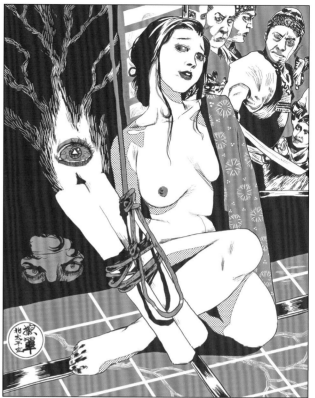

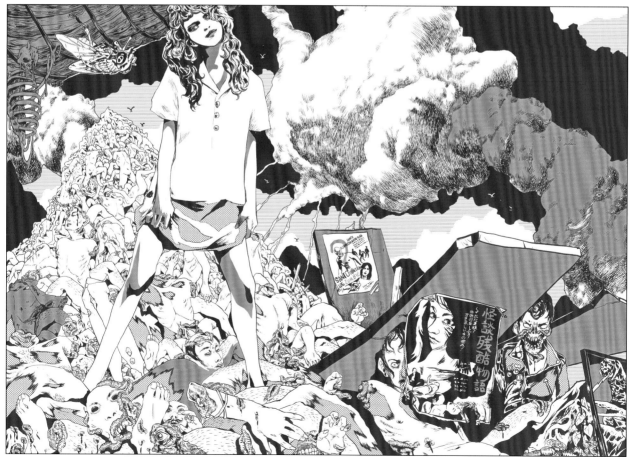

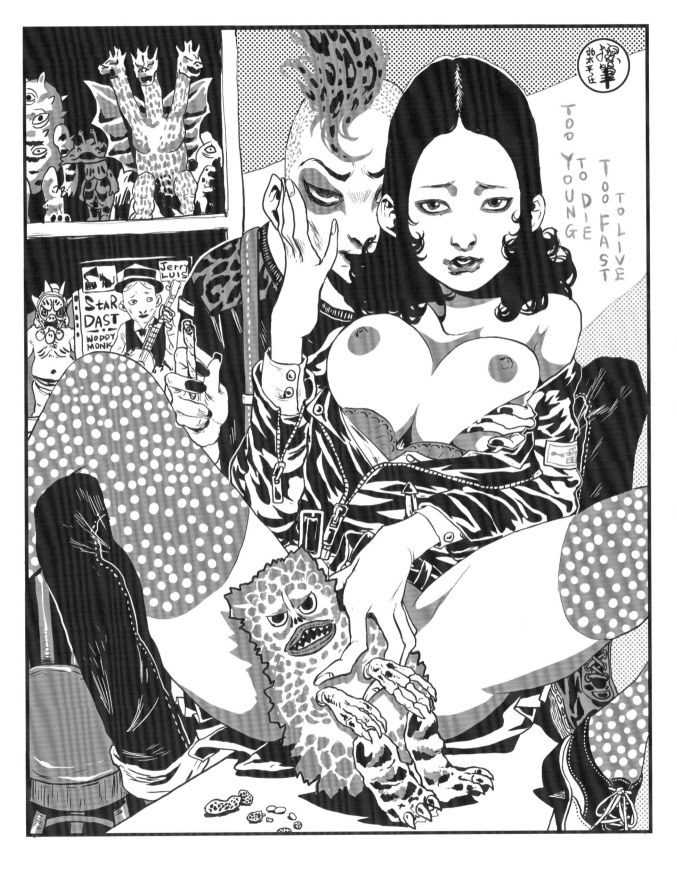

I draw a dark story as below.

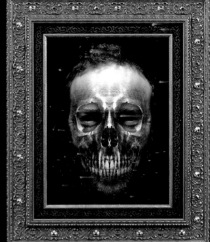

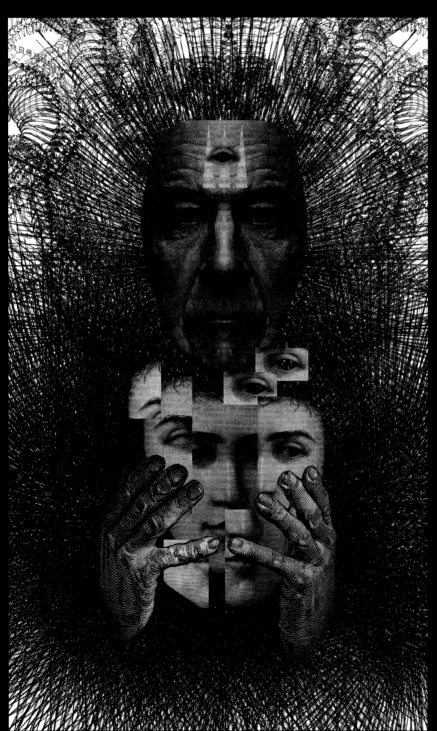

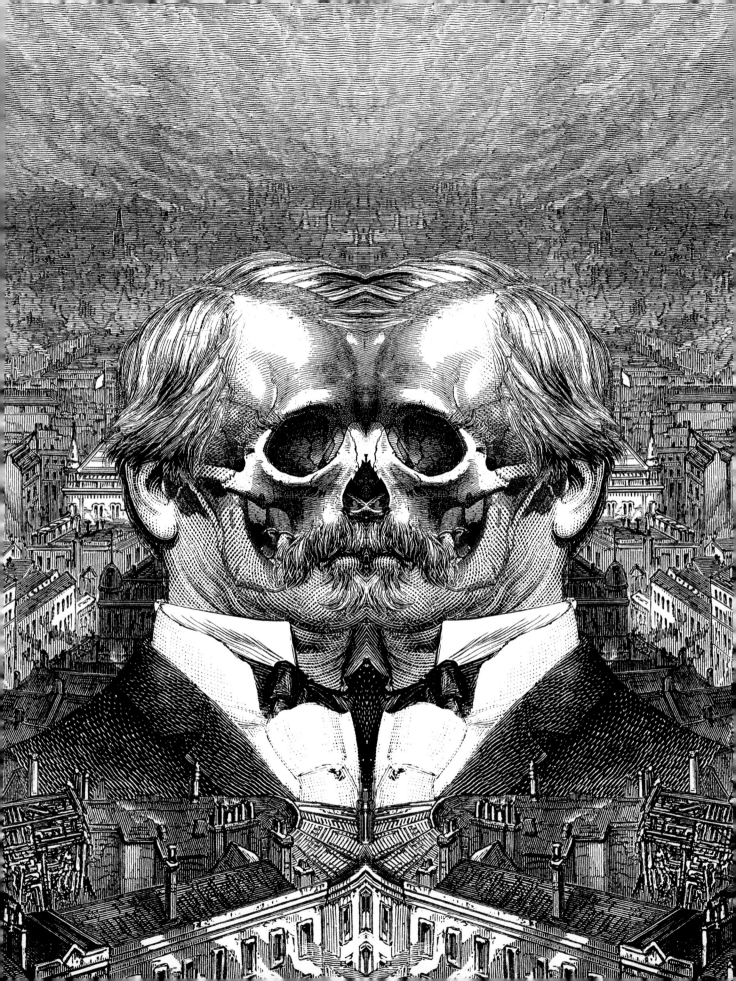

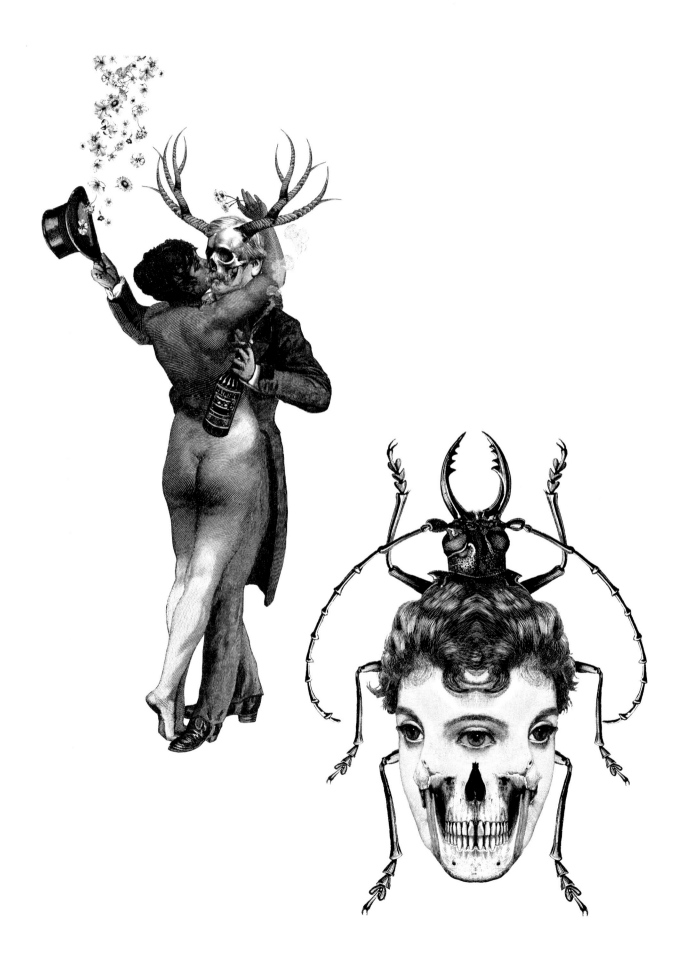

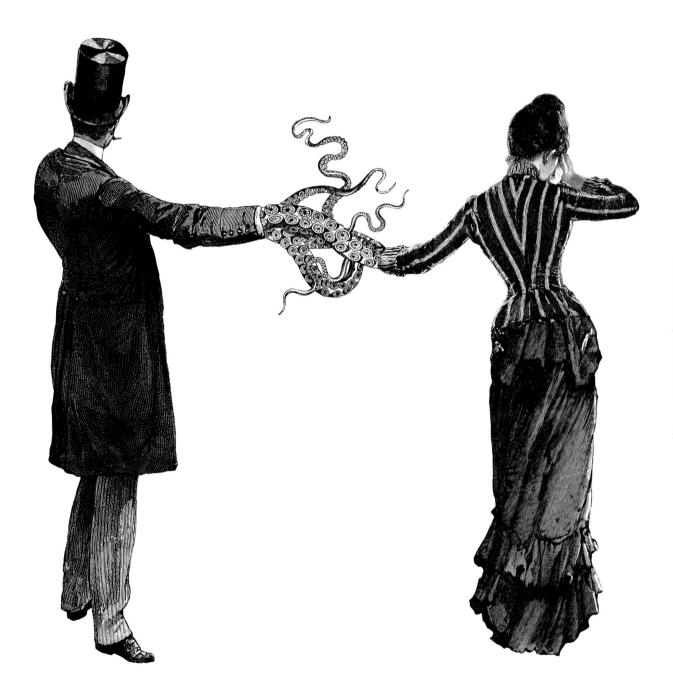

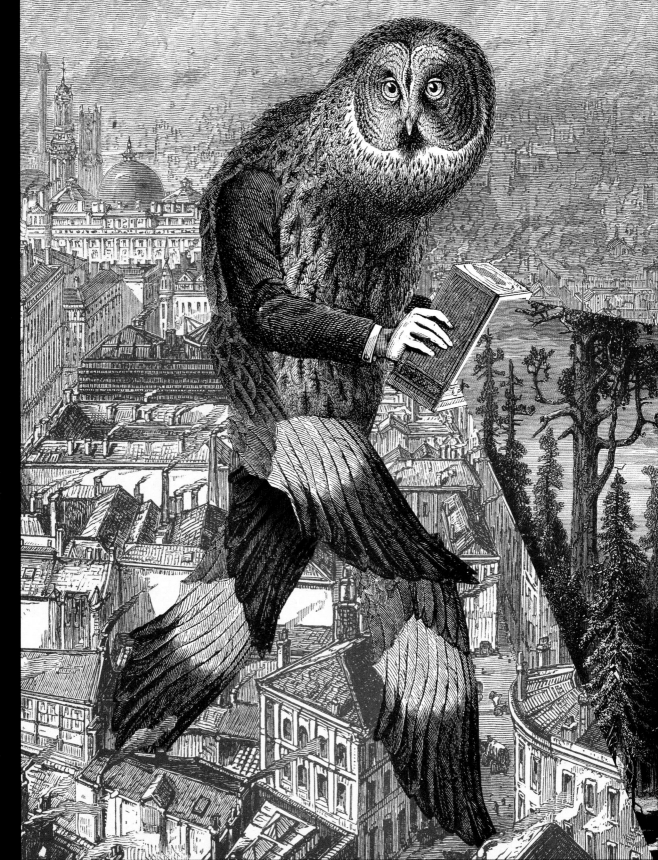

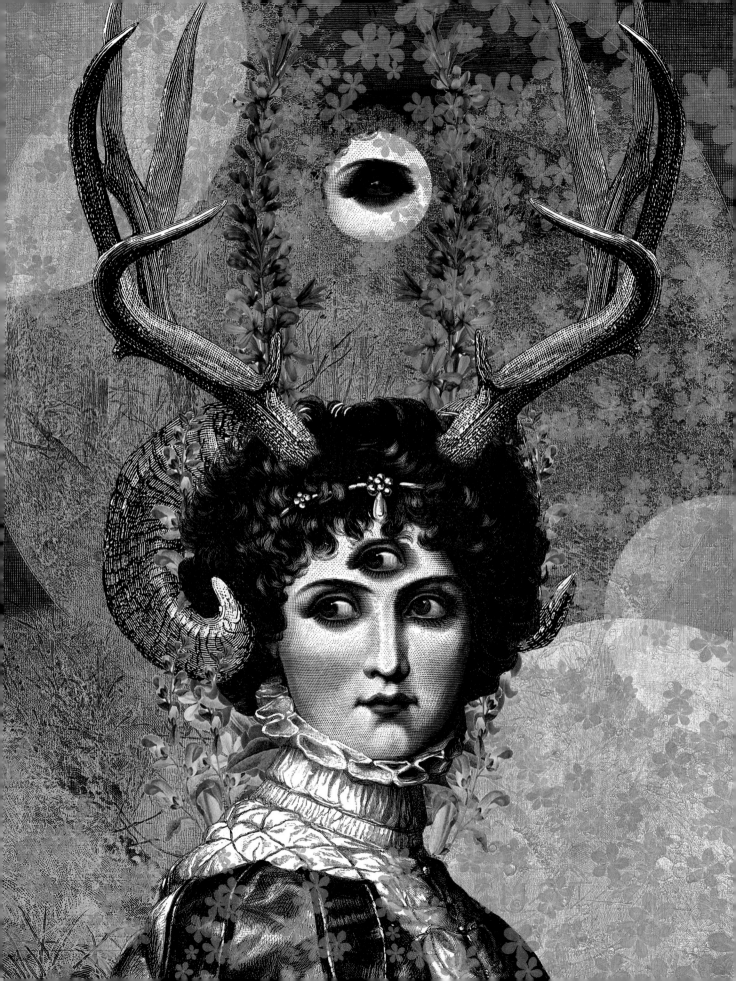

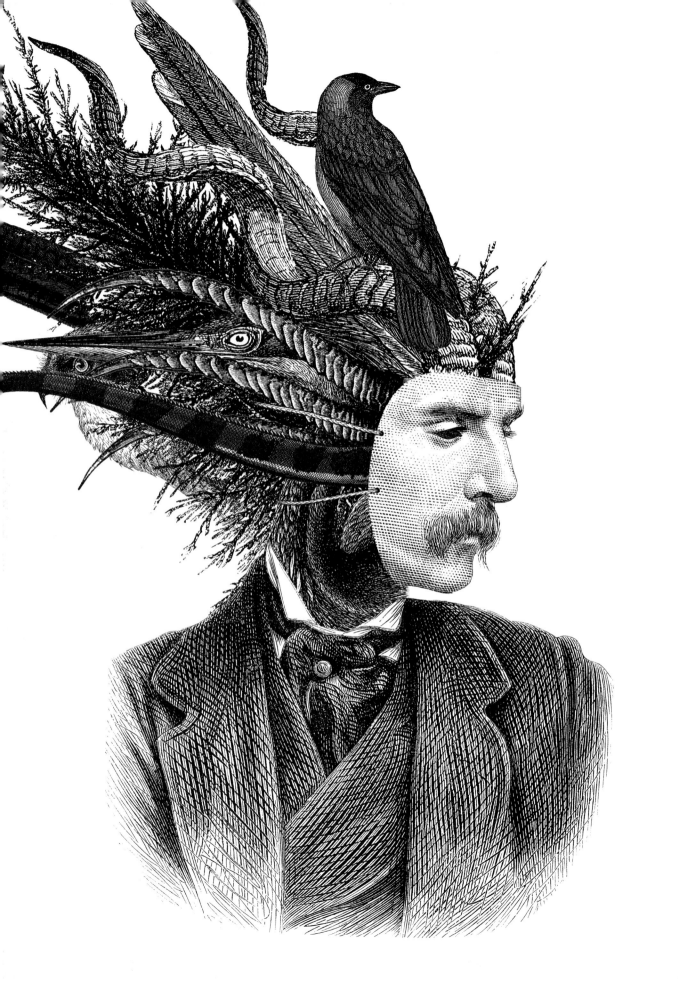

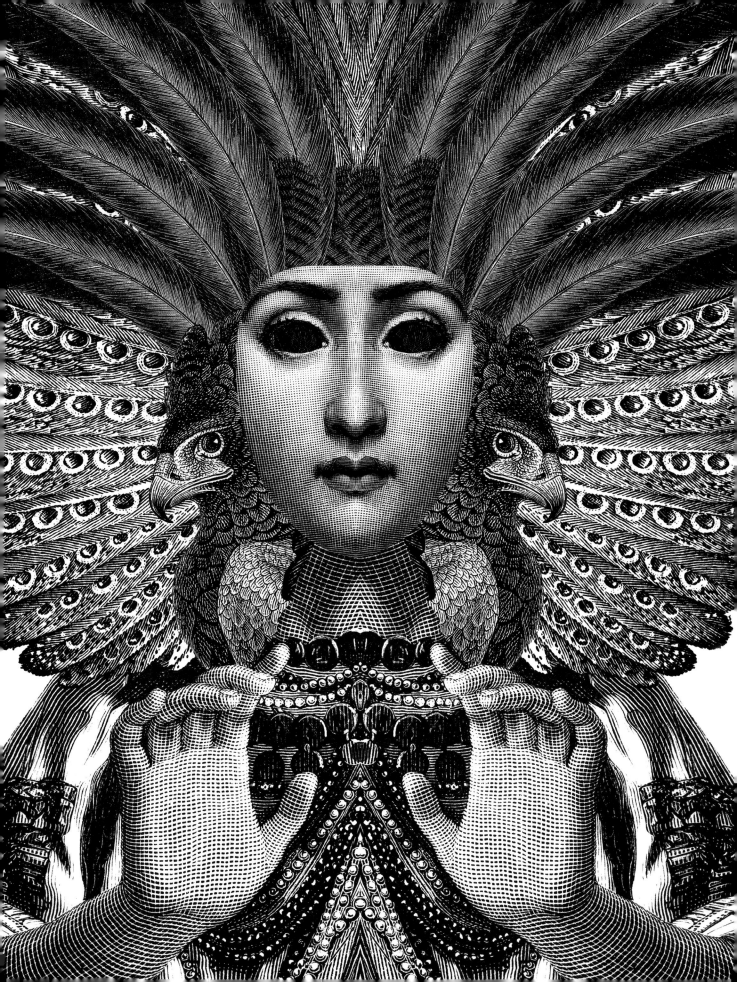

TARA McPHERSON *& Her Dark Story*

The thought of being alone, utterly alone, is one of the darkest fears one can have. Maybe because it is real. Ghosts, demons, monsters, are all myths with no firm evidence that they may exist. But someone ripping your heart out, leaving you empty and broken, or giving so much of your heart to someone that you have nothing left but a hollow shell, now that has happened to all of us. We fear the abandonment of a break up, the horror of divorce, so much that we may stay in a seriously dysfunctional and physically dangerous relationship, all for the fact that we don't want to be alone. But there is hope lingering after the darkness that one can pull through, that one can persevere, that one has strength. For that reason we tread on through dangerous soil filled with land mines of the heart; we try again and again through torturous pain to find the one that won't hurt us. To find the one true love that won't leave us feeling alone.

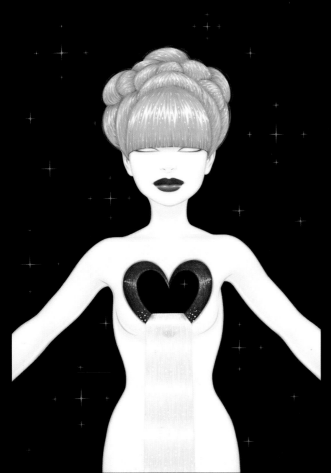

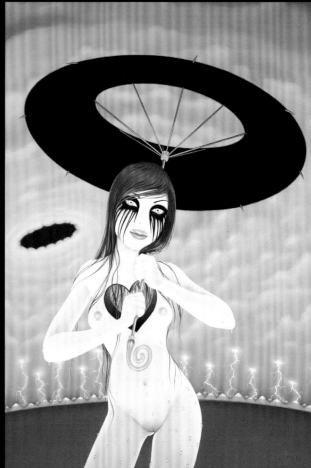

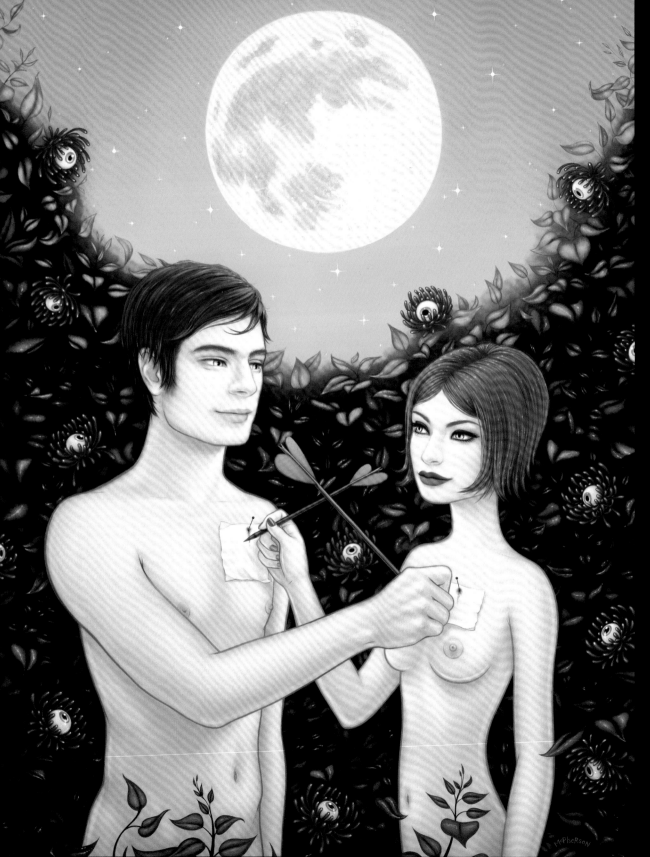

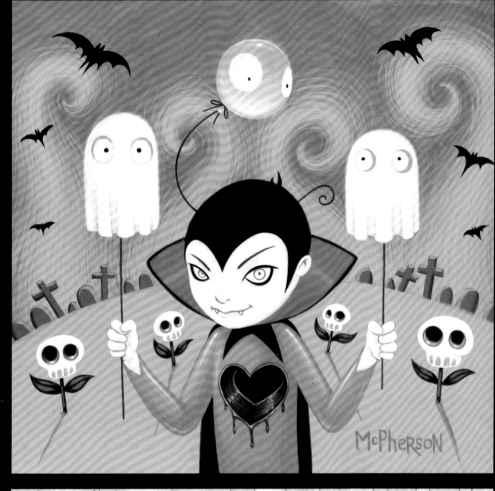

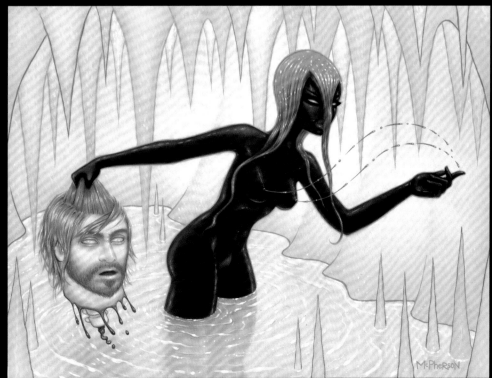

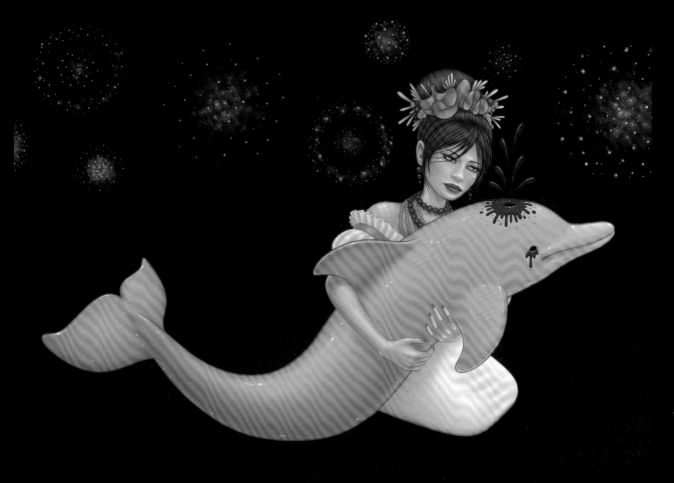

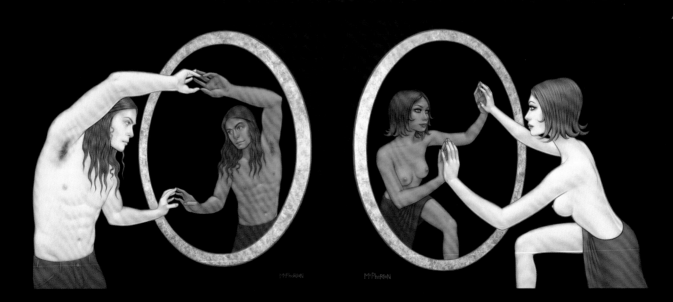

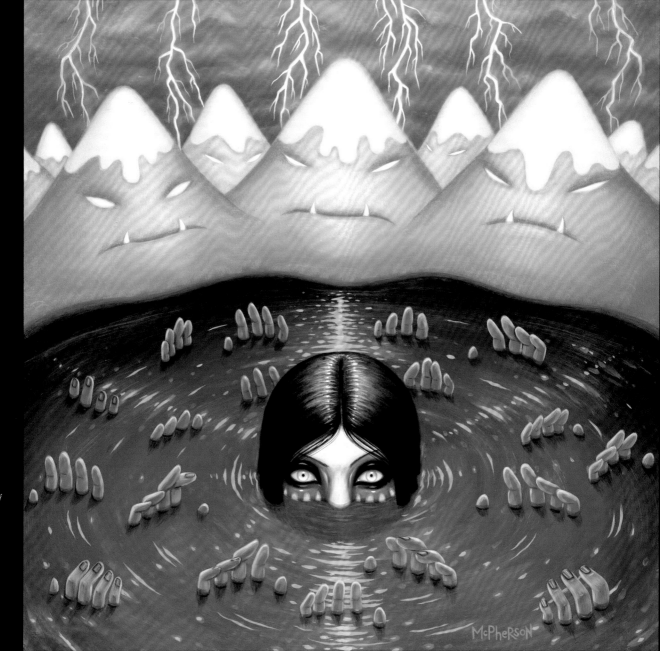

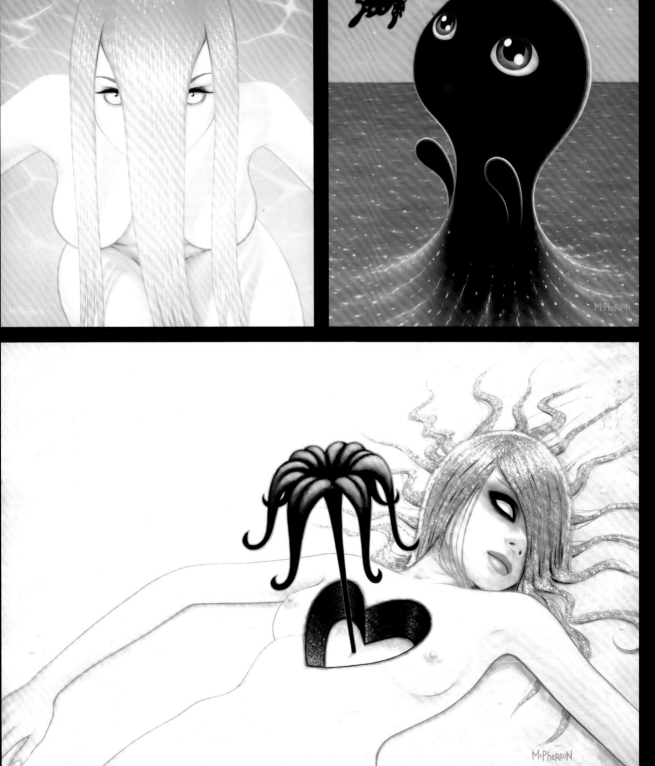

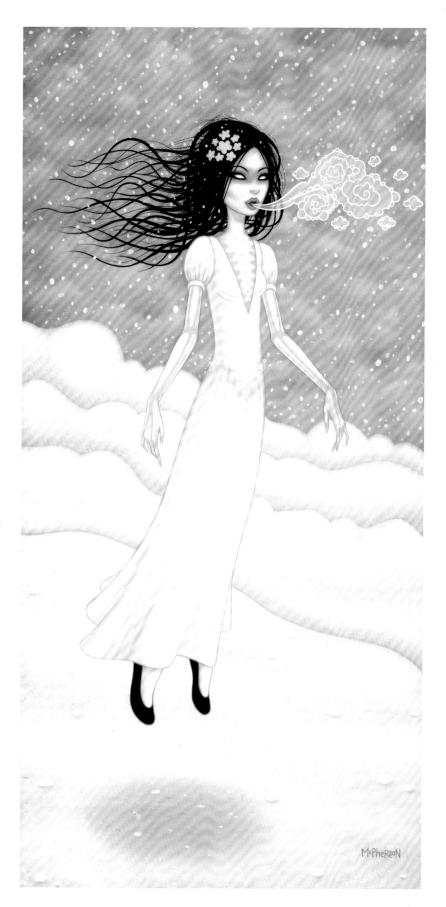

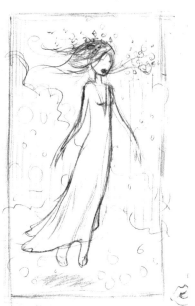

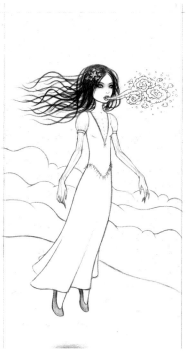

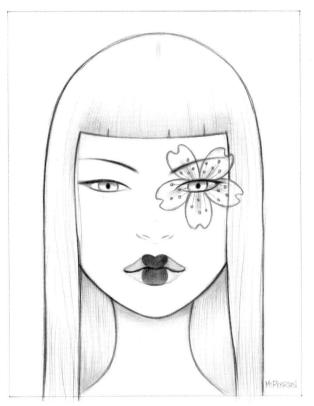
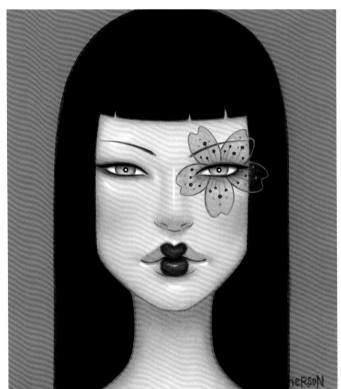
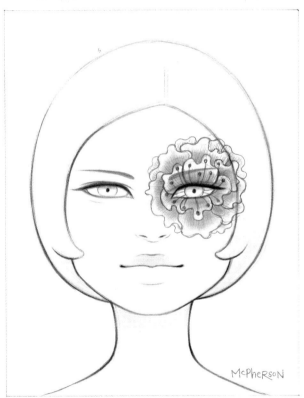
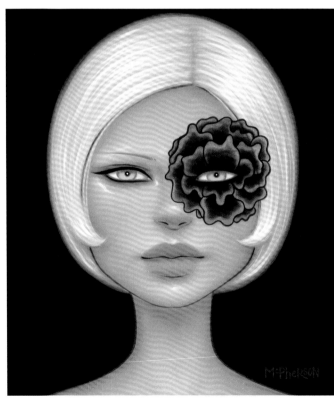

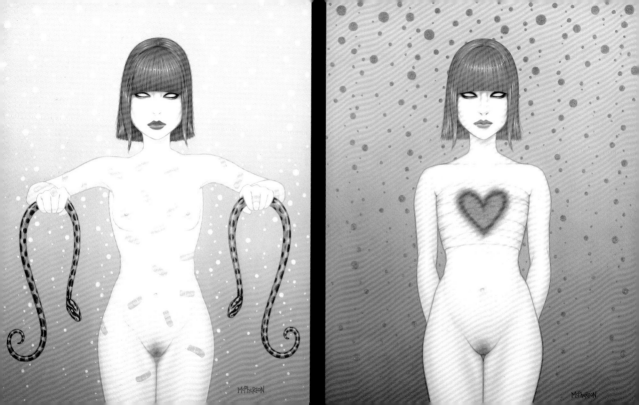

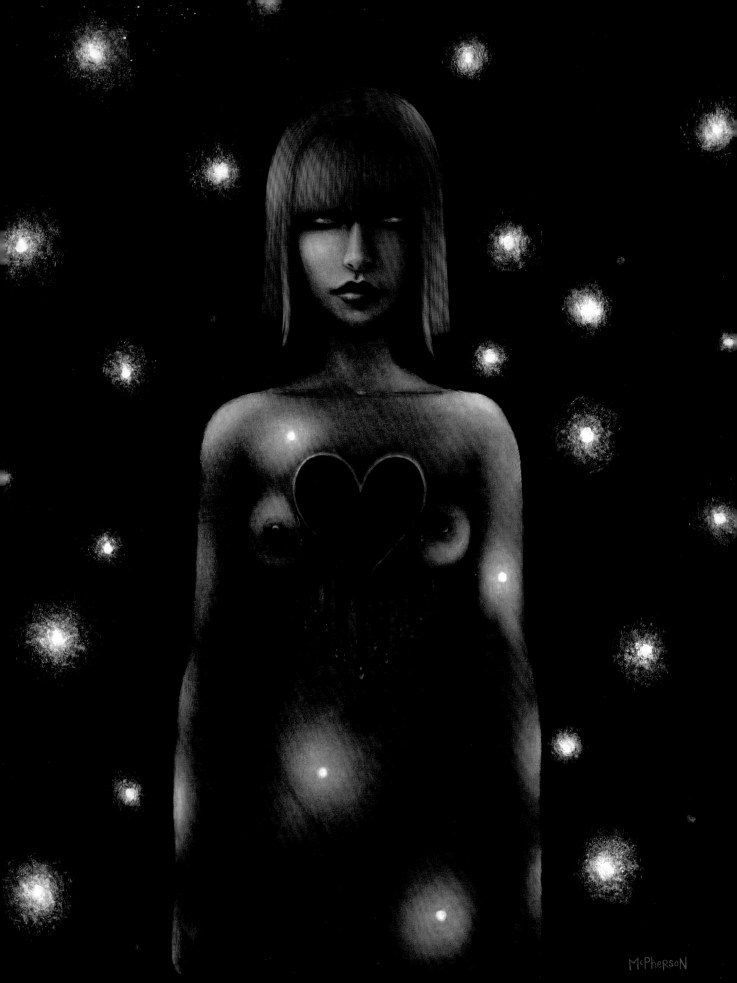

CHARLIE IMMER & *His Dark Story*

My style was created from a combination of horror movies and gross out cartoons. I used to have nightmares that ET was tearing my dog n half. I was fascinated by slime and its various levels of viscosity.

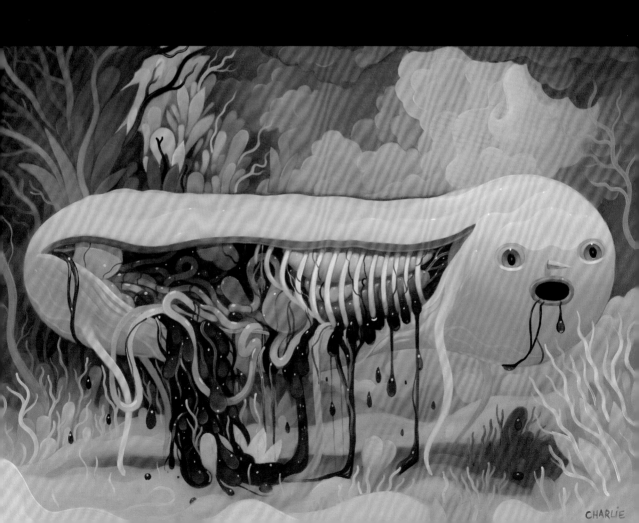

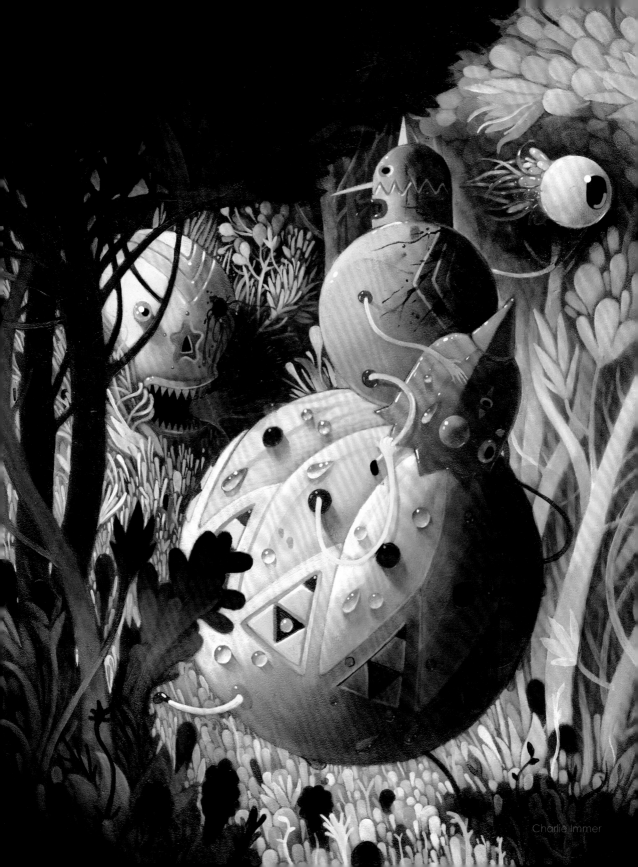

Charlie Immer

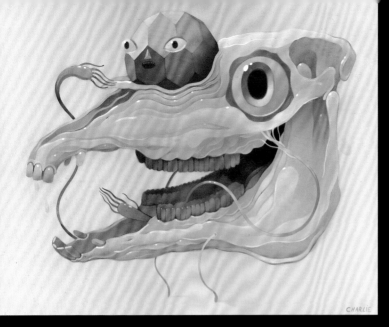

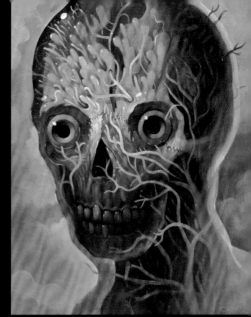

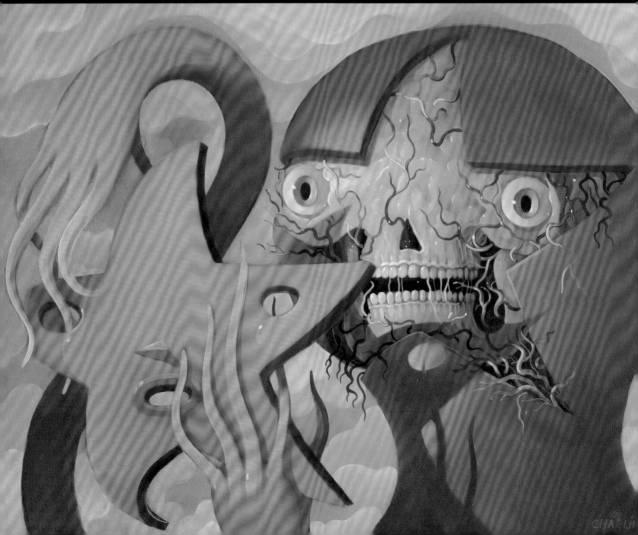

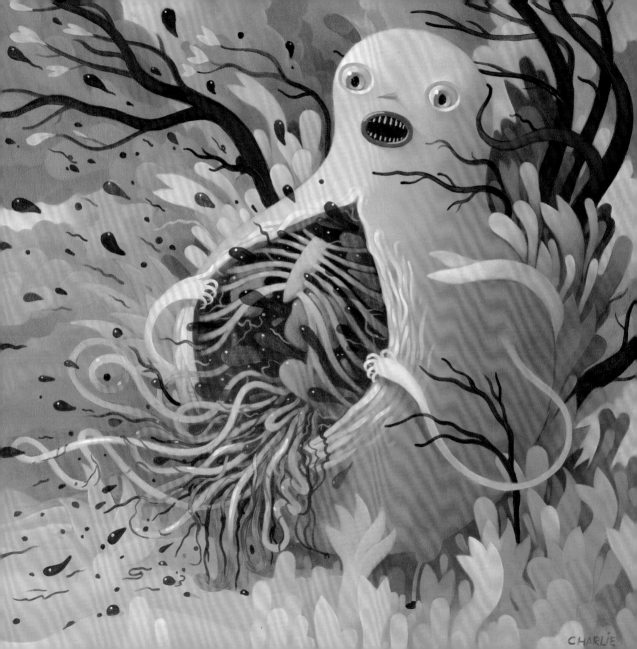
CHARLIE

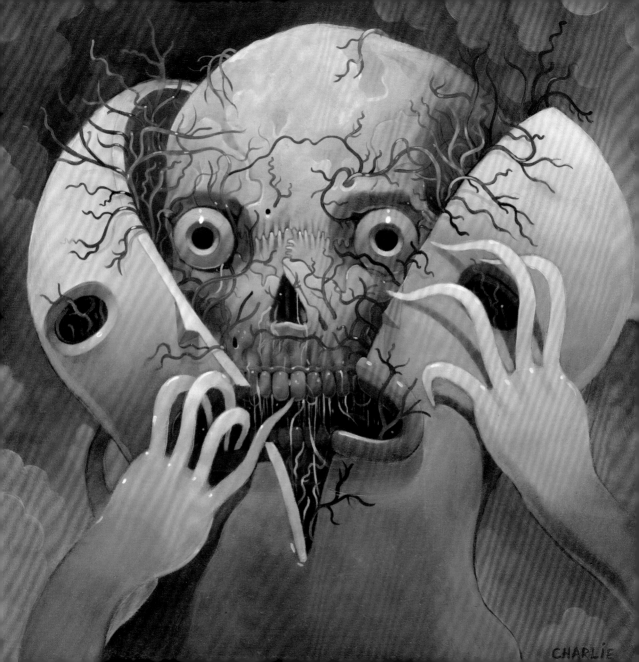

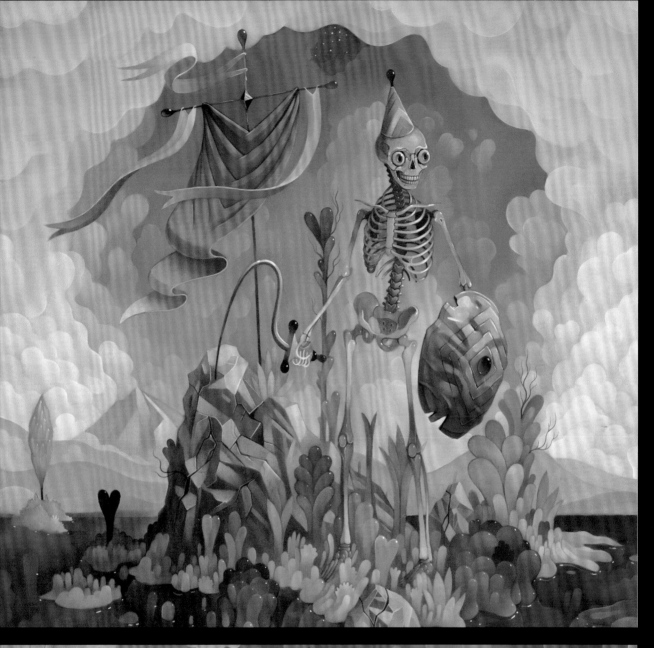

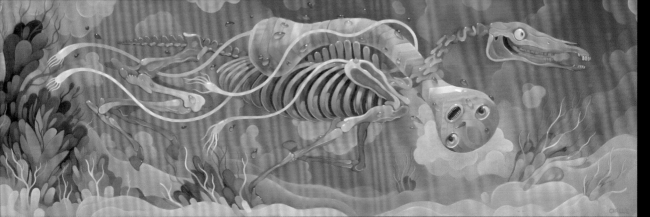

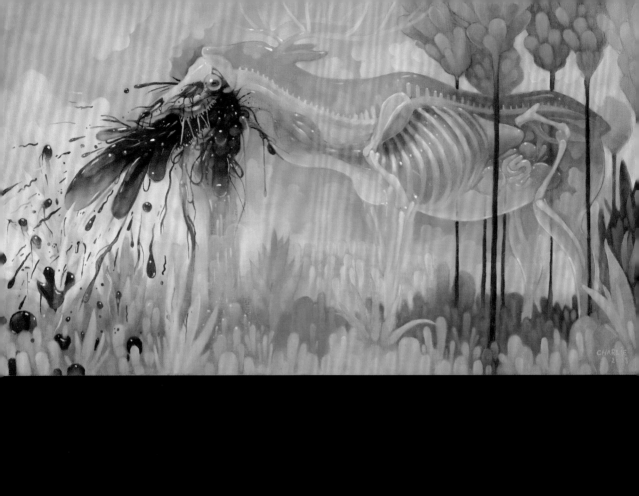

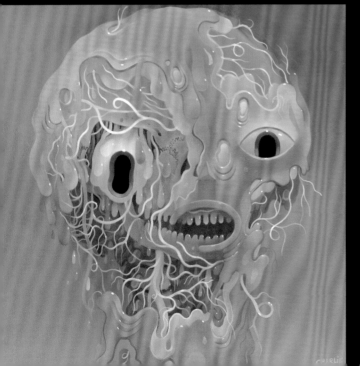

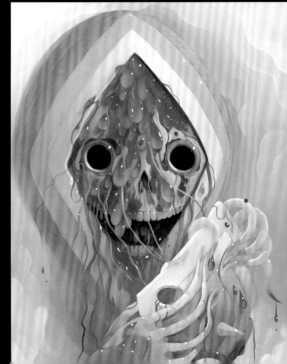

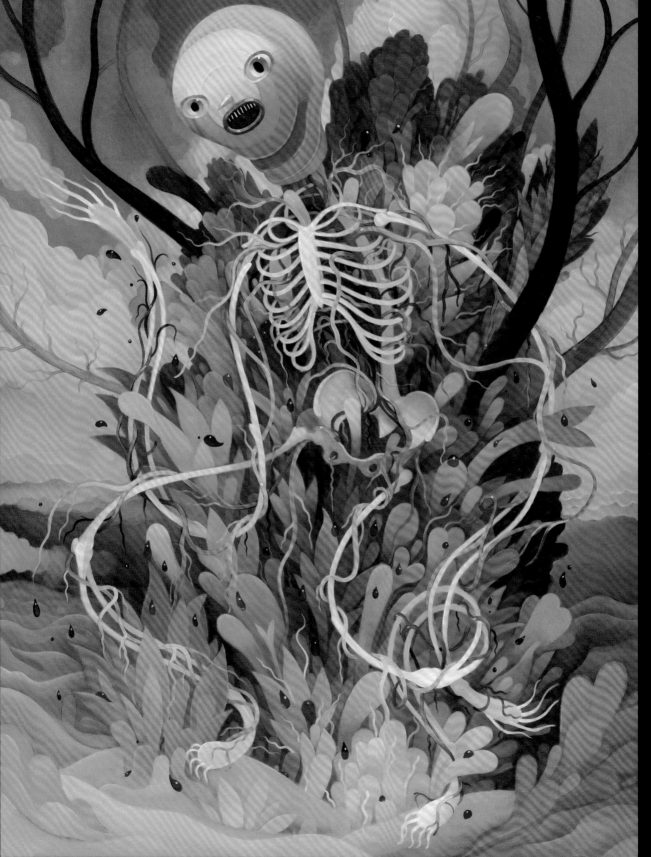

NICOLETTA CECCOLI *& Her Dark Story*

In a dream, I am a young girl on top of a high castle, looking down. All at once, I lose equilibrium and start to fall. While falling, I look through the windows of the endless castle wall into other people's lives while they look back at me as well. The fall lasts a long time, I could say years. I finally brake myself at the bottom as an old lady.

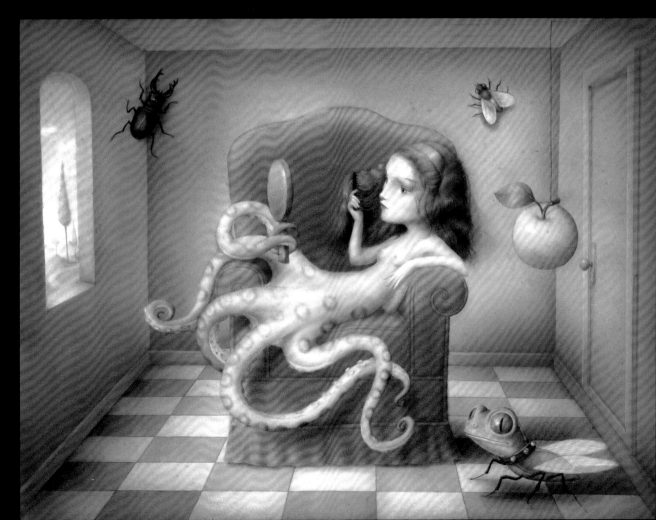

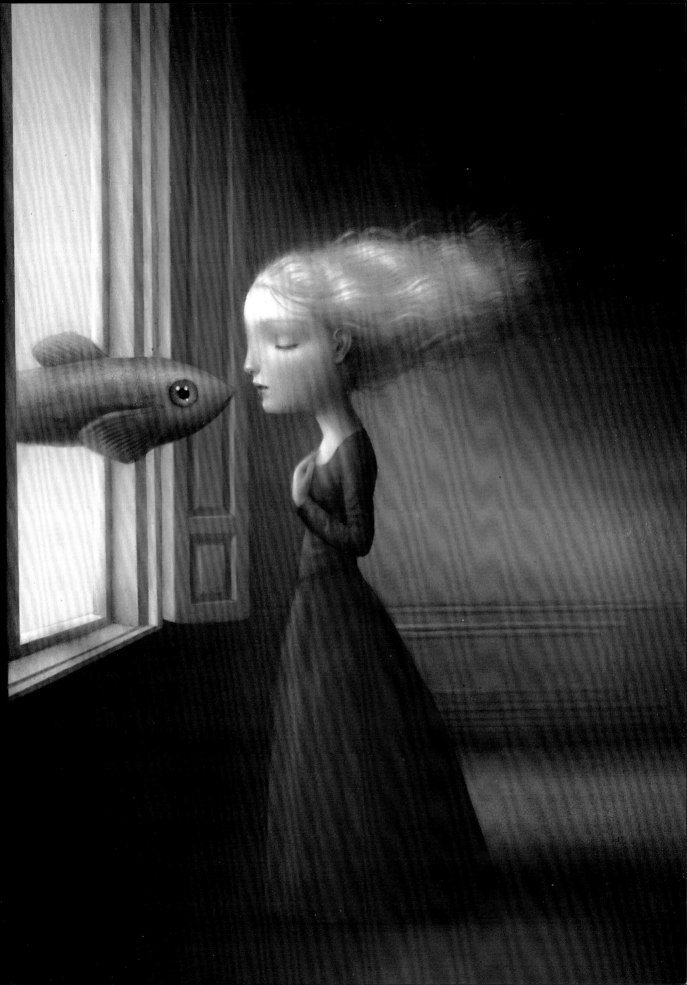

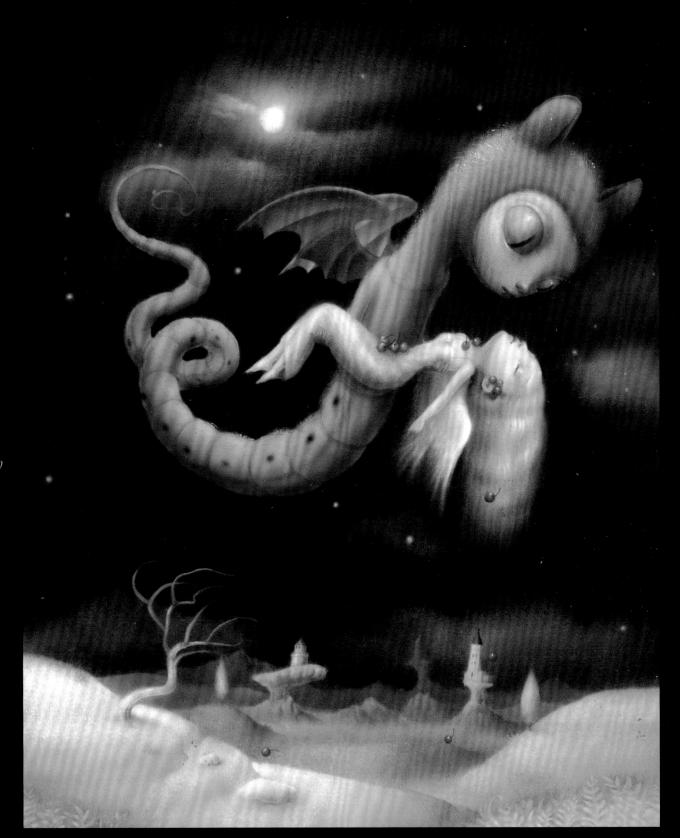

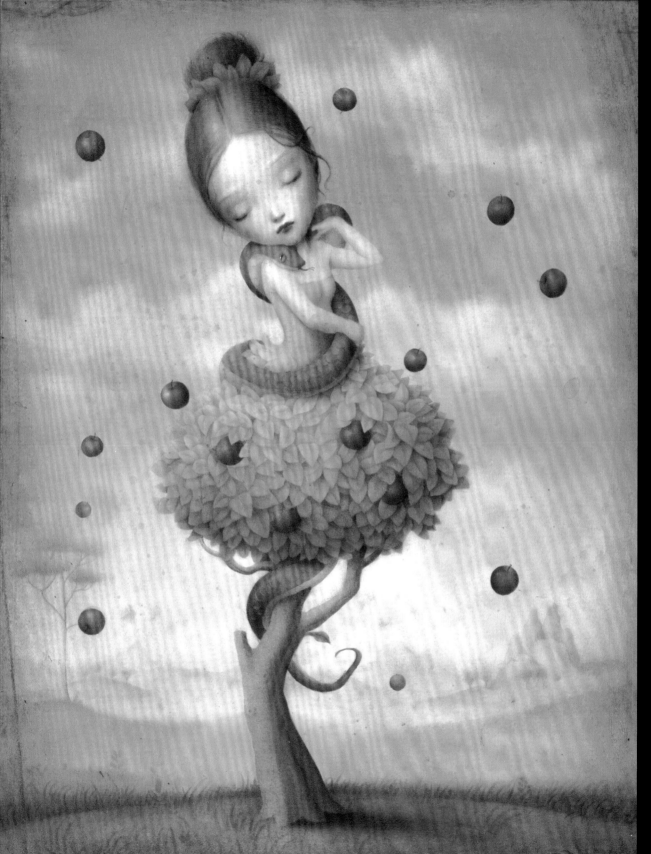

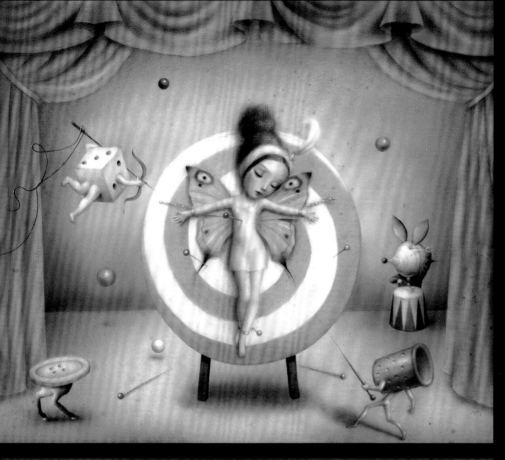

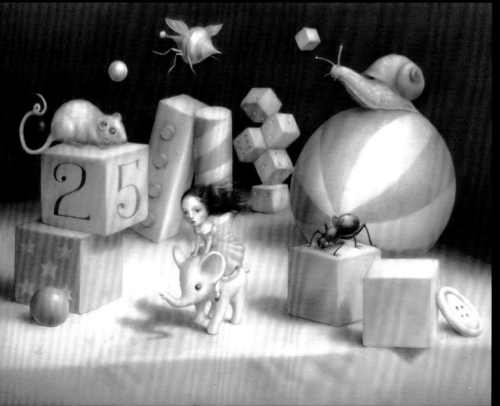

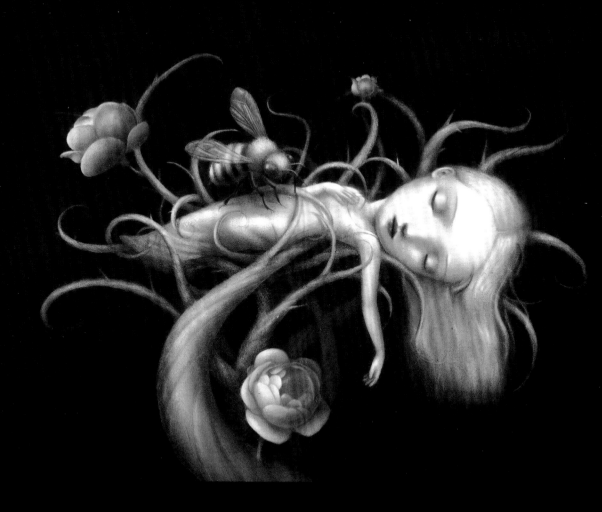

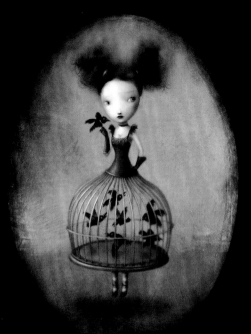

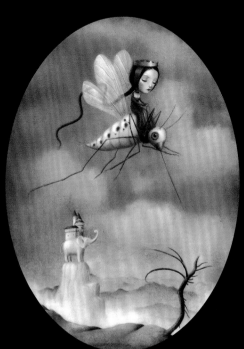

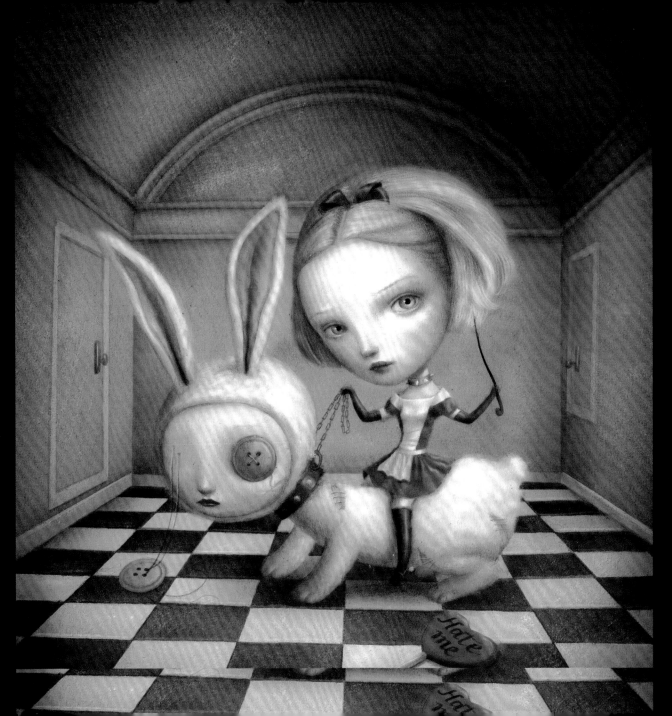

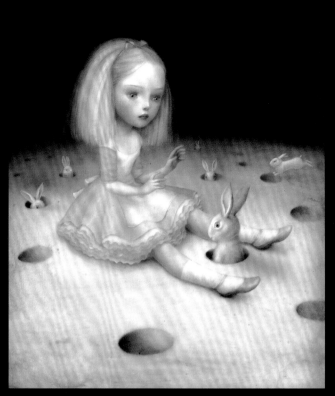
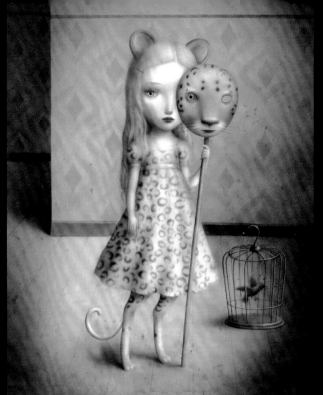

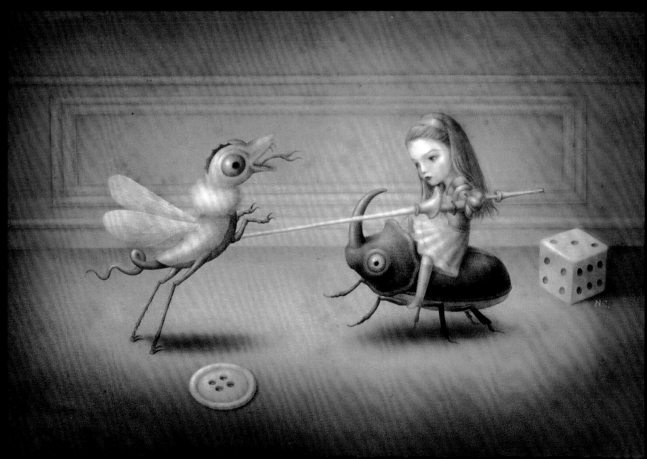

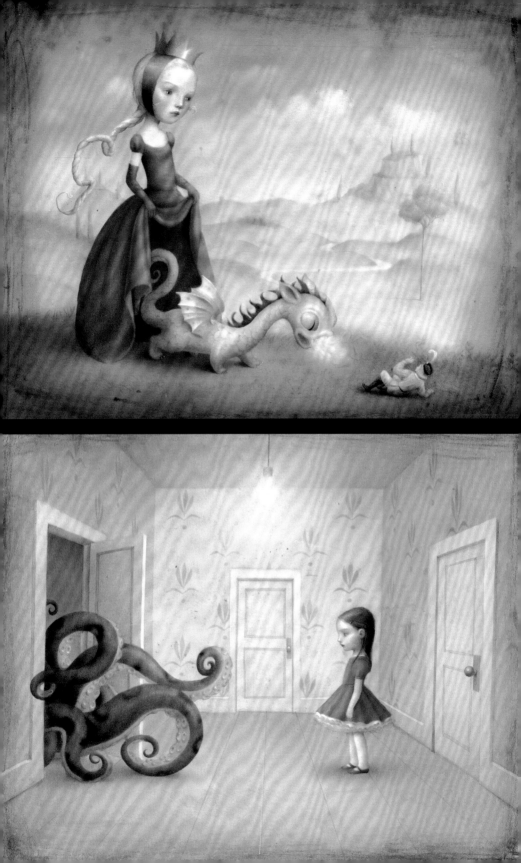

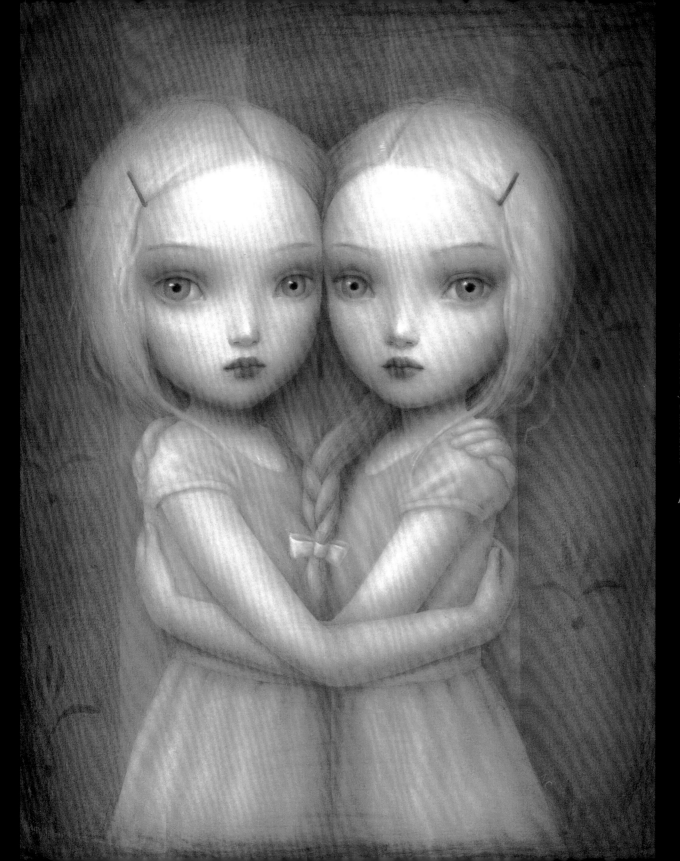

The Entranced Multitude

She has been taught the cause. She can notice the symptoms. Like a dormant monster inside, it waits to be nourished by hate, envy, and greed. Nothing seems to have prepared her for what she is about to face.

She watches hopelessly and helplessly at the entranced multitude being led by their ego's obscured agenda. They move in a wave of perpetual motion, each member falling into sync like some wicked tribal dance. The rows of dancing masses fade into the distance. She can't see clearly what they all are heading for, but she senses that they are heading for their inevitable end like cattle to be slaughtered.

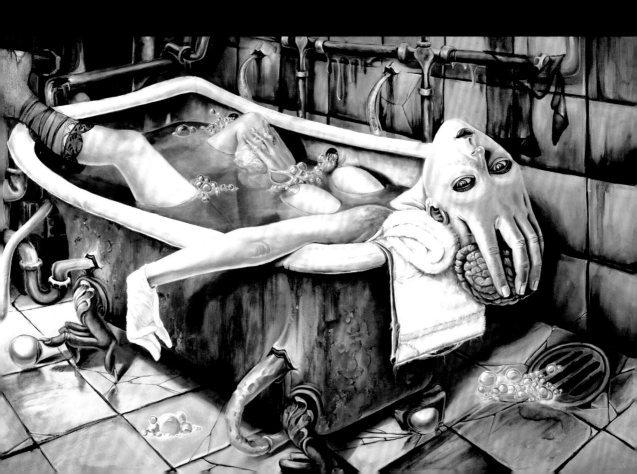

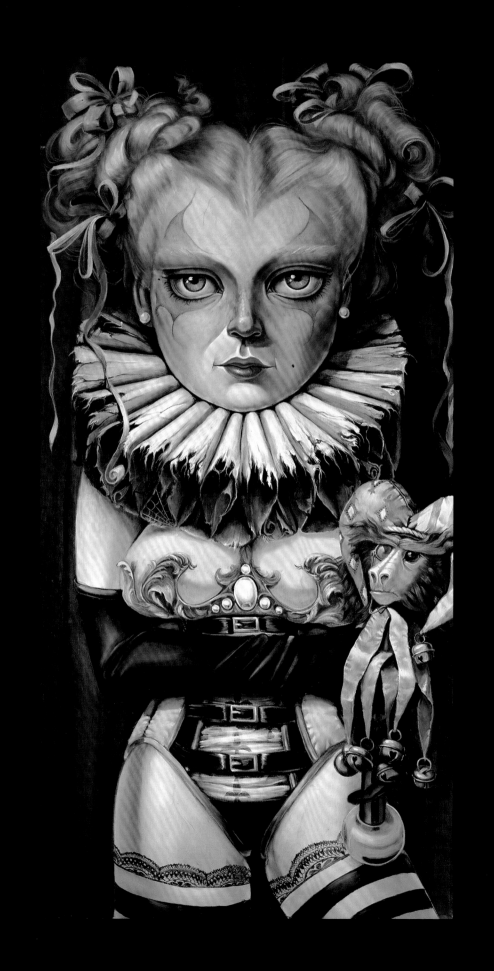

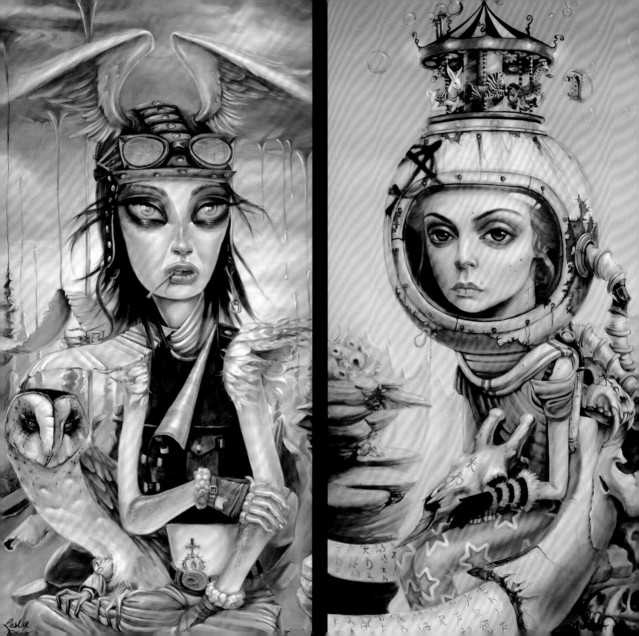

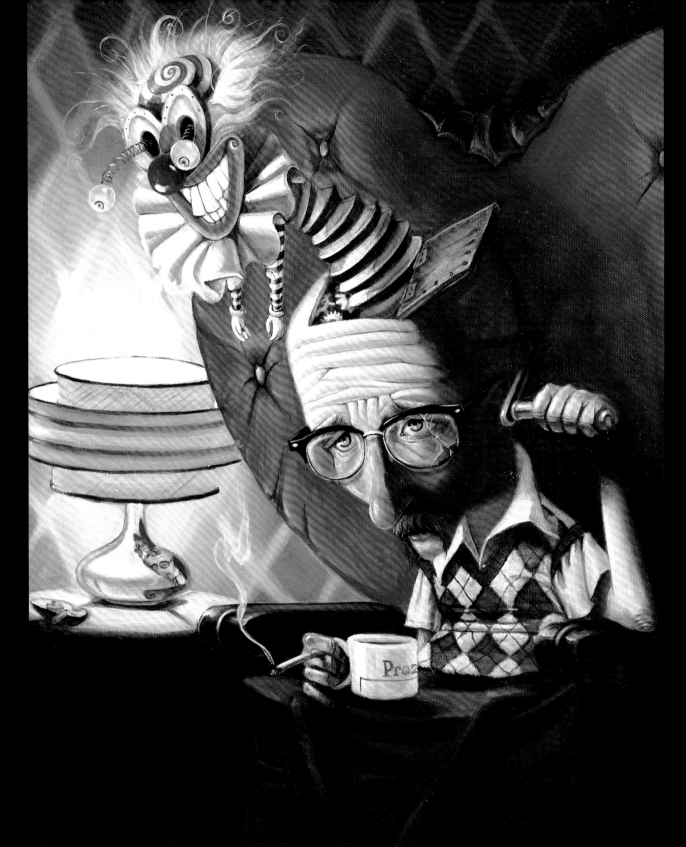

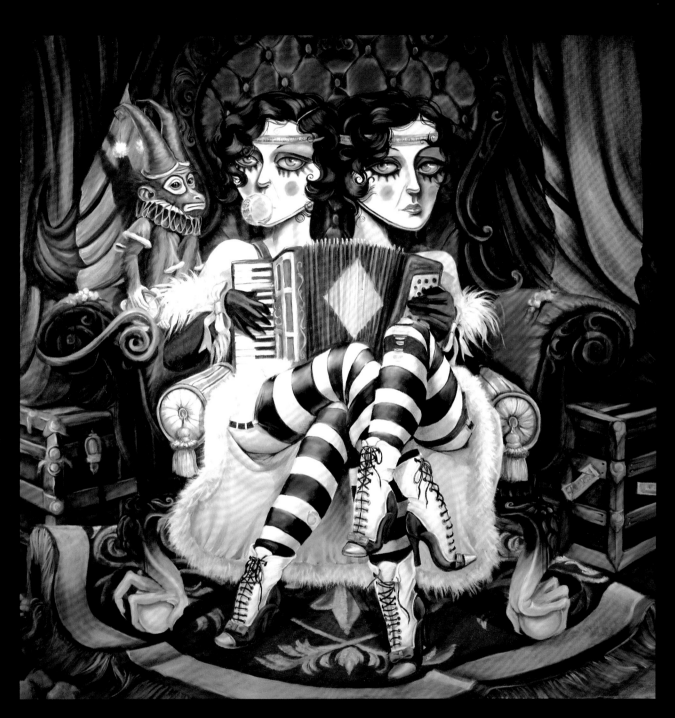

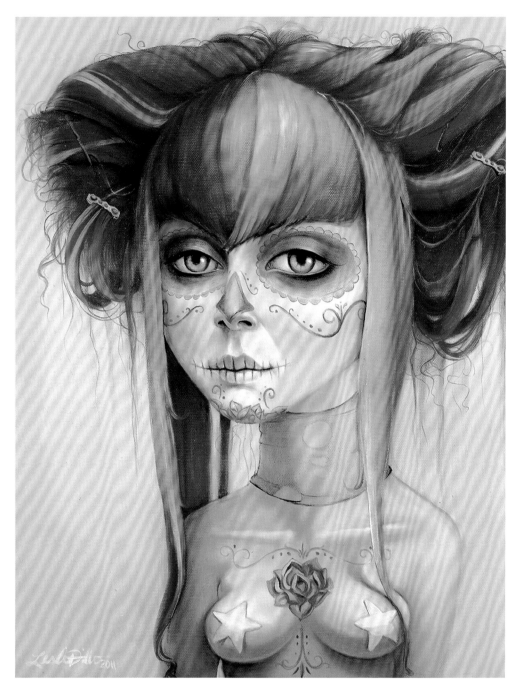

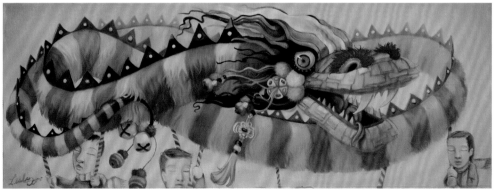

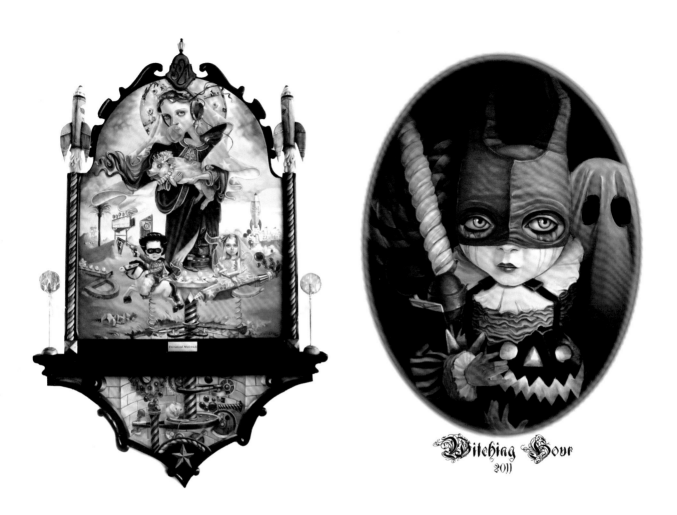

Witching Hour
2011

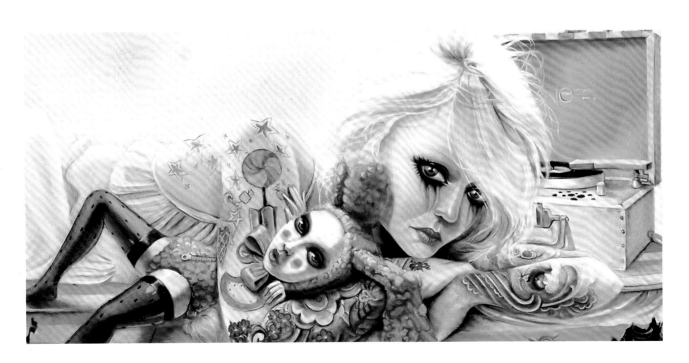

JULES JULIEN *& His Dark Story*

I don't have a really dark story to tell you. The only thing that I can tell you is that as a child I was very sensitive and my nights were full of nightmares.

So like a lot of children, the night was synonymous with eeriness and fear. I think this child is still in me, forever.

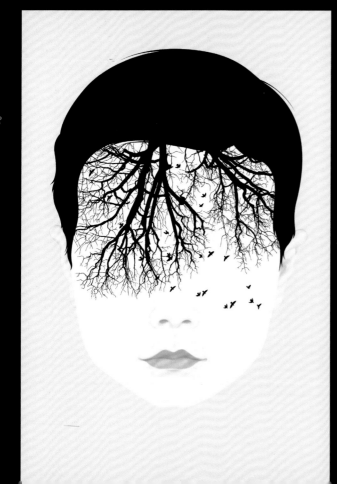

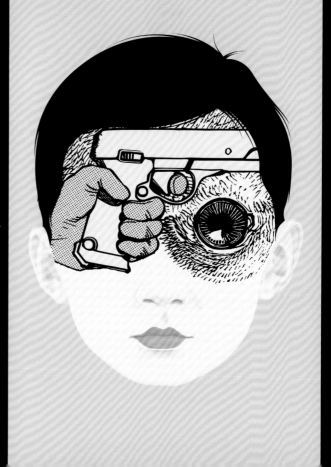

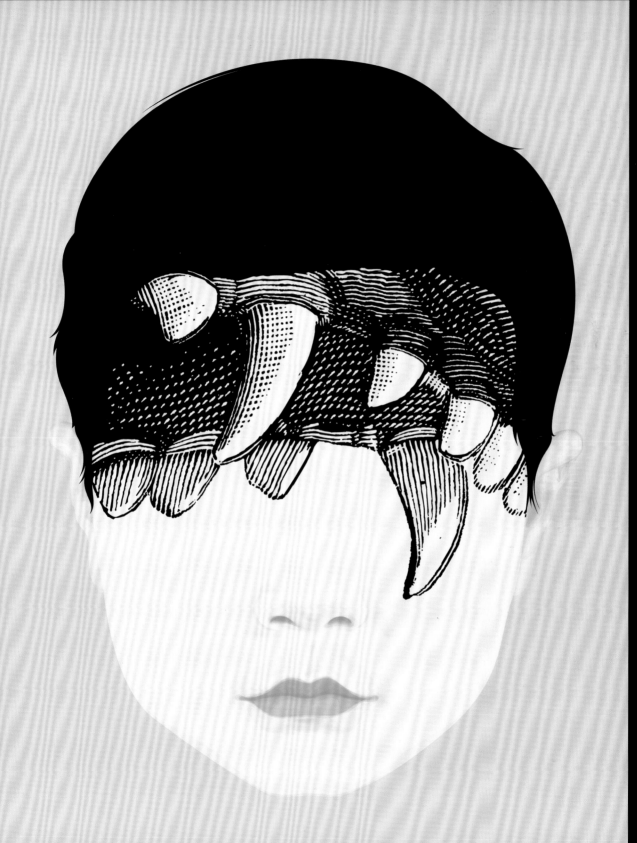

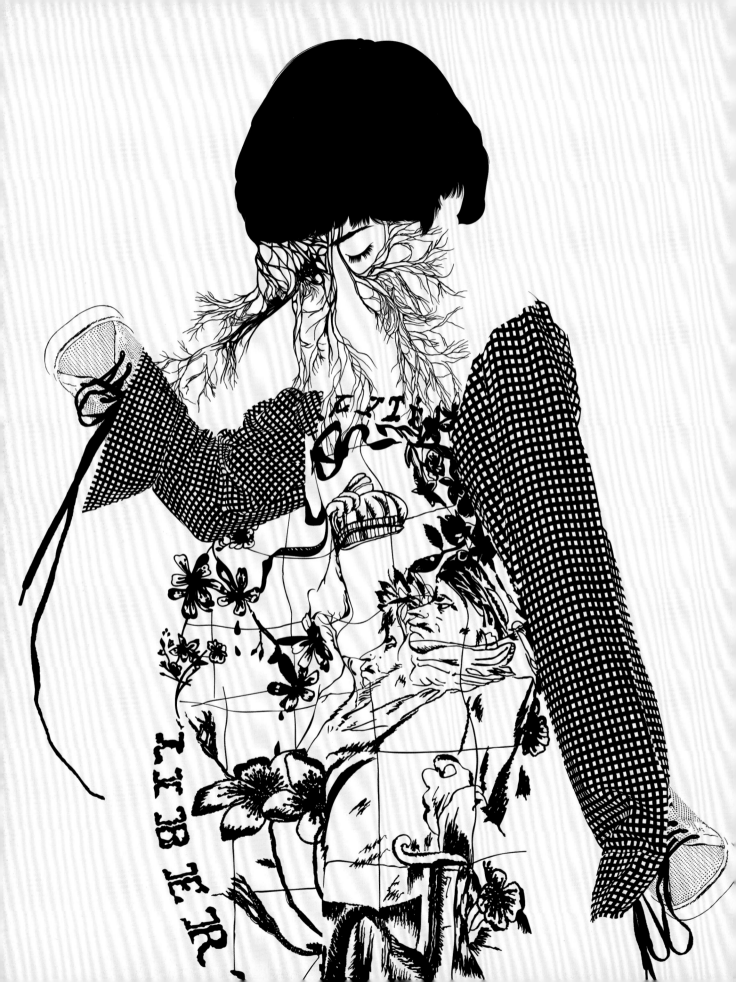

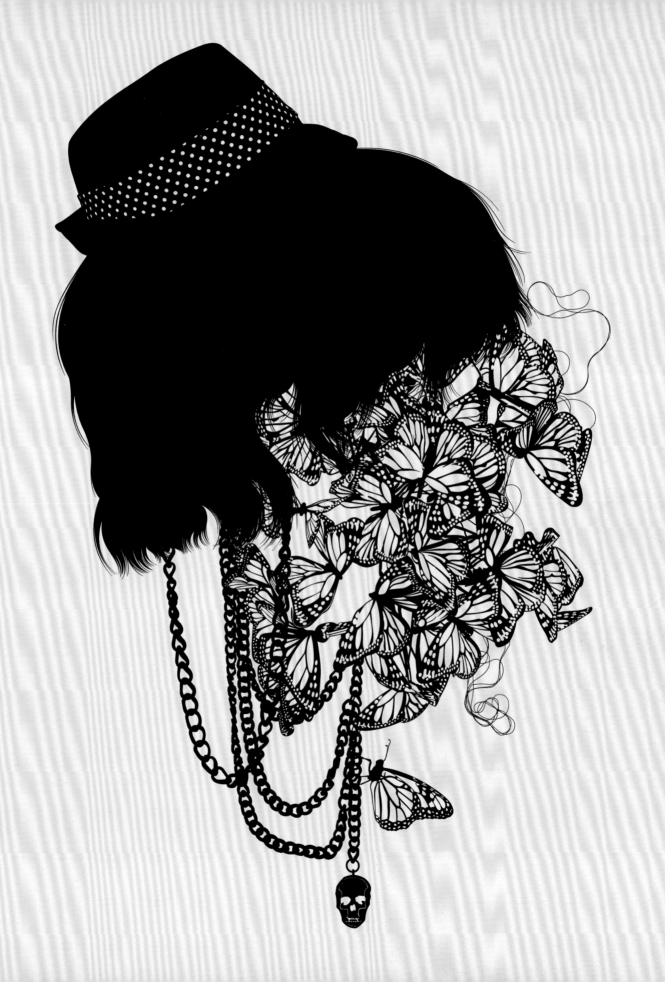

In my dreams I saw my mother dying covered in blood with a broken wing and a big shot hole in her giant bird chest, looking at me with her demon face as if she were about to eat my soul. I was scared by my grandma walking blurred through the walls and doors, with her blurred farsighted face looking to infinity as though crazed, floating in front of me as if she were dead, releasing electricity in the air. I saw my wife killing my dad and throwing him from a balcony. I saw a shape-shifting demon eating my imaginary baby sister in the form of an enormous pit-bull and shape-shifting into an old woman, Freddy Krueger killing a cop, a giant albino snake eating a child and at the end a giant albino wolf-fox with multiple heads that spoke to me as the god of duality, all in the same dream.

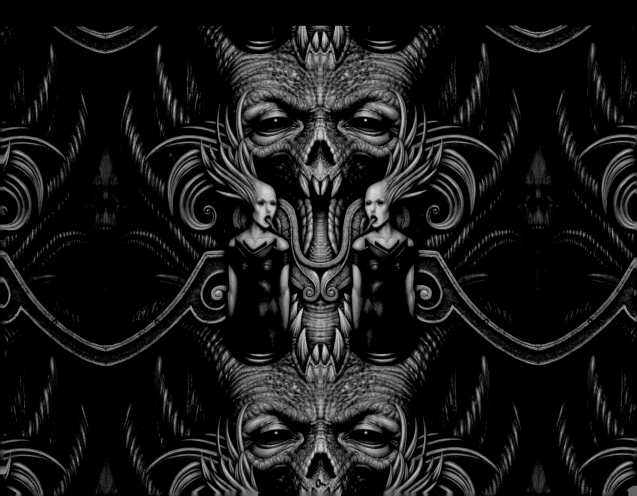

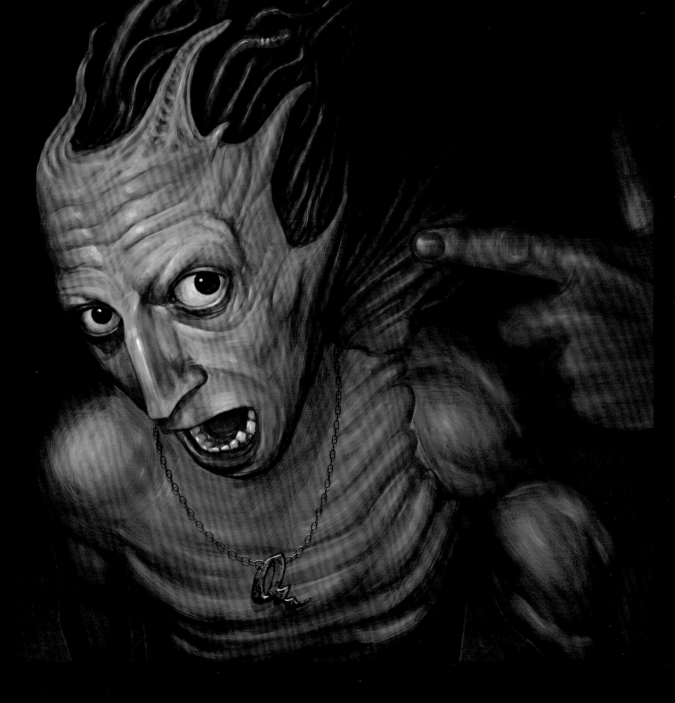

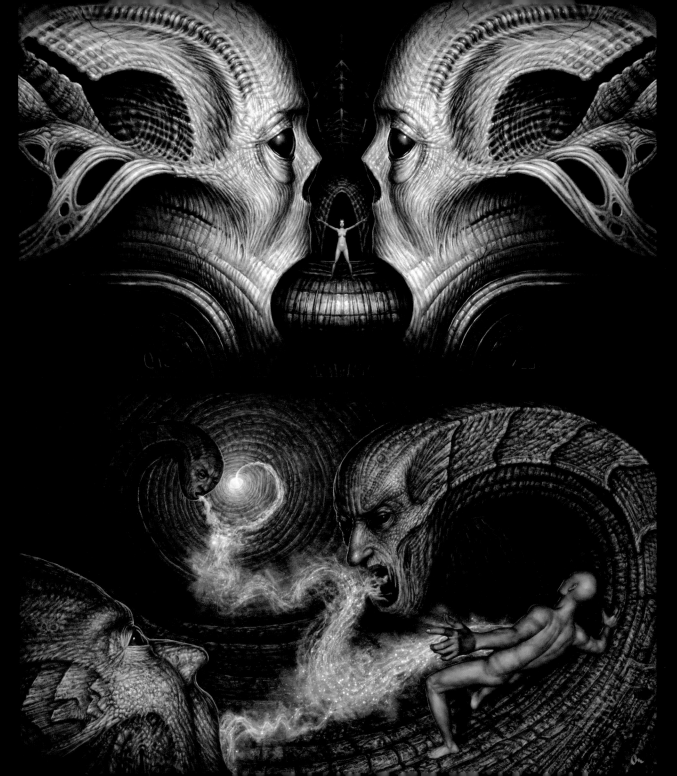

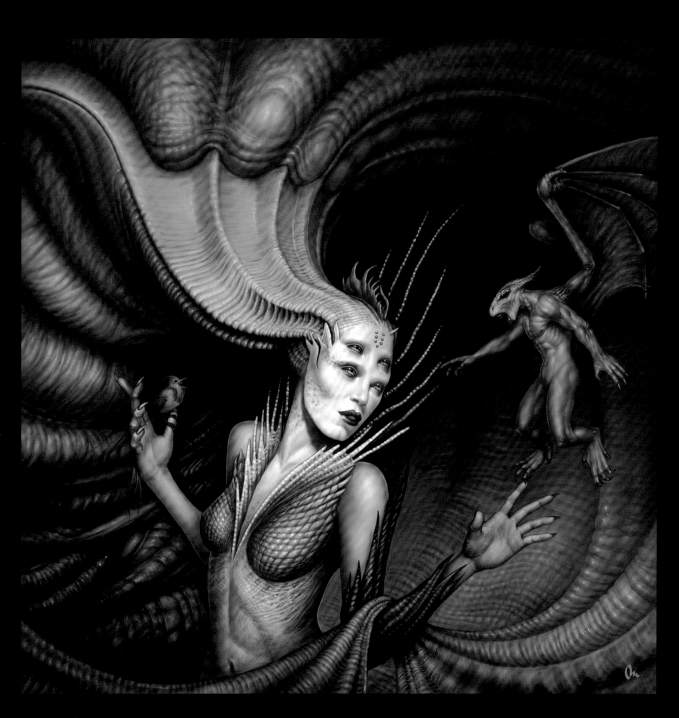

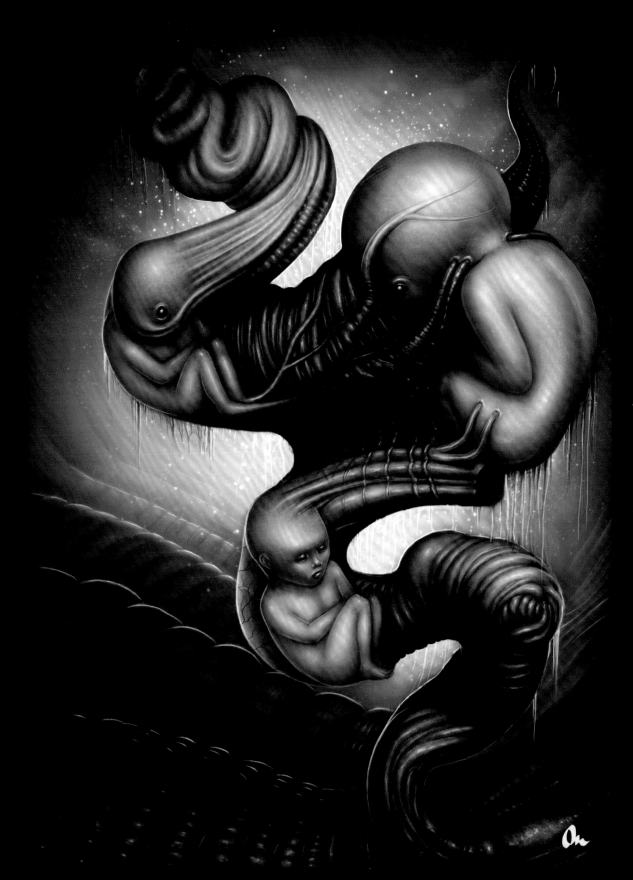

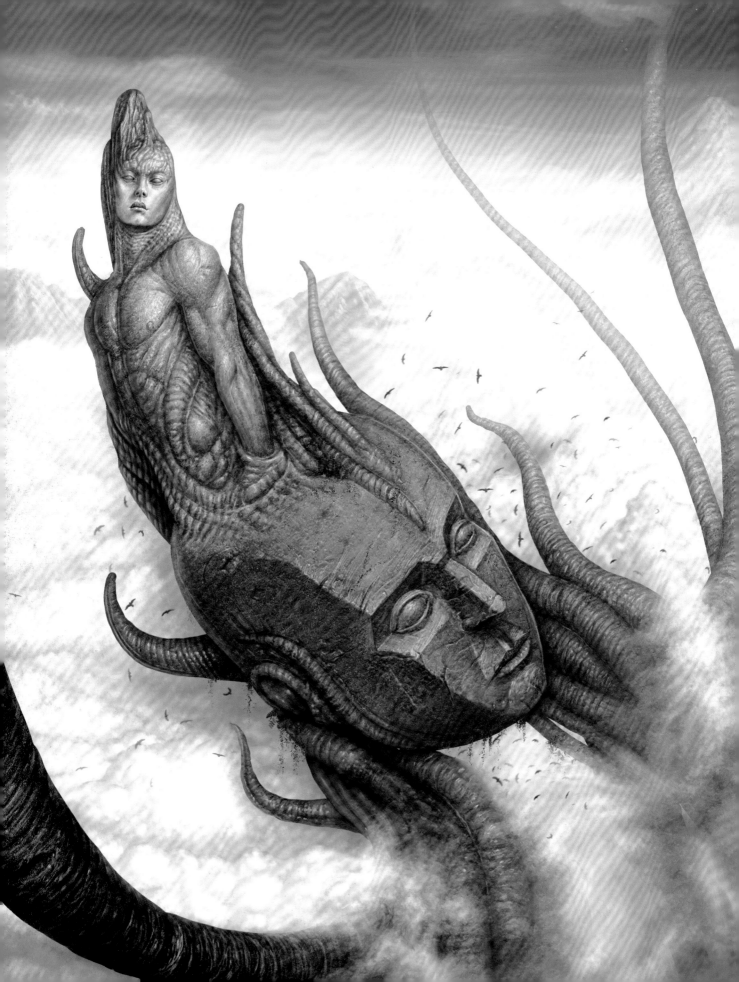

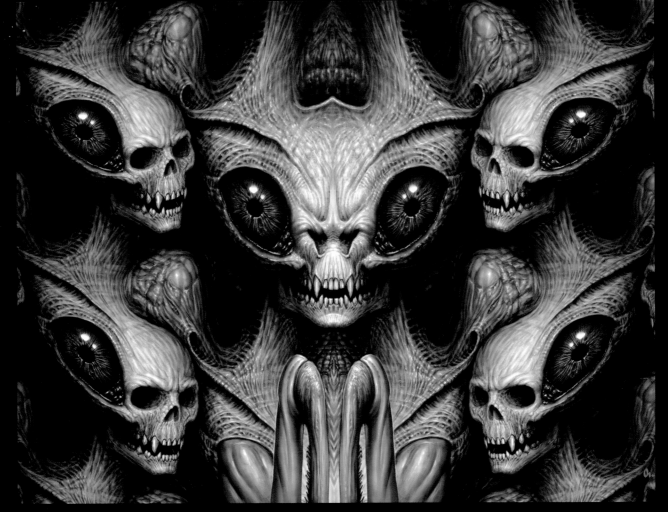

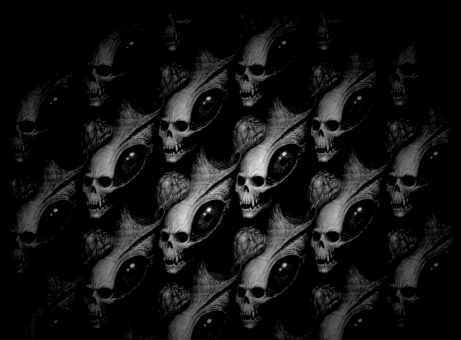

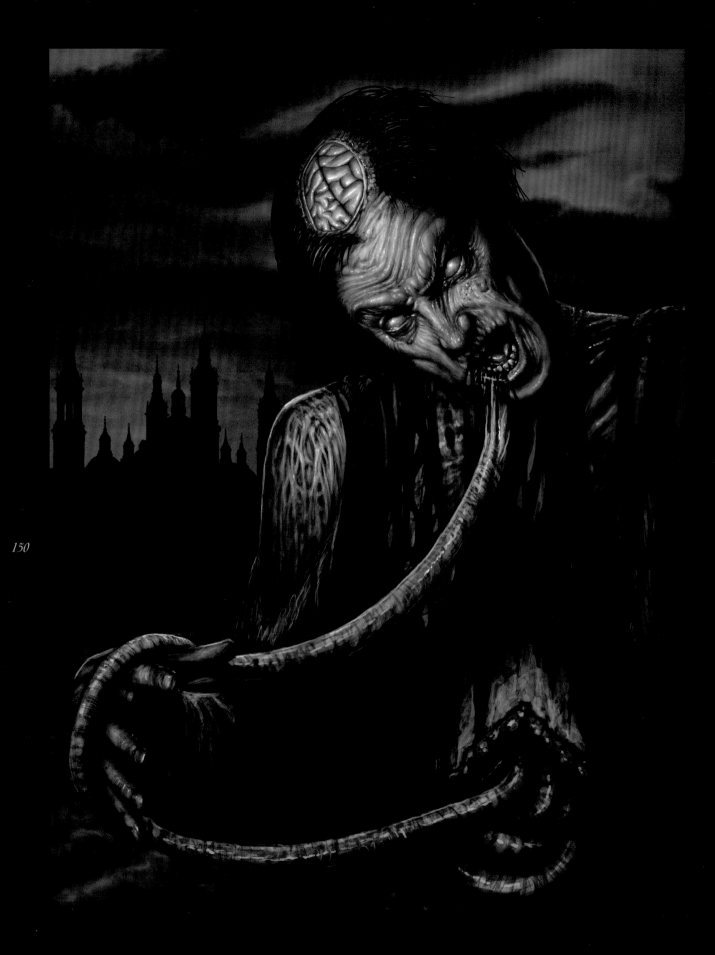

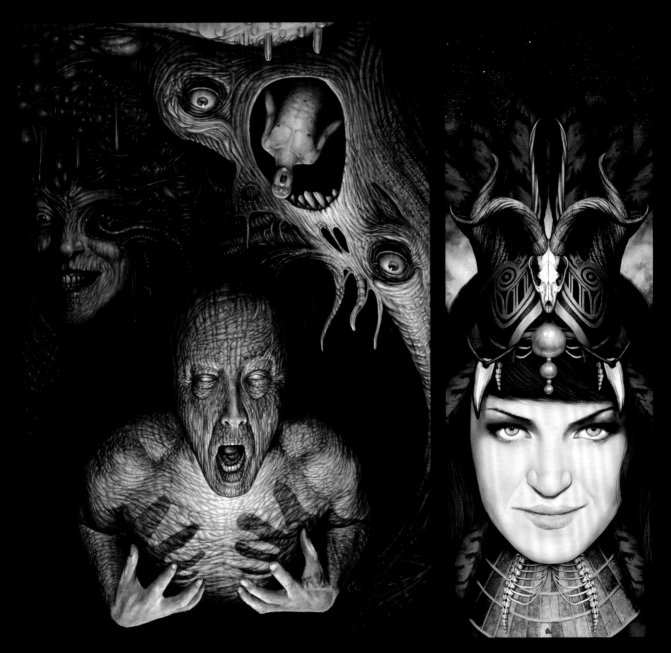

HEIKO MUELLER *& His Dark Story*

I woke up with a feeling of terror and saw the silhouette of a man in the chair. I asked him what he wanted. He answered with a clearly audible voice: "You know what I want." Terrified I bolted for the door, but as soon as I crossed the threshold and noticed he hadn't lunged at me, I realized something wasn't quite right. I calmed down and turned the light on. Of course, nobody was there.

One thing confused me though: there was nothing lying on the chair that could have remotely resembled the silhouette of a man in the dark. Apparently I had woken up with my brain still in a dream state. Despite my terror the experience continues to fascinate me. I remember the man's voice as clearly as if I had been awake, which somehow casts a doubt on what I think is reality.

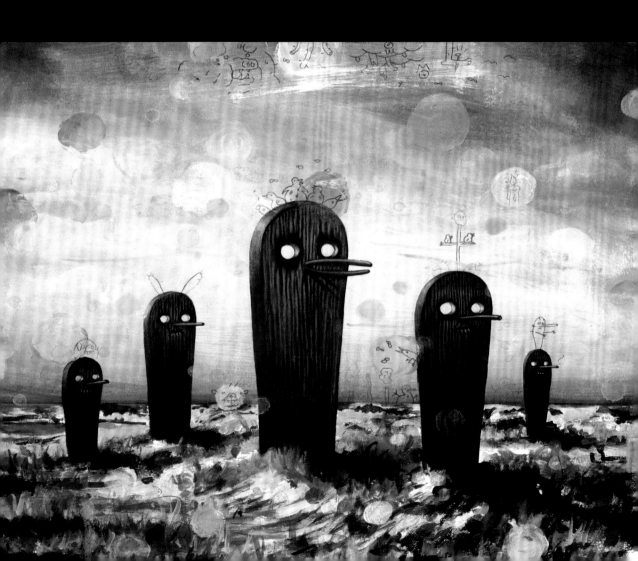

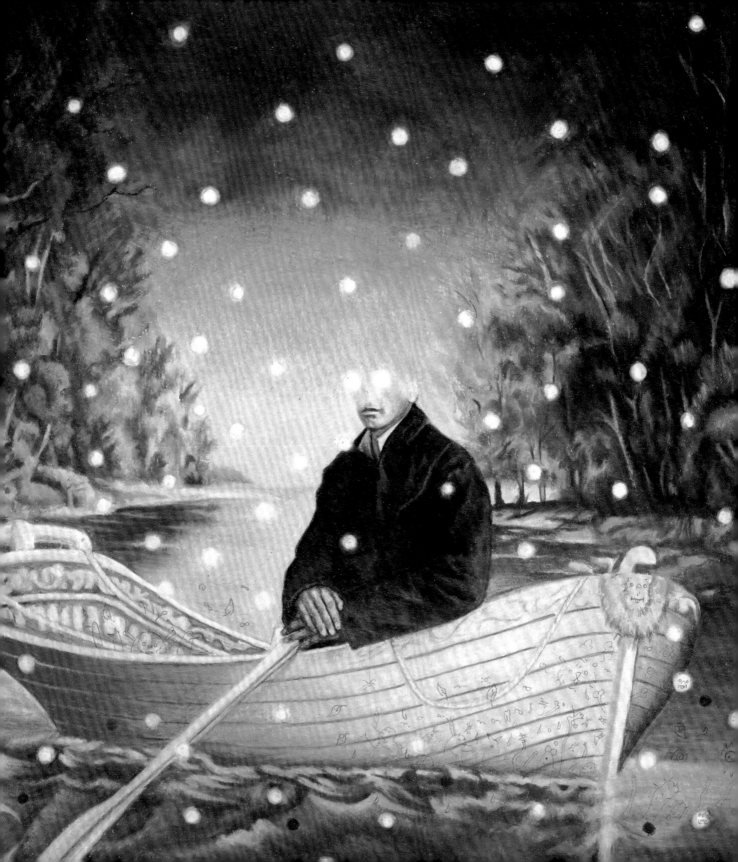

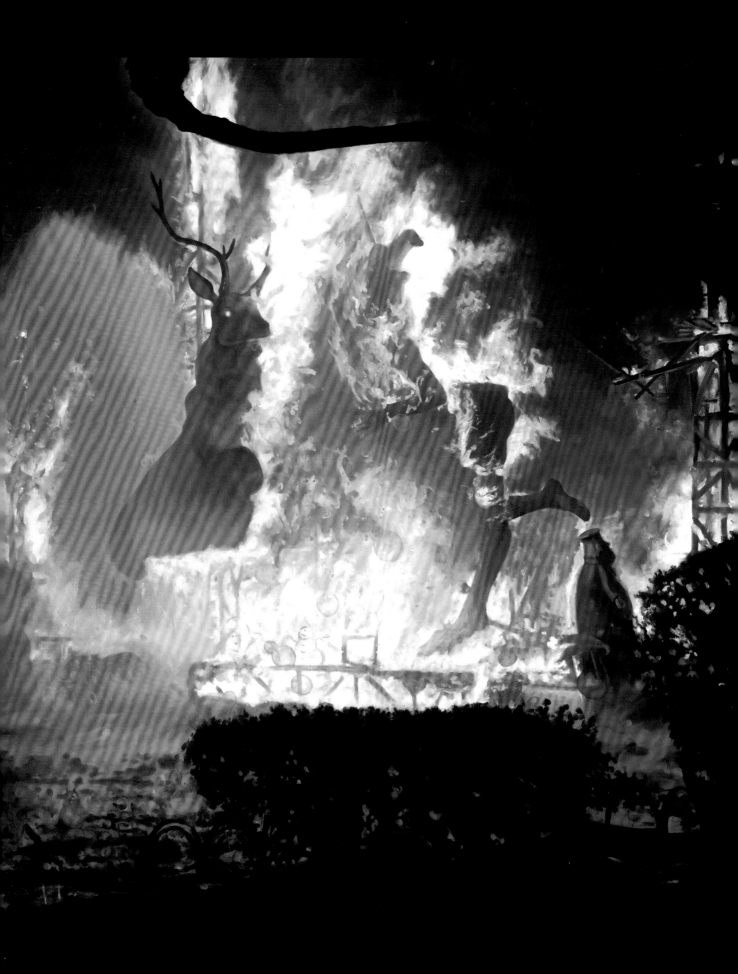

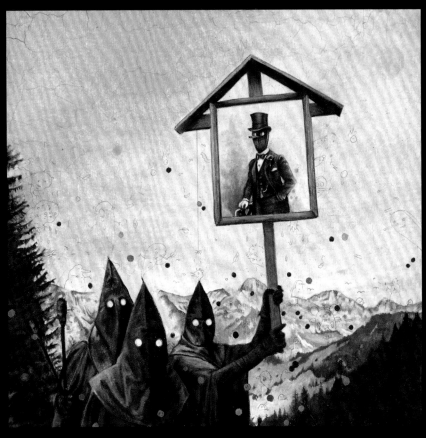

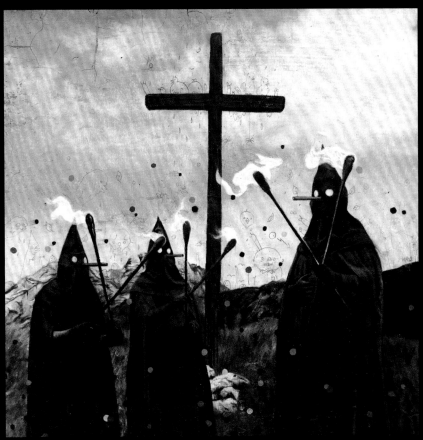

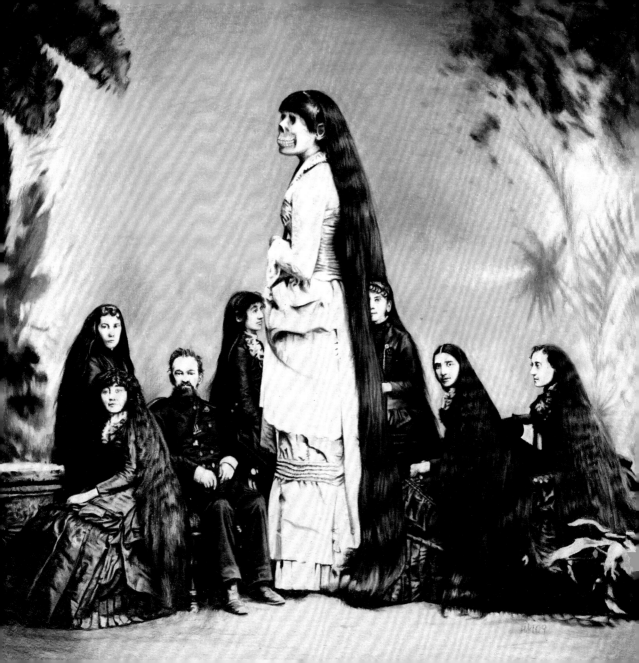

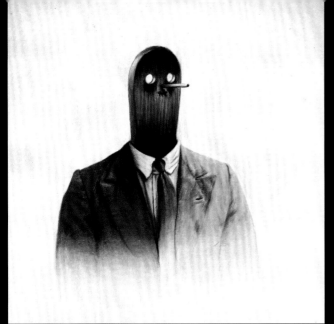
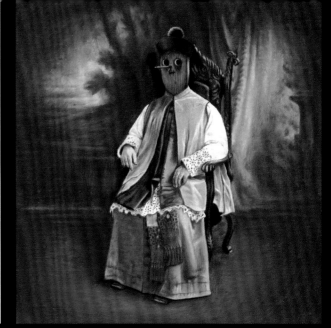
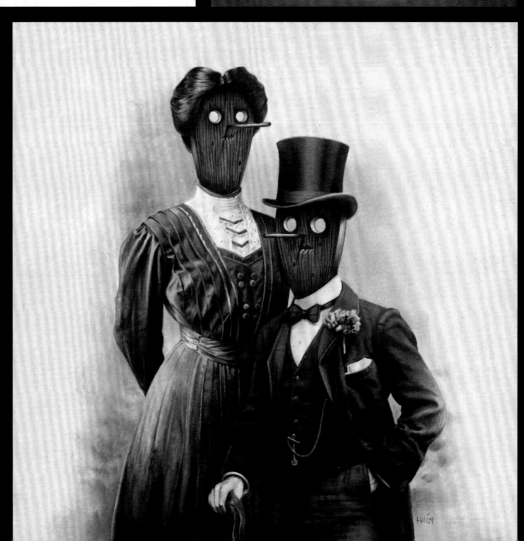

RHYS OWENS & *His Dark Story*

As a child, I was terrified of shadows. Almost every night, I'd imagine that each shift of light that played across my bedroom wall was some dark, unidentifiable creature that was watching my every move. Now, as an adult, it's obvious that these thoughts were nothing but tricks of the mind brought about by an active imagination, but they're still strong enough to remain in my memory after many years and maybe even influence my artwork on a subconscious level.

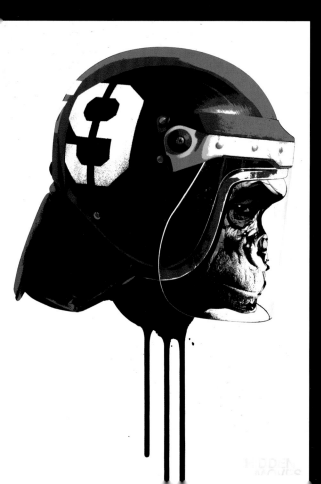

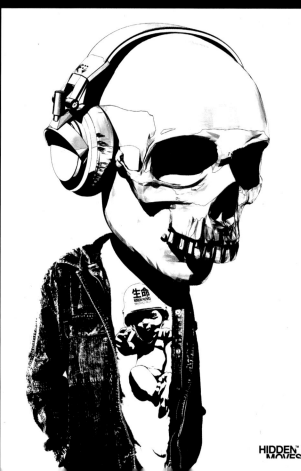

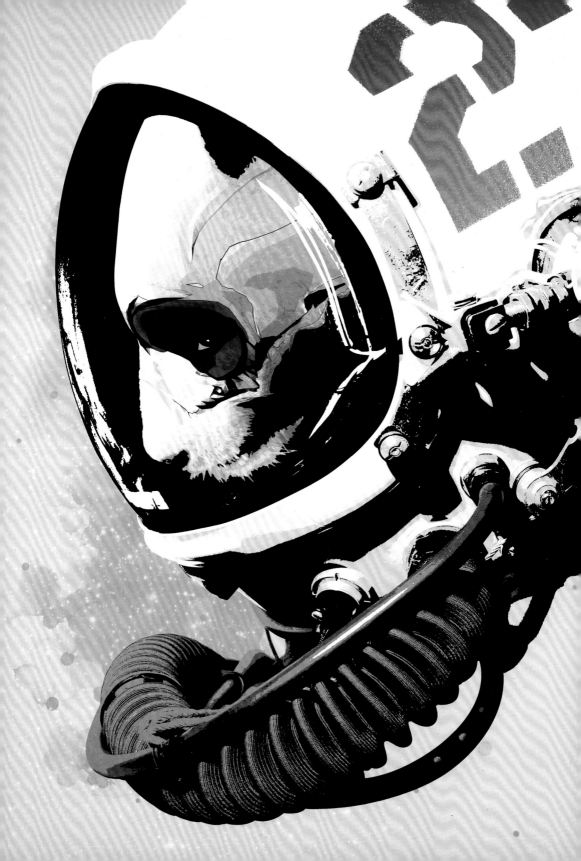

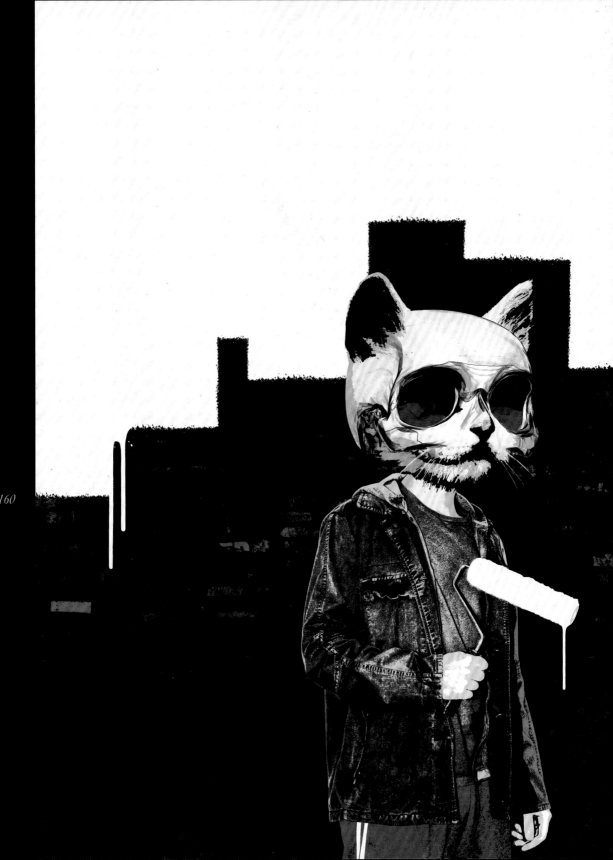

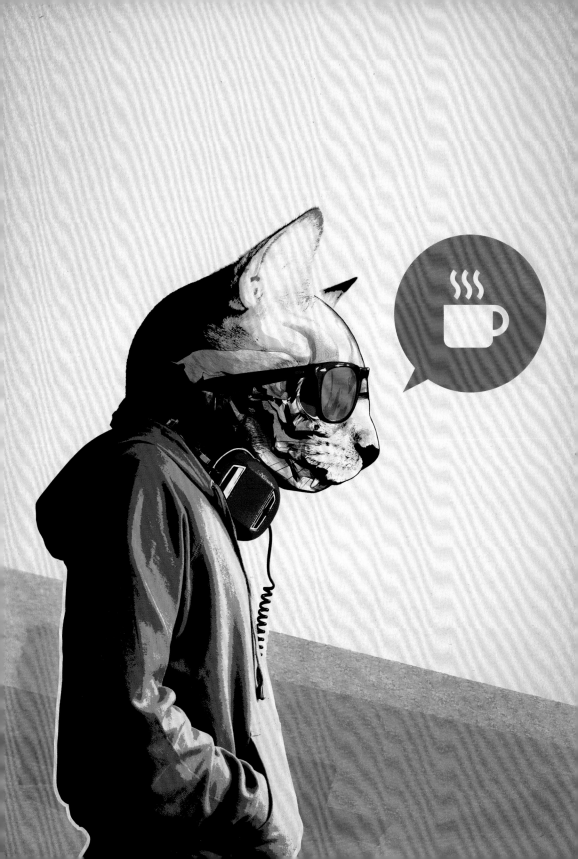

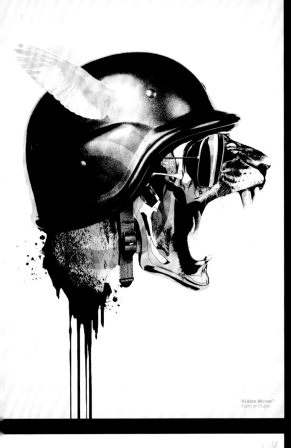

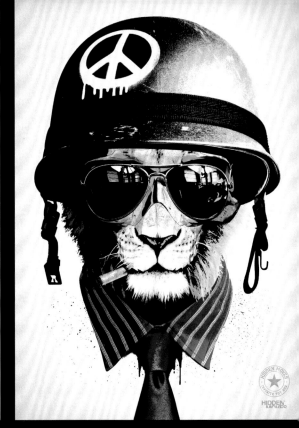

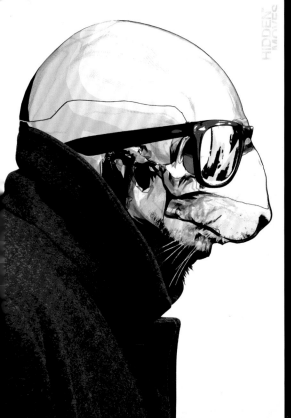

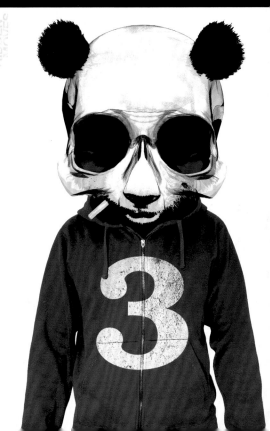

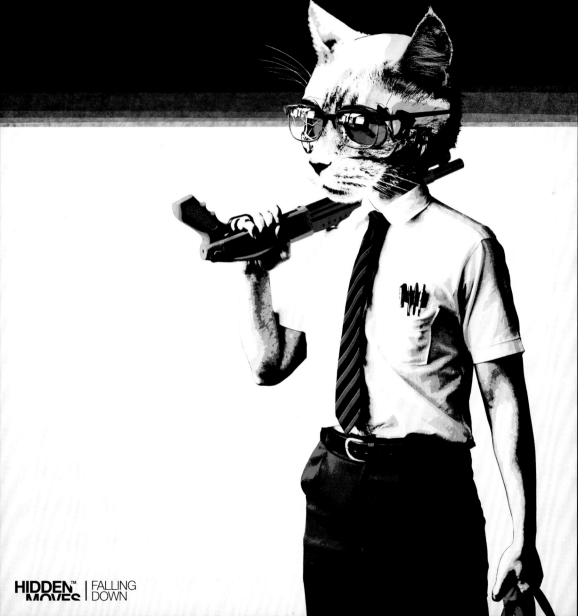

HIDDEN™ MOVES | FALLING DOWN

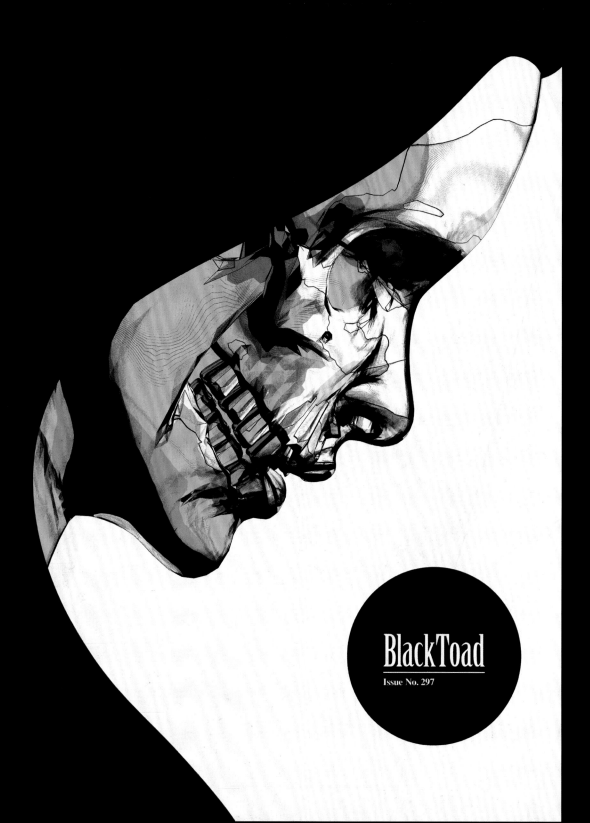

164

BlackToad

Issue No. 297

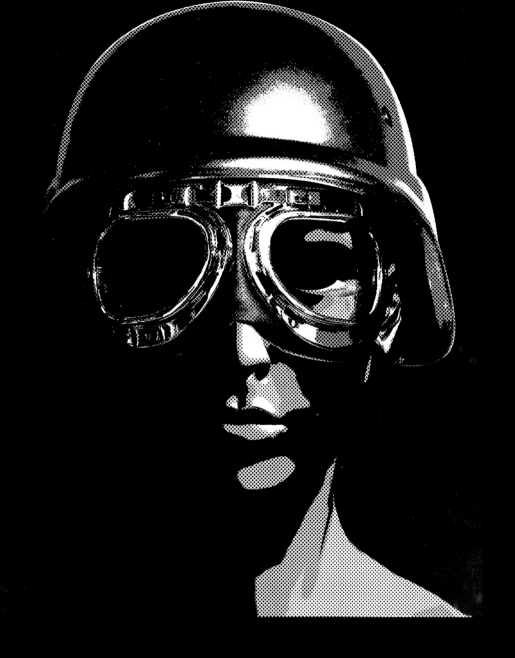

JESSE AUERSALO *& His Dark Story*

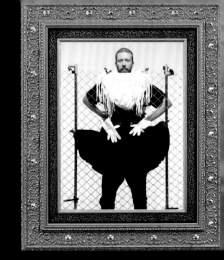

"Sleepwalkers"

While working on "Sleepwalkers," I was inspired by some of the disturbing horror movies I saw when I was a teenager. "Sleepwalkers" was a movie based on a screenplay by Stephen King in the early nineties. American actress Mädchen Amick, who had a role in "Sleepwalkers" also starred in "Twin Peaks" by David Lynch that was running on television at the time. I thought she was so pretty and I remember shitting my pants because I was so scared of the evil Bob.

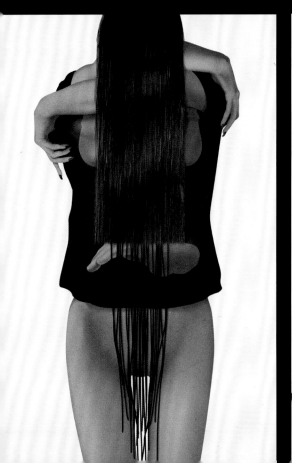

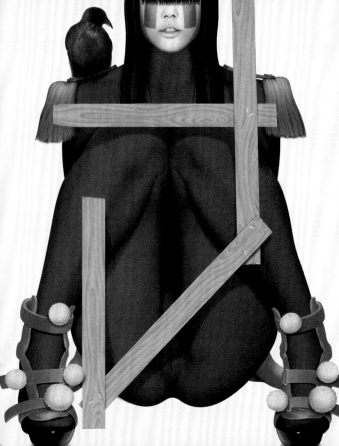

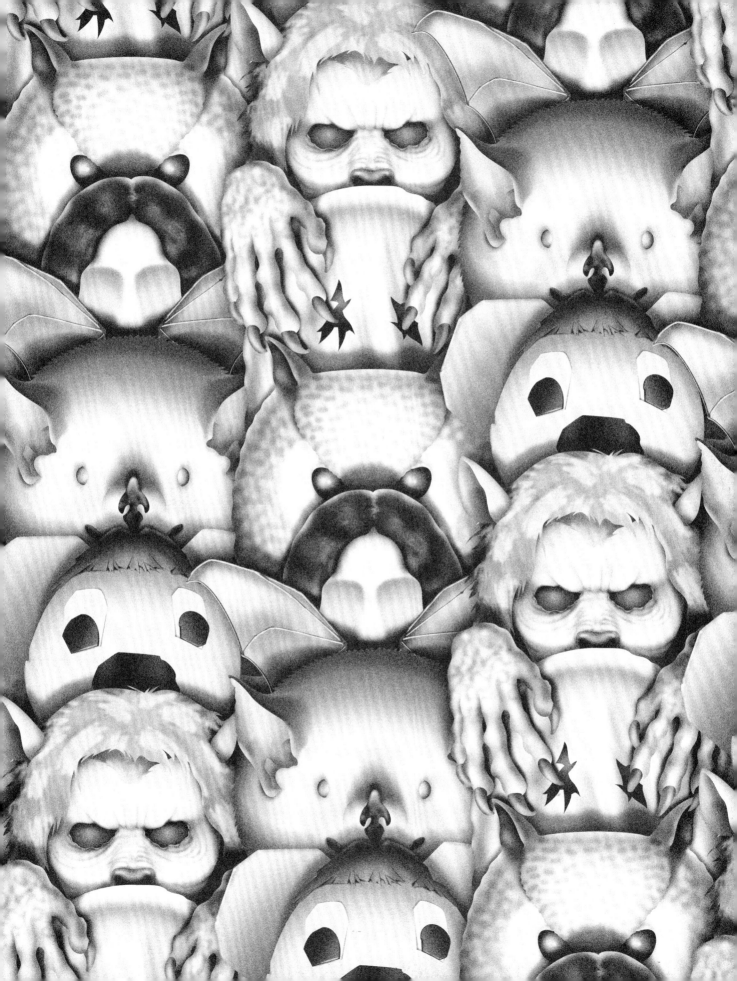

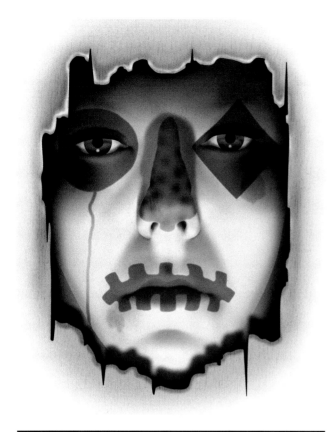

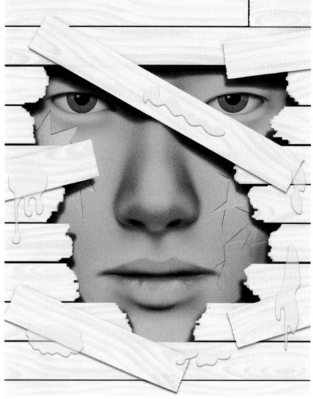

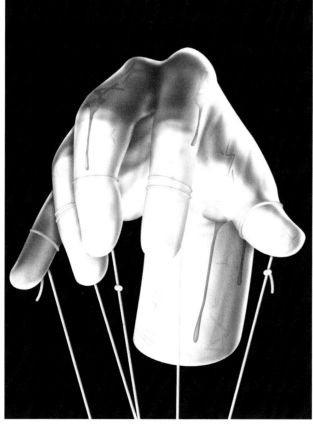

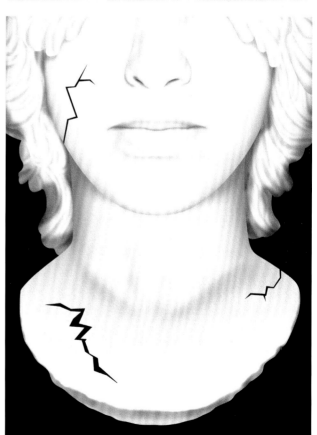

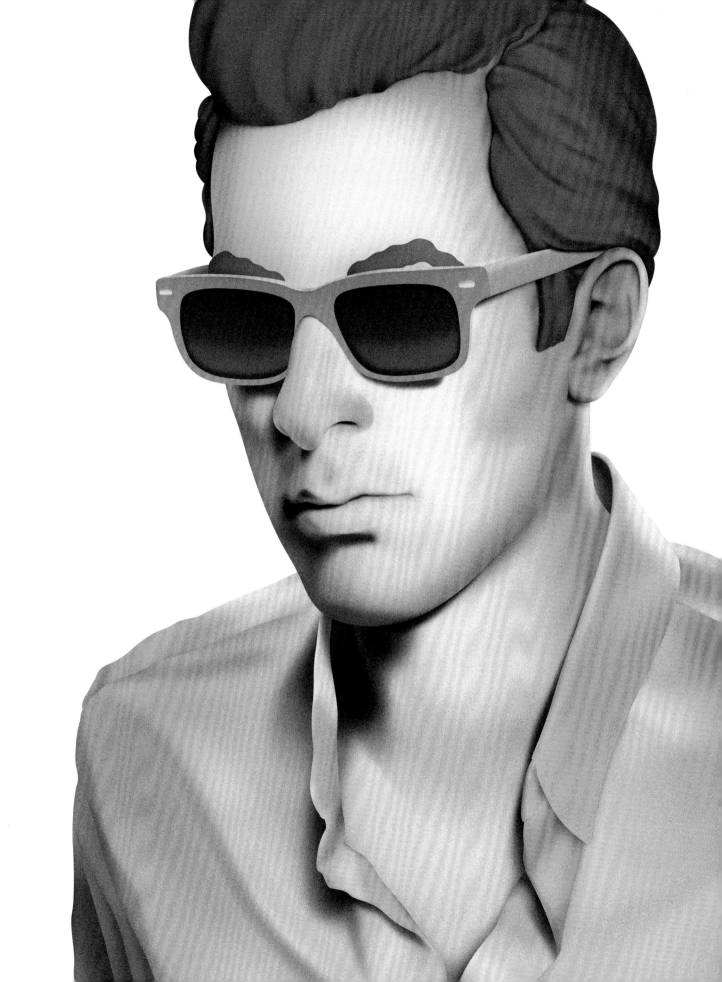

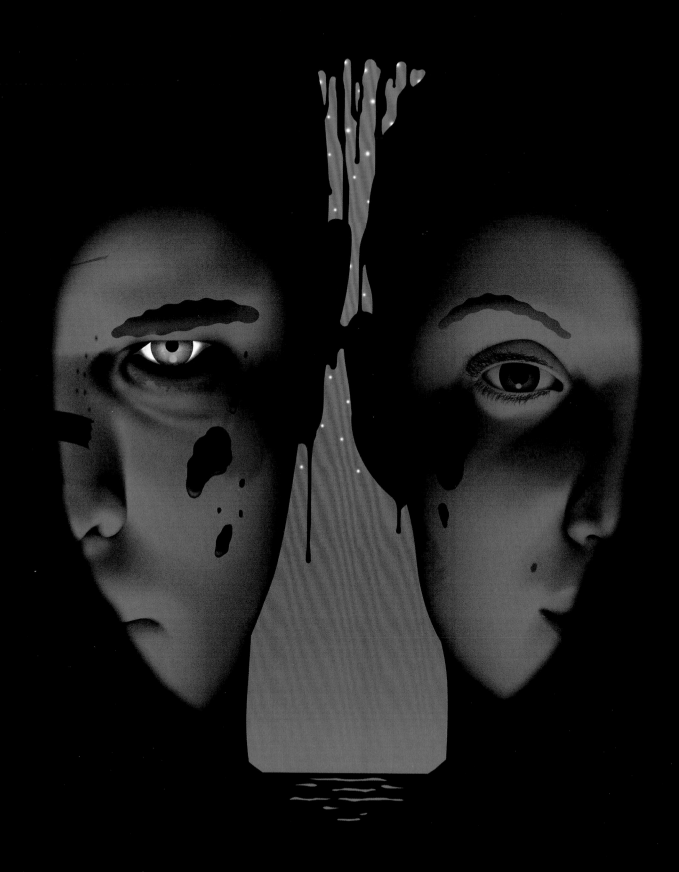

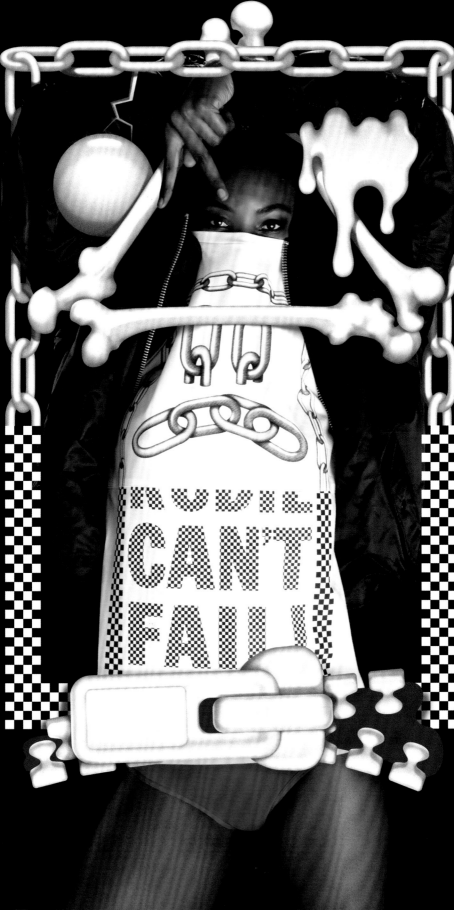

VER MAR *& Her Dark Story*

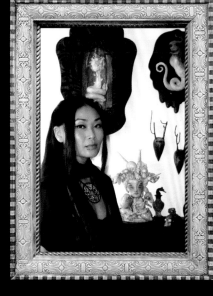

I was a normal child who lived in a haunted house. I didn't think of it as haunted then. It was home, with a hallway that filled me with unease every night I was sent through it to the bedroom at the other end. I was certain that something creeped there in the dark.

Plagued by chronic sleepwalking, I'd often be awakened while wandering in the middle of the night by my mother. Once, she told me, I tried to go out through the front door.

On a rainy night, I was delivered a disembodied message through a bedroom window by what sounded like a woman. The click-clack of her shoes grew louder and closer and stopped, and then she spoke softly into my ear about "February."

When I was eleven, we moved, leaving my sleepwalking and unexplained occurrences behind in that old house.

These experiences tapped me into the mysteries of life and left me with an interest for things unusual.

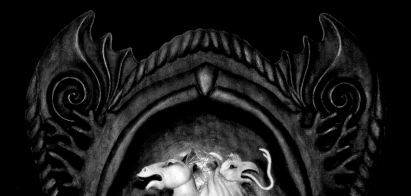

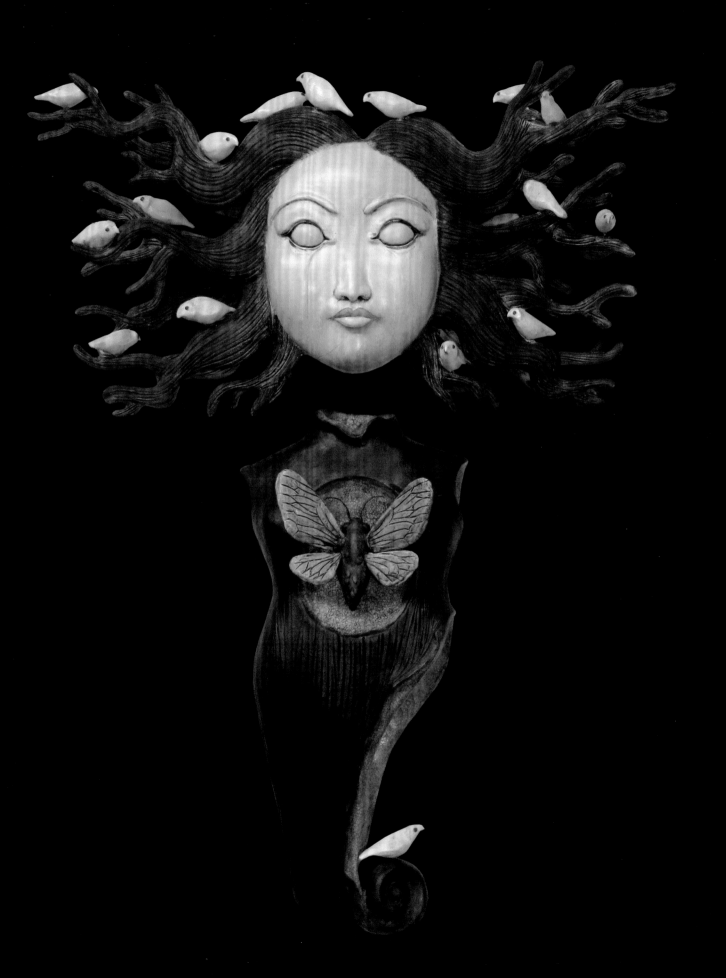

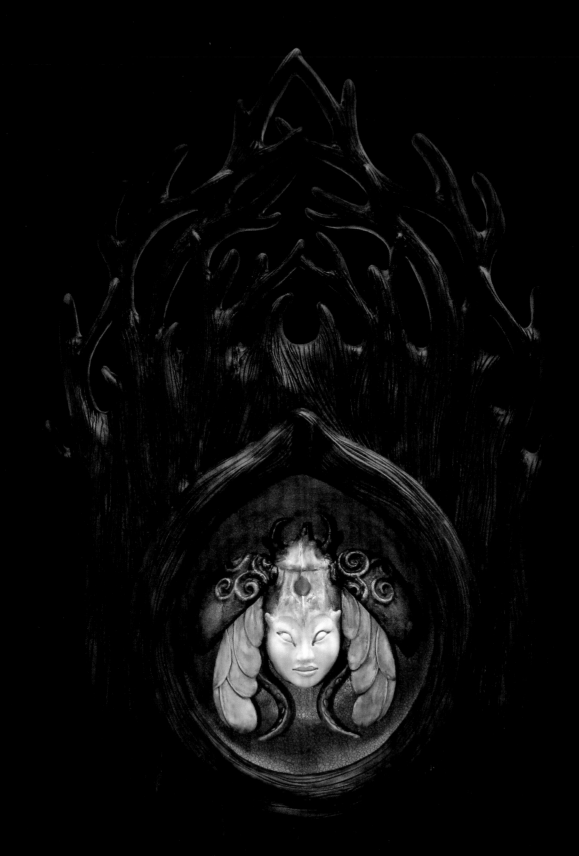

174

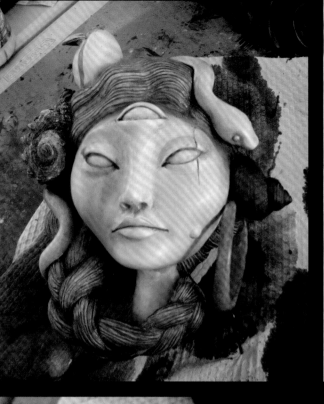
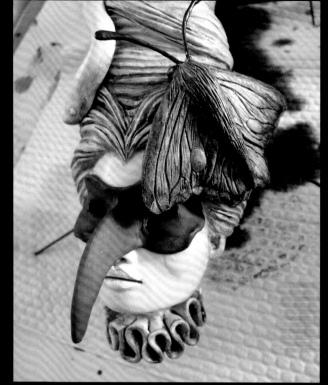
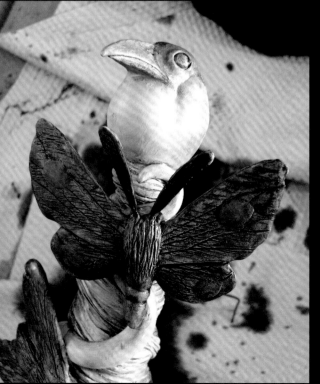
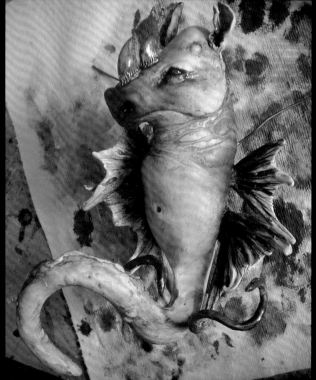

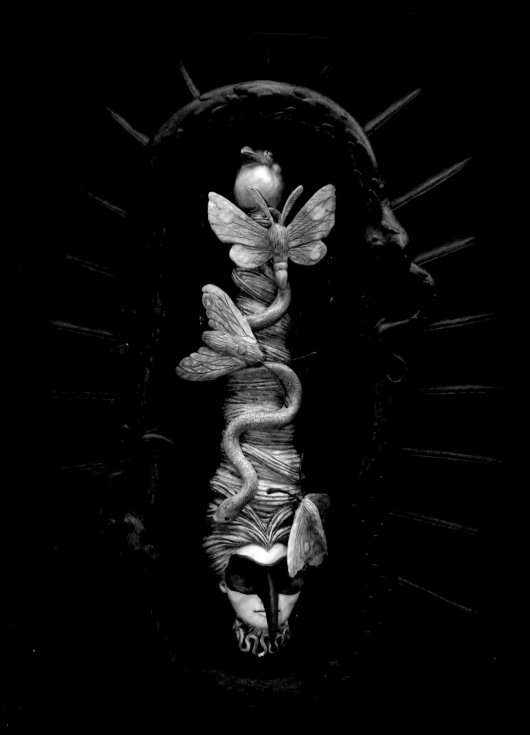

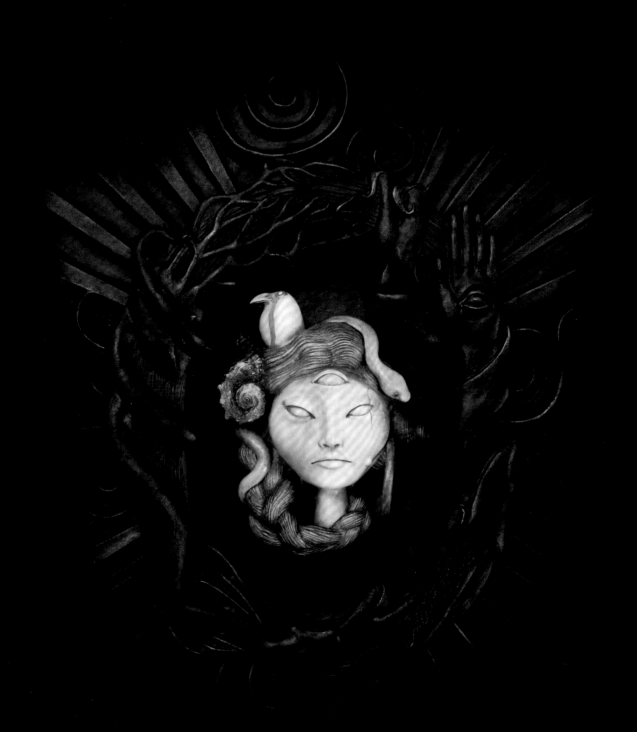

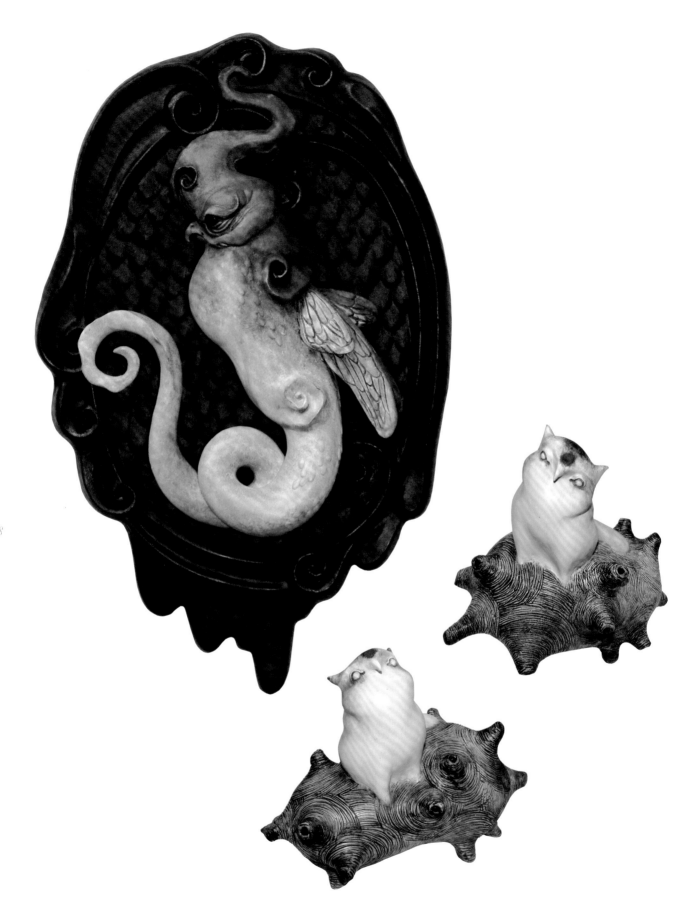

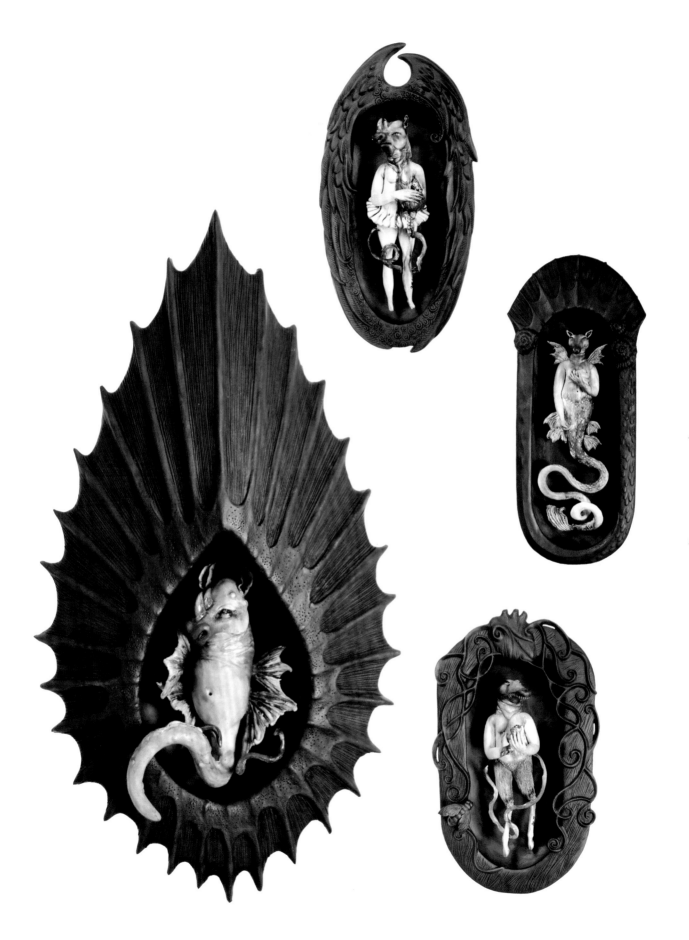

SCOTT RADKE & *His Dark Story*

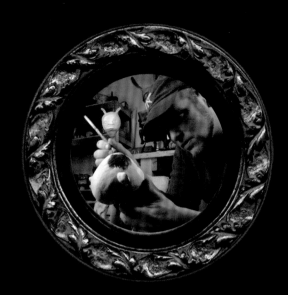

I used to have horrifying nightmares as a child of a large knot swinging back and forth towards my face.

I would get sick looking at all the twists and turns. It was the bottom of a bull rope like the ones you have to climb in gym class. The knotted end was twisted and tied in endless ways. Everything else in the dream was black – in total space.

Maybe it was because I could not climb them at the time. Who knows, but I still get a lump in my throat when I think about those dreams. They lasted for years.

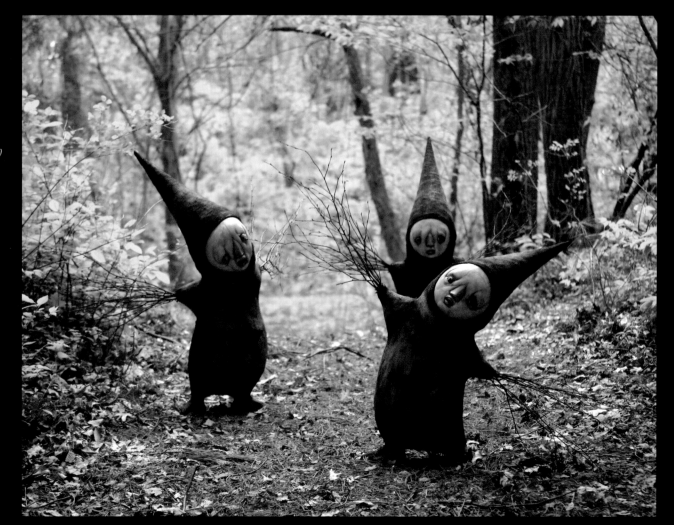

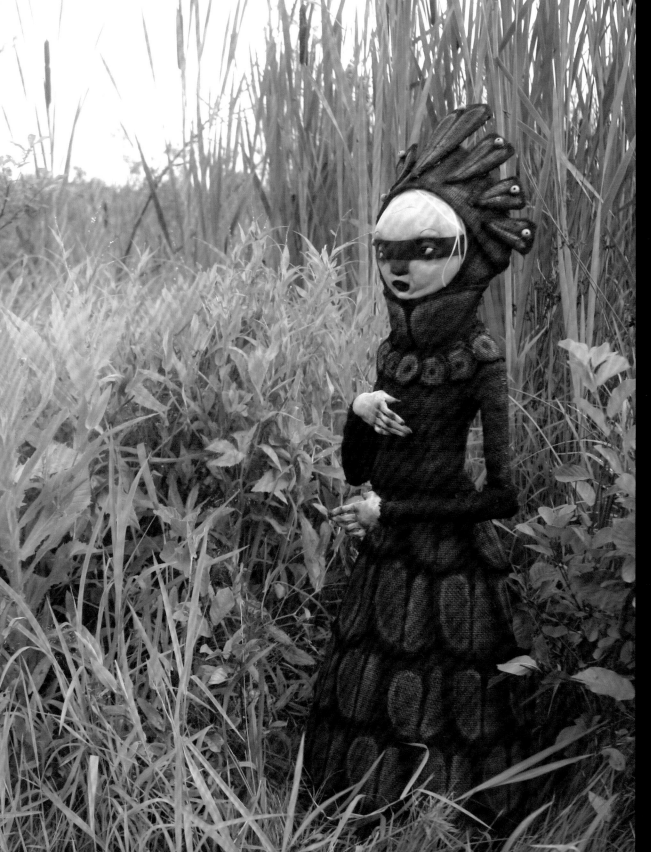

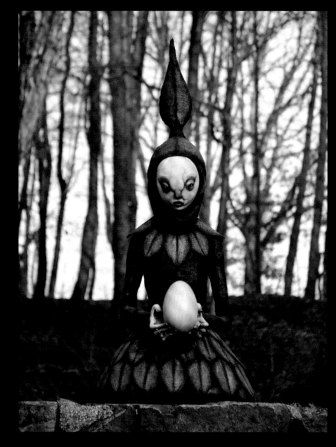
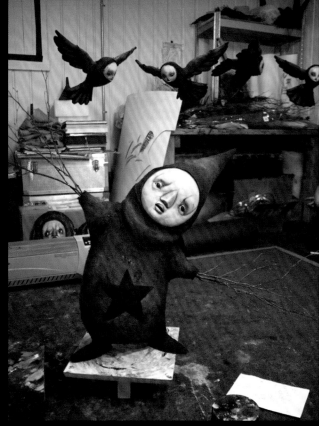

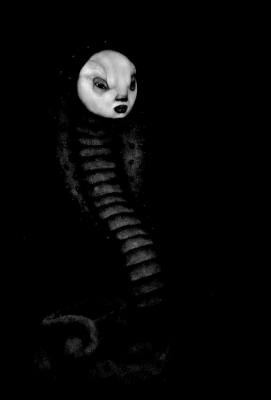
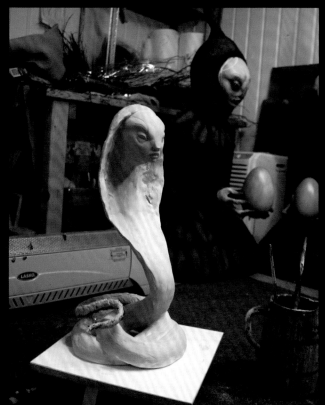

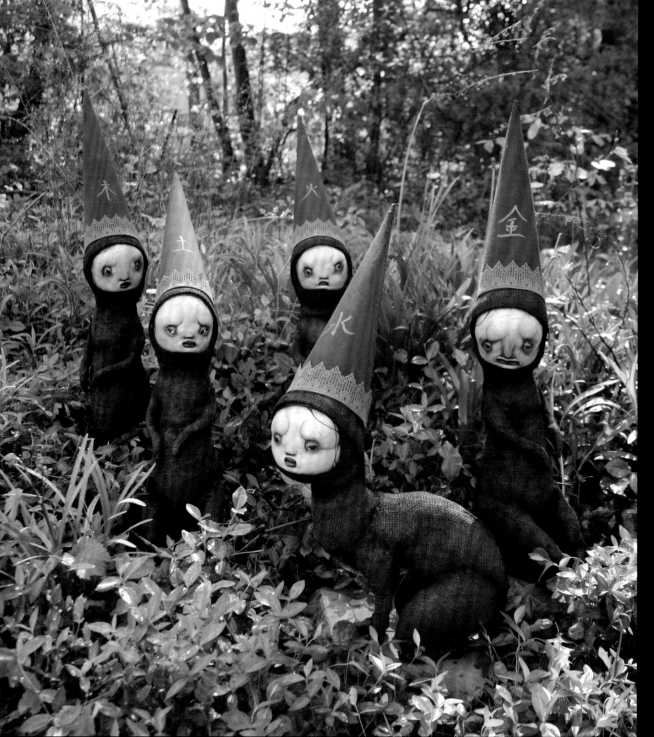

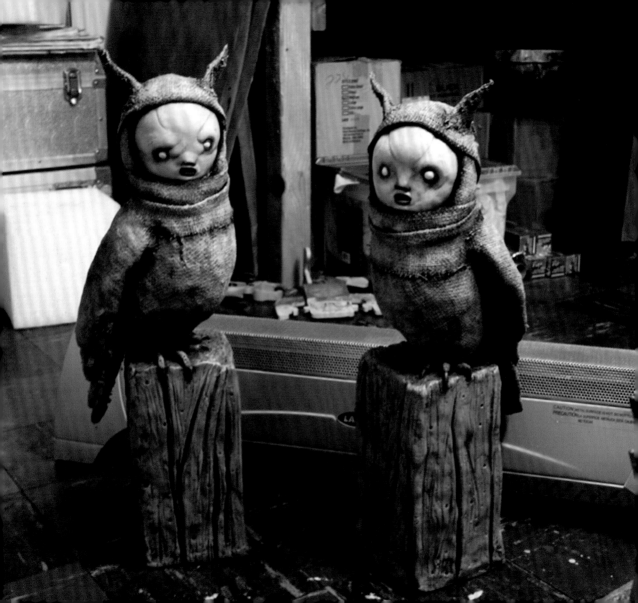

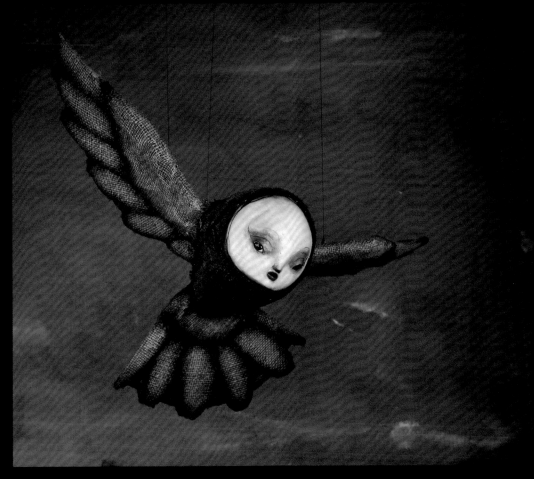

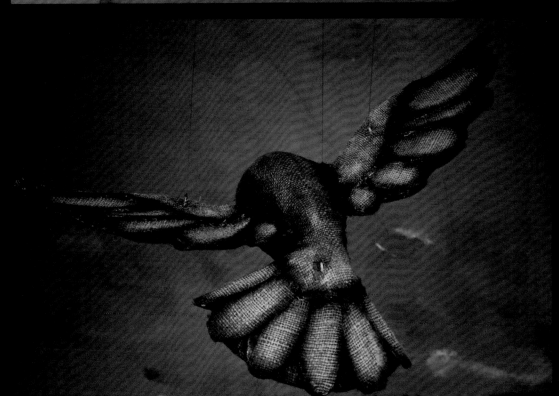

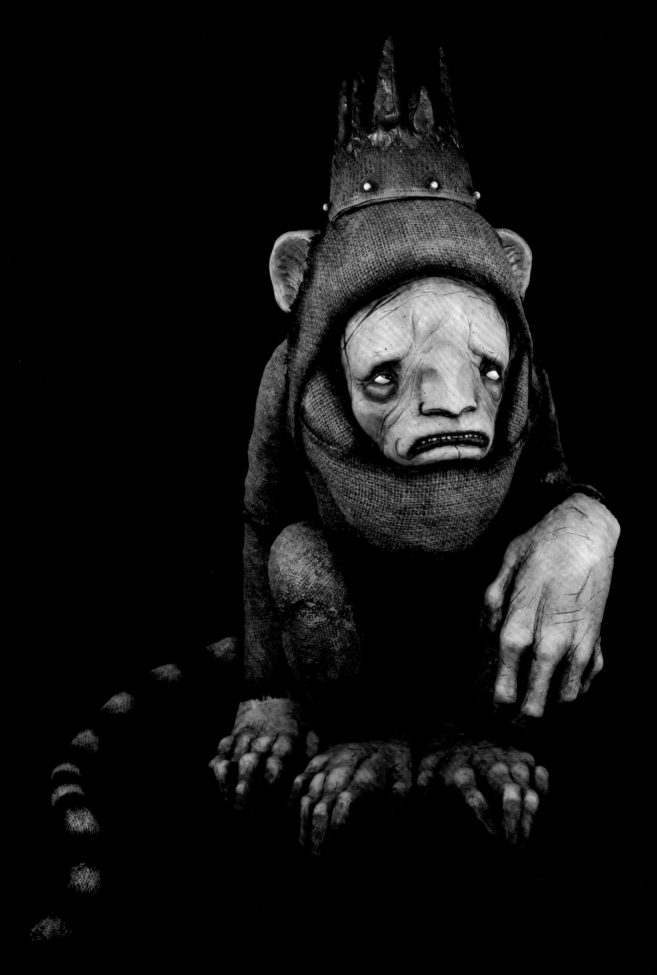

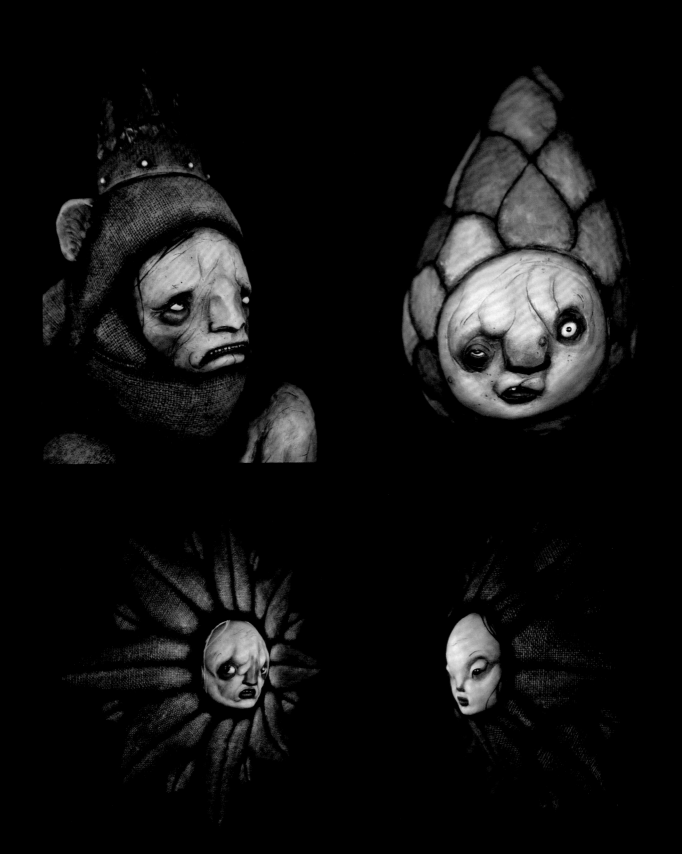

"First and Last Breath"

My favorite book as a child was Watership Down, but I found the part when the warrens are gassed to make way for new development terrifying. The mother rabbits in the den with their babies, the other rabbits dashing for the safety of their holes when the men arrive with machinery only to be trapped underground, the choking gas, and then the bulldozing of the whole field gave me nightmares.

In the book, a rabbit has visions of this happening and successfully convinces others to leave the warren and strike out overland having adventures along the way. I always thought of wild animals as heroic after that, facing terrifyingly casual brutality from humankind, but embodying virtues like brotherhood, ingenuity, insight and an admirable instinct for survival. They have figured in my artwork ever since. My piece "First and Last Breath" is inspired by this childhood story.

188

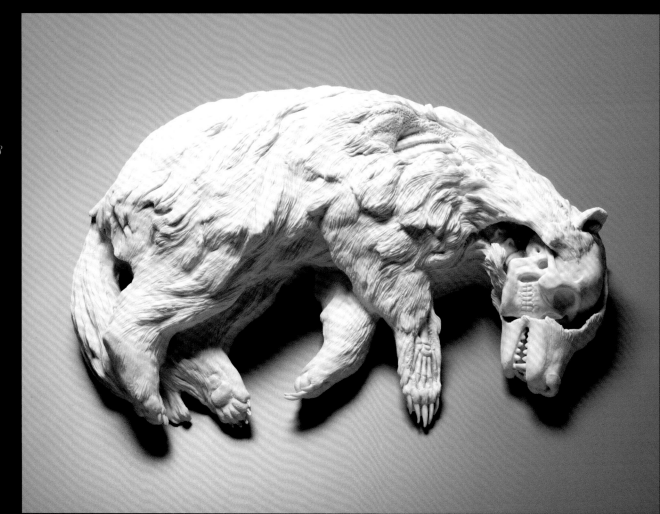

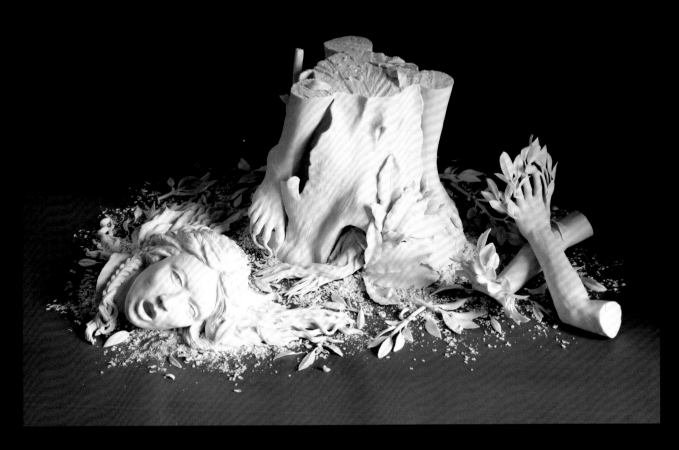

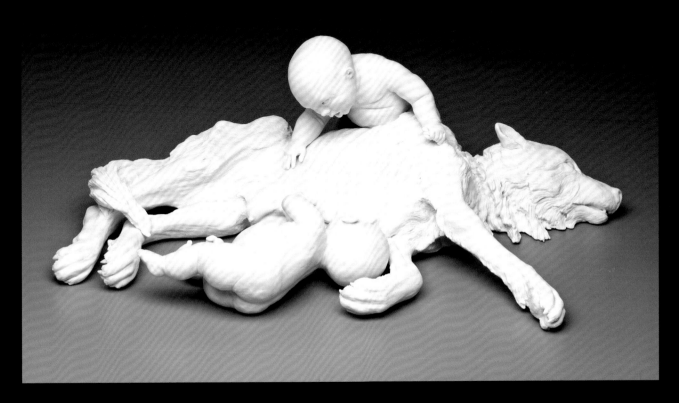

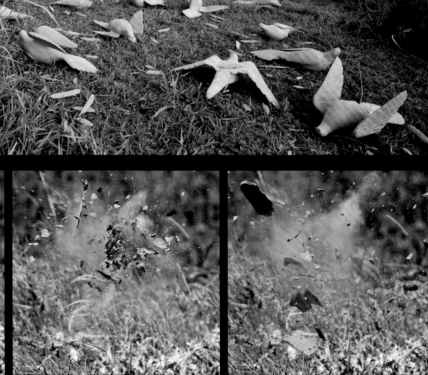

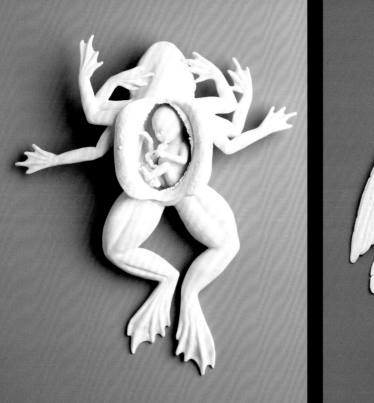
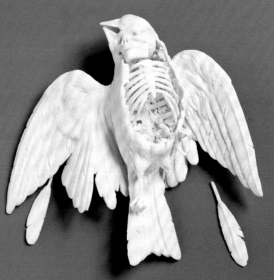

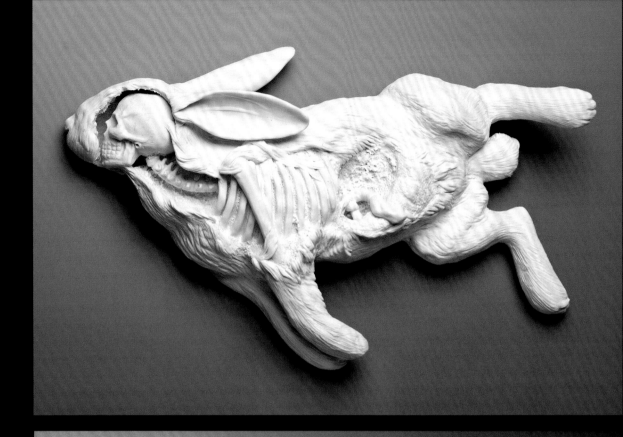

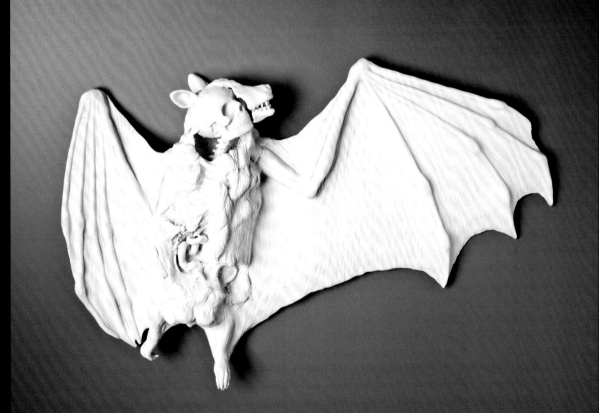

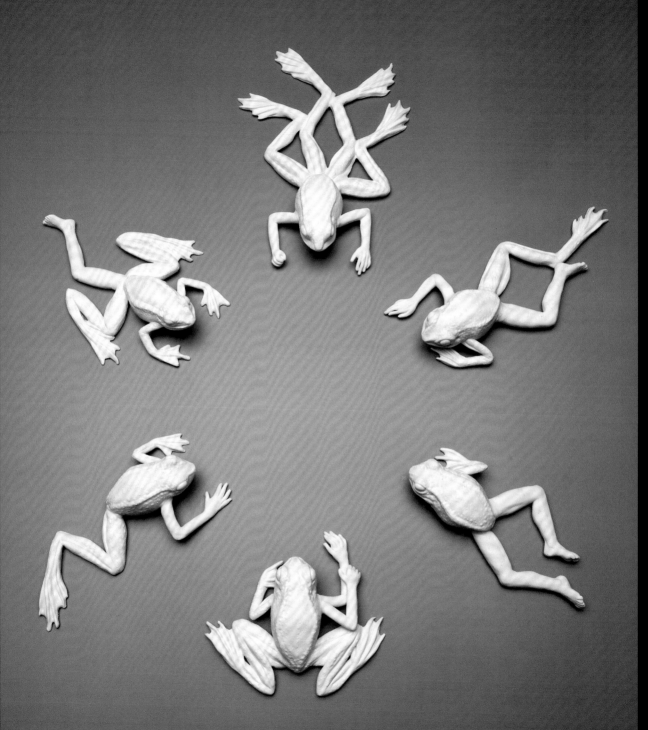

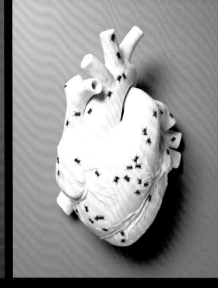
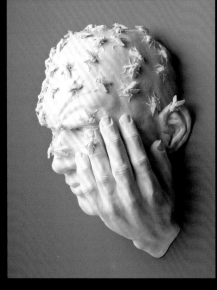
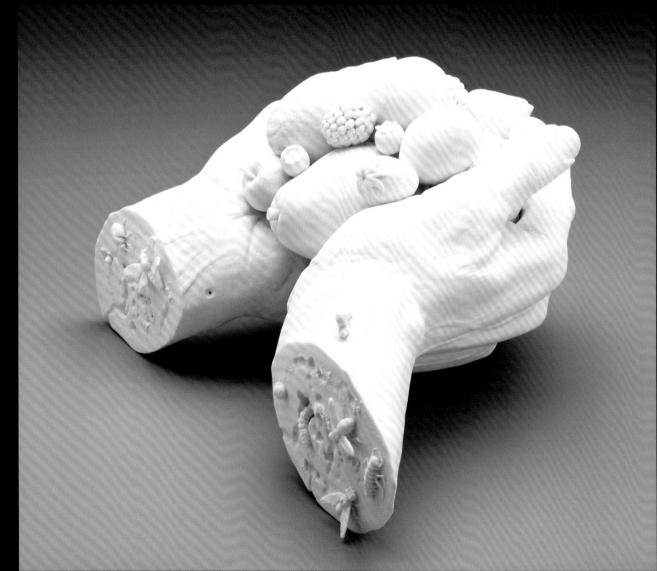

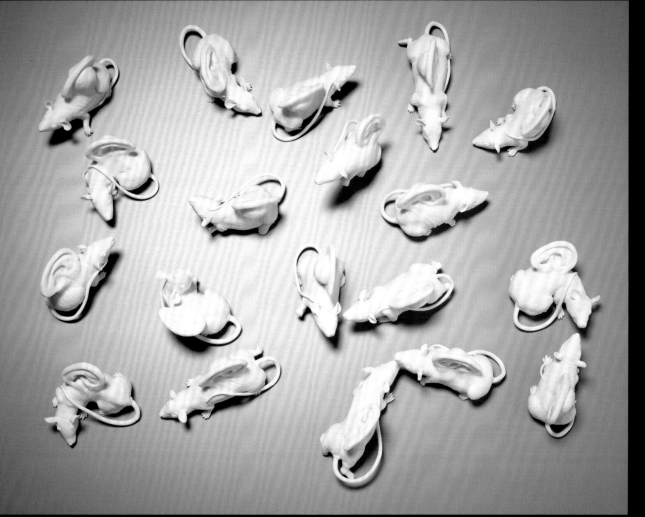

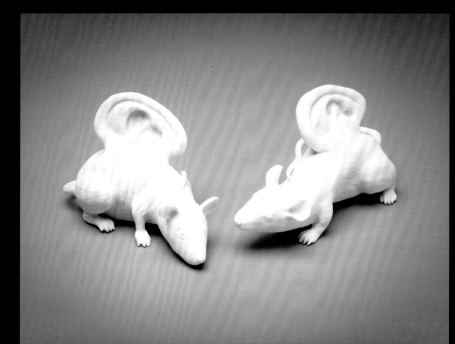

My father was the polar opposite of my mother. All I heard of him were stories of alcoholism, mild insanity, and a constant urge to impress his friends with his gun collection and cannons. I never knew him nor spoke with him until visiting him at his deathbed in November 2000 in the tiny town of Humansville, Missouri. He was an emaciated man, moaning in pain from progressive lung cancer, a gift from tobacco and a lifelong smoking habit. He lay on a hospital bed before me and I could only hold his hand and hear his moaning as though it were my own voice. I had no strength to say anything to him and he died a few hours later.

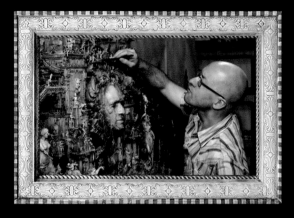

196

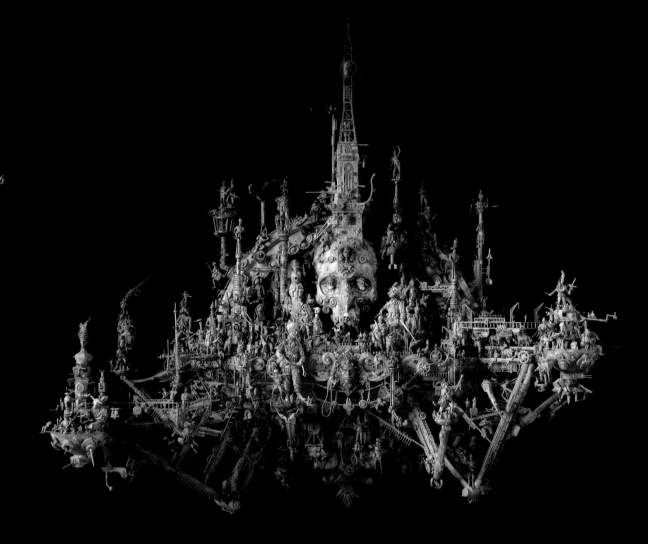

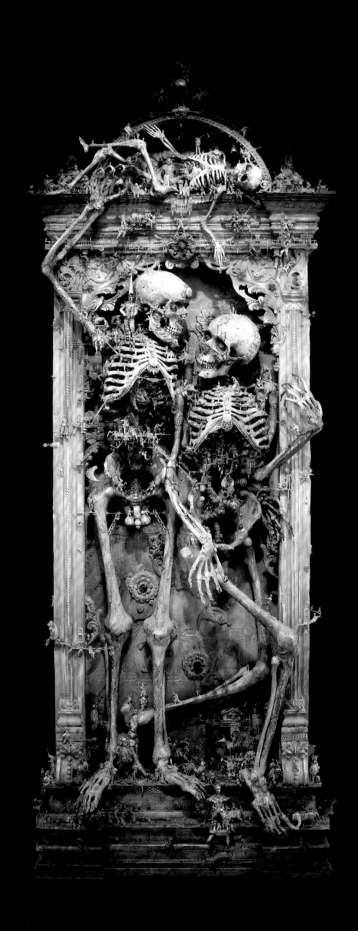

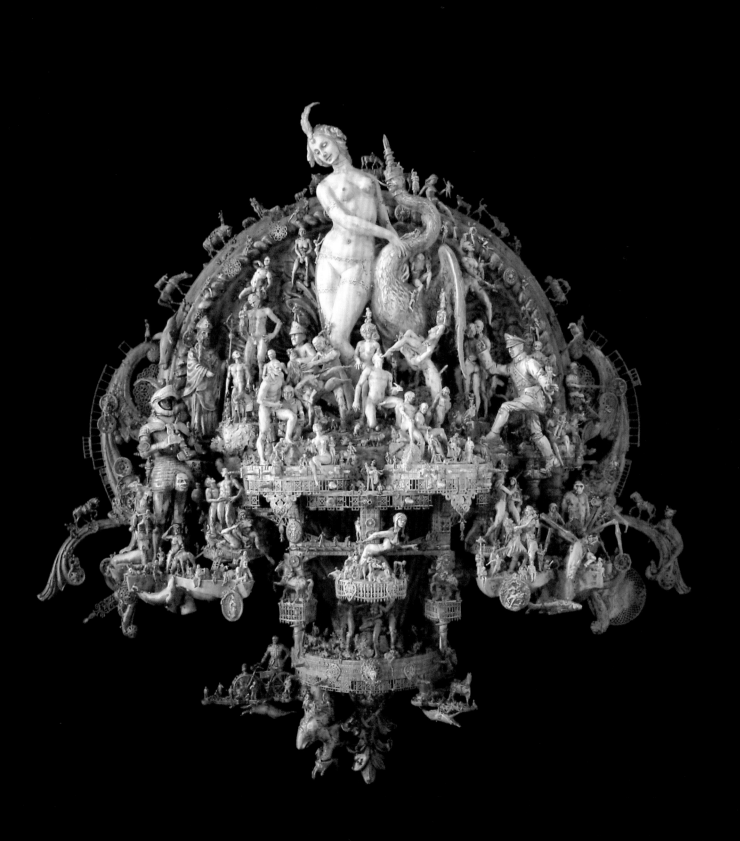

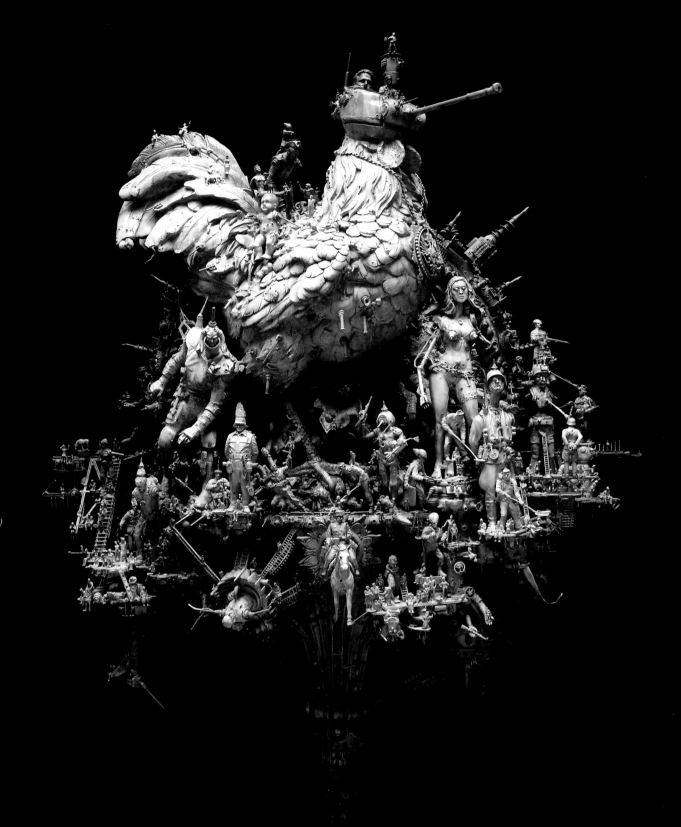

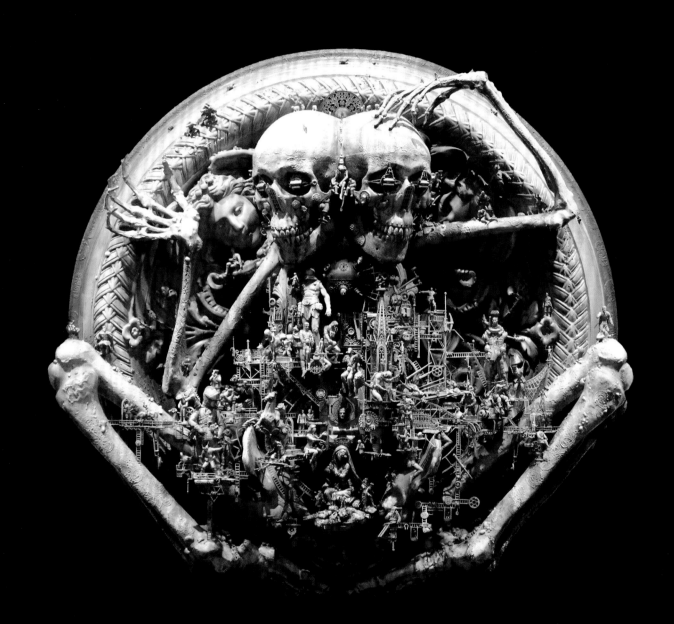

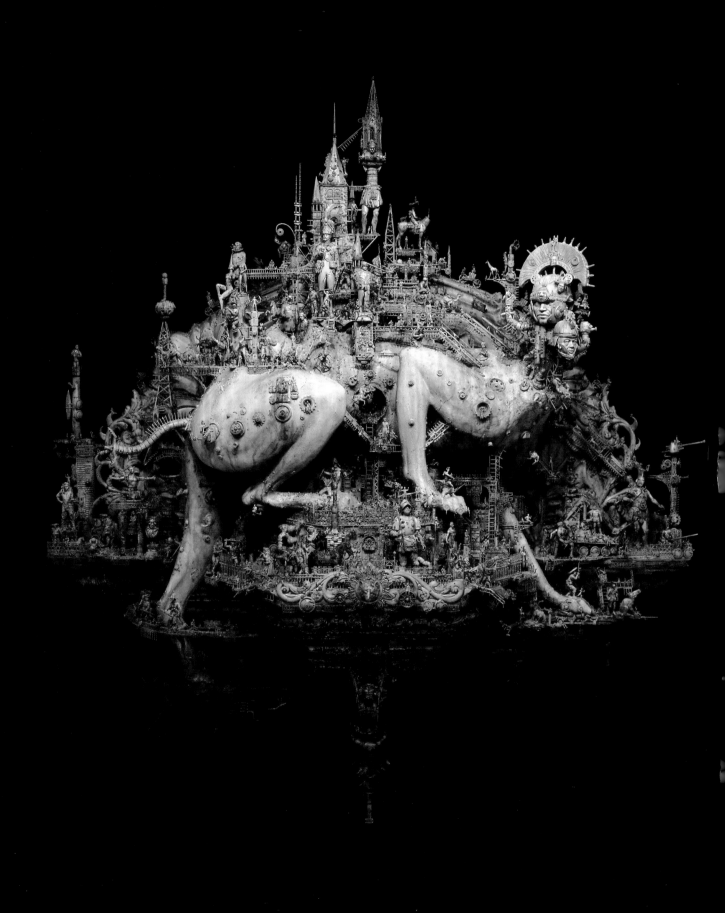

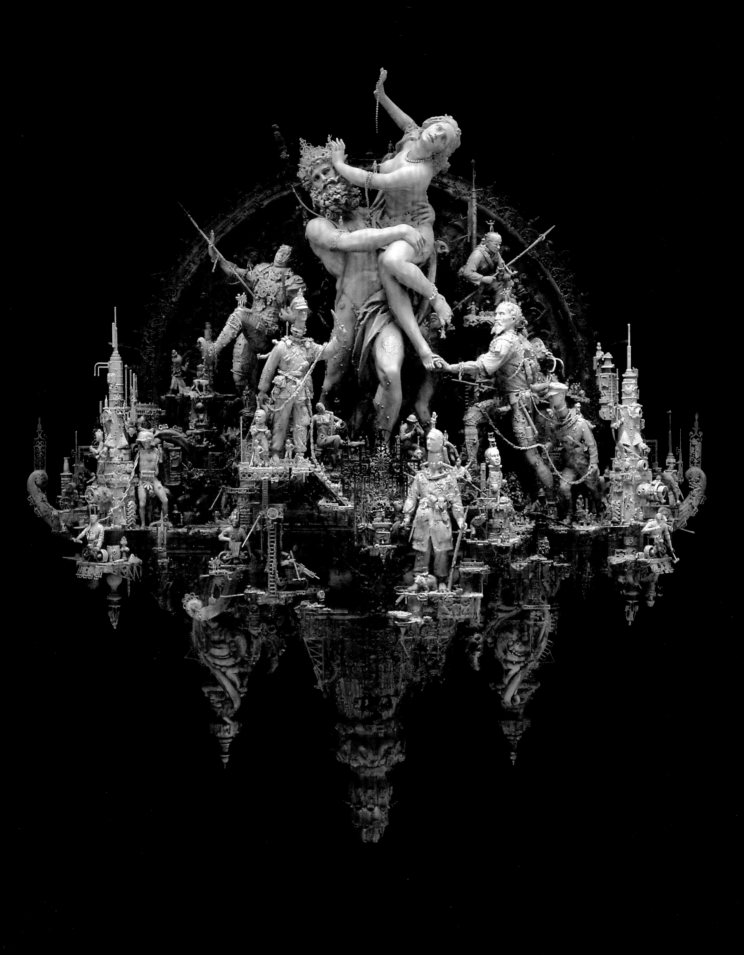

FRANCOIS ROBERT & His Dark Story

When I was around fourteen years old, I was exposed to my first disturbing series of images during the projection of the movie "Night and Fog" by Alain Resnais. It featured a bulldozer pushing the dead bodies of Jews into a mass grave after the liberation of the concentration camps. Six years later my brother died.

I have recently seen the movie "Tyrannosaur."

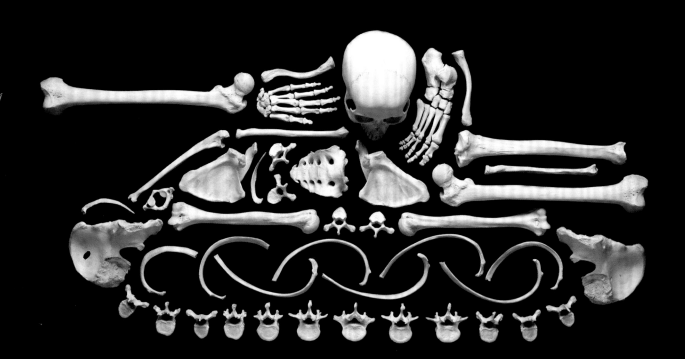

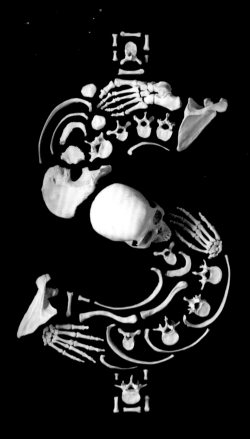
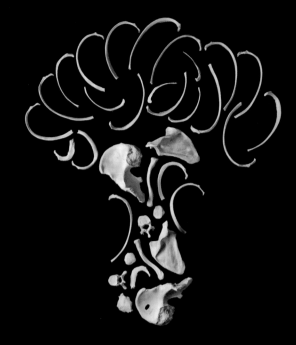

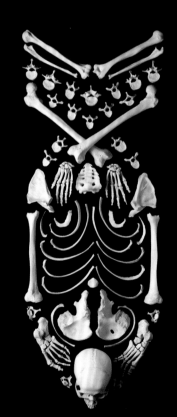
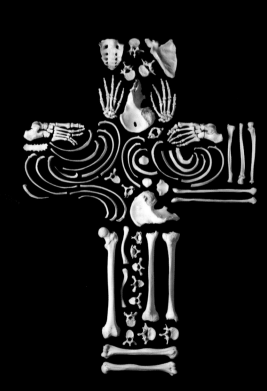

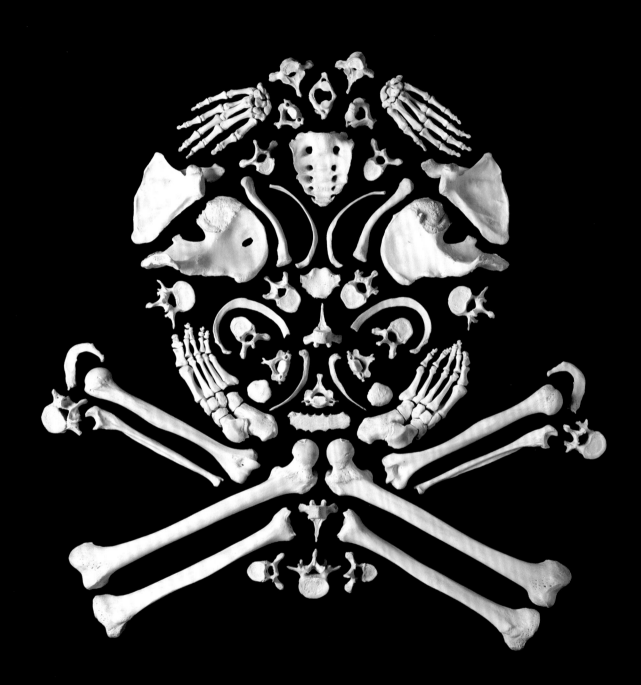

206

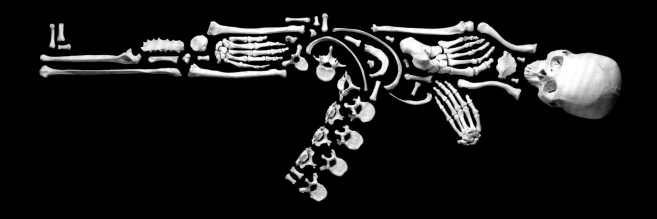

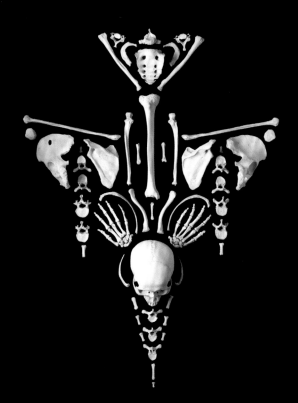

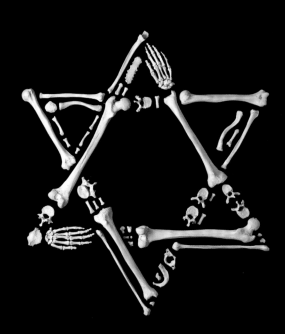

Author: Nie Youjia

Executive Directors: Guang Guo, Mang Yu

Project Editor: Jean Chao

Translator: Coral Yee

Copy Editor: Lee Perkins

Book Designer: Tang Di

Dark Stories by Dark Artists

First published in the United Kingdom in 2012 by CYPI PRESS

Add: 79 College Road, Harrow Middlesex, Greater London, HA1 1BD, UK

Tel: +44 (0) 20 3178 7279

Fax: +44 (0) 19 2345 0465

E-mail: sales@cypi.net editor@cypi.net

Website: www.cypi.co.uk

ISBN: 978-1-908175-29-8

Printed in China